The Art of Cartooning

Walter Foster™

Walter Foster Publishing • 23062 La Cadena Drive • Laguna Hills, CA 92653

The Art of
Cartooning

Contents

Begin at the Beginning by Jack Keely

Everybody loves cartoons. We eat our oatmeal with the comics keeping us company, and we paper the refrigerator with our favorites. We consume comic books and absorb endless hours of animation. Our T shirts, key chains, lunch boxes, and bed sheets are emblazoned with the faces of our cartoon buddies. It seems we can't get enough of them.

The mania for cartoons began around a century ago. In the late 1890s, *Puck, Judge,* and other humor magazines overflowed with cartoons. New technology allowed newspaper publishers to print more papers at a faster rate and improve the quality of reproduction. Sunday supplements were created as a way to boost circulation. *The New York World* began featuring color cartoons, including *The Doings in Hogan's Alley*. A single-panel cartoon depicting life in the slums, it featured the Yellow Kid, a gap-toothed brat in a billowing nightshirt. The Yellow Kid's immediate popularity sparked a lively competition among the newspaper publishers, and the modern comic strip was born.

Readers were seduced by the adventures of personable brats, newlyweds, and talking animals shown in single "gag" panels or told through a series of images and talk balloons. A masterpiece of fantasy and draftsmanship, *Little Nemo in Slumberland* by Winsor McCay appeared in 1905. Newspaper cartoons were quickly followed by short animated films and, eventually, feature films. Today's cartoonist has the opportunity to work in these areas, as well as on comic books, greeting cards, toys, advertising, television, and computer animation.

Cartoons are even more fun when you create your own, and this book will get the ball rolling. This edition contains a sampling of books from Walter Foster Publishing, selected to offer the beginning cartoonist the basics needed to create characters for comic strips or animation. Here are suggestions on where to find inspiration and how to give life and personality to your brainchild through facial expression, body position, and costume. You'll find drawing and inking techniques as well.

Mix the information and opinions you find in this book in a tall glass of undiluted imagination. Add your own point of view, a big splash of humor (the essential ingredient), and a spark of inspiration. Enjoy!

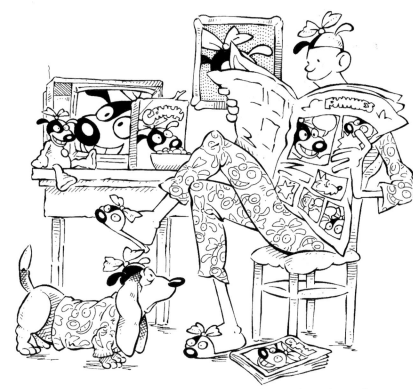

Cartoon characters cover the landscape. They're transformed into plastic toys, plush dolls, video games, vitamin pills, and bubble-bath bottles, and they hover above us as humongous balloons in holiday parades.

Section 1

GET GOING

As a 7-year-old nerd in the 1950s, my path home from Theodore Roosevelt Elementary School took me past Irmgard's drug store every day. In addition to aspirin and antacid tablets, Irmgard had a soda machine, a fairly good toy department, and an amazing array of comic books.

The super heroes were all there, saving the world in their silly suits, but they held no allure for me. A corral full of cowboy comics that had spun off from popular TV shows also failed to tempt me. I preferred the comics that were comical, and there were plenty. I shared my world with a friendly ghost, a merry Martian, a poor little rich boy, a giant baby duck, an overheated little devil, the world's biggest little girl, and a wacky batch of teenagers. My mother would have preferred to see me reading loftier literature, but she figured reading anything was positive and supplied a steady stream of dimes to finance my lurid little library. Thanks again, Mom.

It was a short step from reading the comics to drawing my own. Soon I was a nonstop drawing machine, pondering such deep questions as how the clothes of a toad should be tailored or if fish could have fingers. My school notebooks contained very few notes, but they overflowed with skewed and rude portraits of my teachers and classmates. Smiling cakes covered my homemade birthday cards. Every postcard or envelope I mailed became a canvas covered with cartoons. Holidays triggered explosions of cupids, leprechauns, elves, and witches. I drew cartoons for the school paper, upgrading my image from anonymous geek to class artist along the way.

One high school art teacher felt I should abandon my "squiggly little cartoons" for more serious artistic venues— oil paintings and such. No thanks. Thirty years later, I'm still squiggling, and it pays the rent. On a recent visit to an animation studio, I met some truly ancient cartoonists. Apparently, unlike a dancers, football players, or brain surgeons, the lucky cartoonist's career has no time limit. So I hope to be squiggling at 90.

The two essential qualities an aspiring squiggler must possess are a sense of humor and love of drawing. It's more important to love drawing than to be "good" at it. Your skills will develop—and besides, there's no one correct way of cartooning. Every drawing style, from slick line work and brilliant draftsmanship to casual scribble, can work as well as every other.

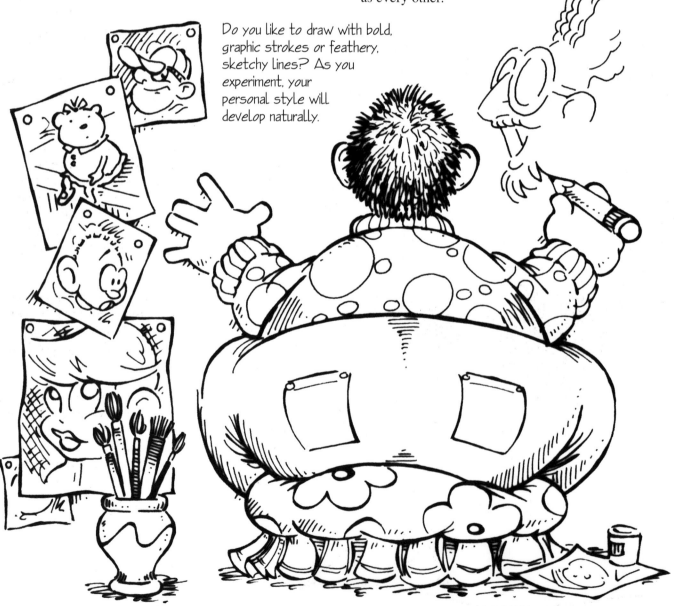

Do you like to draw with bold, graphic strokes or feathery, sketchy lines? As you experiment, your personal style will develop naturally.

However, practice does help. Keep a sketchbook and draw. Draw a lot. Draw your toaster. Draw your mother. Draw your telephone and your dog. Try to master representational drawing. The drawings for an adventure cartoon are usually firmly based in reality. A strong knowledge of shading, anatomy, and perspective provides a sturdy artistic foundation, even if you spin off and start doing totally wacky and abstract cartoons.

A good drawing is a pleasure to look at, but lots of cartoonists who can hardly draw at all have very successful careers. The reason is simple—good ideas. A strong idea can be very funny and can succeed in spite of a weak drawing. A good drawing with a weak concept may be decorative, but it's not very interesting.

So how do you get ideas? Just look around. Friends, relatives, and celebrities are all potential sources of inspiration. Your roly-poly Aunt Frances might make a perfect scatterbrained socialite. Your sourpuss neighbor could become a depraved jewel thief. An exaggerated version of the local greasy spoon, zoo, or hair salon may be the ideal setting for your story line.

Take a look at what other people in the field are doing, but don't feel compelled to copy them. Just because nobody else is doing a comic strip about a trio of singing poodles doesn't mean it won't make a million for you.

Your options are unlimited. If you draw well but can't work out gags or stories, you may eventually team up with a writer. Do you like to draw only people? You could focus on caricature or become a character designer for an animation studio. My own projects have included over 20 children's books, as well as book covers and magazine illustrations. I've developed characters that have been turned into puppets, puzzles, and plastic toys. The variety of projects available keeps each assignment fresh and exciting.

Old movies, newspaper articles, childhood memories, hobbies, and dreams can all provide sparks of inspiration.

Value your own ideas and artwork no matter where or when they occur. Some of your best ideas may start out as a doodle on a paper napkin.

Start a collection of images that you can use for inspiration. This is called a **morgue**. It's a great help to be able to have useful images at your fingertips, so you can know what a speedboat, a wedding cake, or a mole actually look like before you pick up your pen. Many libraries also have clipping files where you can check out images of everything from asphalt to zebras.

Of course, you can draw anywhere. But if you are going to spend hours drawing, it helps to start with a comfortable workspace—a clean, well-lit place where you can keep your materials in order and your drawings out of harm's way.

Once again, draw anything, and draw often. Draw, draw, draw. Then walk the dog, eat Mexican food, read slim volumes of Victorian poetry, play tennis, or just lie under your desk for a while and let your thoughts wander. Then draw some more. You're bound to come up with something amazing.

TOOLS OF THE TRADE

The beginning painter, ceramicist, or photographer requires an expensive array of materials before taking the first step. All a cartoonist needs is something to draw with and a surface to draw on. You can draw a great cartoon on a sidewalk with a stick of chalk or a bad one using expensive vellum and a technical pen. It's your imagination and technique that will determine the outcome. As you experiment with various supplies, you'll find which feel comfortable to you and enable you to get the result you want.

Pencils

Most cartoonists use graphite pencils. Soft lead (B series) graphite pencils are good for making dark lines and are fairly easy to erase. However, the leads break easily, and the lines are easy to smear. Hard lead (H series) graphite pencils maintain sharp points, but they make lighter lines, are difficult to erase, and may gouge the drawing surface. HB pencils combine the best qualities of the two types.

Nonphoto blue pencils are often used to make a final pencil drawing on illustration board. The drawing can then be inked using a pen or brush, and the blue lines will not show up if the art is intended for reproduction. The lines should be drawn lightly; if not, they may repel the ink.

Erasers

Pink pencil erasers can damage your artwork. Kneaded rubber erasers won't crumble, stain, or cause damage. They're long lasting and can be shaped to a point to erase small areas.

Pens

The classic method for drawing cartoons is with a drawing pen and a bottle of black waterproof India ink. Drawing pens come with many different points, ranging from flexible to stiff. The different types of points produce different lines. Don't drown your pen in ink. Dip the pen point just far enough into the ink bottle to cover the slot in the point. After you use a pen or brush, clean it. It will last much longer that way.

Felt-tip pens and markers are available in seemingly endless varieties. They are fun to draw with, especially if you like to be loose and free with your strokes. They are convenient to carry and use with a sketchbook, since you don't have to worry about having ink around or cleaning them after use. The lines produced by most markers are not as constant or intensely black as the lines produced with India ink.

Technical pens have calibrated points in varying widths and hold a cartridge of ink. You can select points capable of producing lines ranging from hairline to very bold. These pens give you a lot of control, but the results can be less spontaneous than those produced with the traditional pen-and-ink method.

You can draw your cartoons in pencil and then ink them in. After inking the final art, the guidelines can be erased. A kneaded eraser allows you to make corrections without making a mess.

If you prefer to work only in ink, you can draw on tracing paper. Work on overlays until you have your cartoon the way you want it. Then trace the final art onto some high-quality vellum.

Brushes

Brushes are difficult to master, but they make beautiful, expressive lines. Watercolor brushes in sizes 1 through 4 are commonly used, with #3 being the most versatile. Go to an art supply store, and invest in the best brushes you can afford. A high-quality brush won't drop little hairs on your artwork and will give you more control over the type of line produced. Professionals usually use fine red sable brushes. Be sure to wash the ink out of your brush before it dries.

Drawing Surfaces

There are endless papers and illustration boards available to the artist. Typing paper works very well for daily practice sketching because it is bright white and takes ink quite well. An inexpensive tracing paper is also fun for sketching because its transparency allows you to use overlays to perfect your pictures.

For finished artwork, hard **Bristol boards** work well. Bristol boards come in many sizes and weights. Some are stiff paper, and others are heavy illustration board. They also come in two different finishes. The smooth finish is good for pen-and-ink work; the rougher finish takes brush strokes well. Draw your picture in pencil, and then ink it using pen or brush. When you are finished, erase the pencil lines.

Vellum is a smooth-finish, high-quality drawing surface that you can see through. This allows you to place a preliminary sketch beneath the vellum and trace it. That way you can avoid the pencil and erasure stages. Vellum works especially well if you choose to work with a technical pen. When your drawing is finished, you can take the vellum to a copy center and have a high-quality duplicate made from it. Many cartoonists submit copies to their publishers and keep the originals. If the copies are made on card stock, you can color them with pencil or marker.

It is up to you whether you work with a marker, a pen, or a French fry dipped in catsup. Experiment with various materials until you find the medium that's a perfect fit for you.

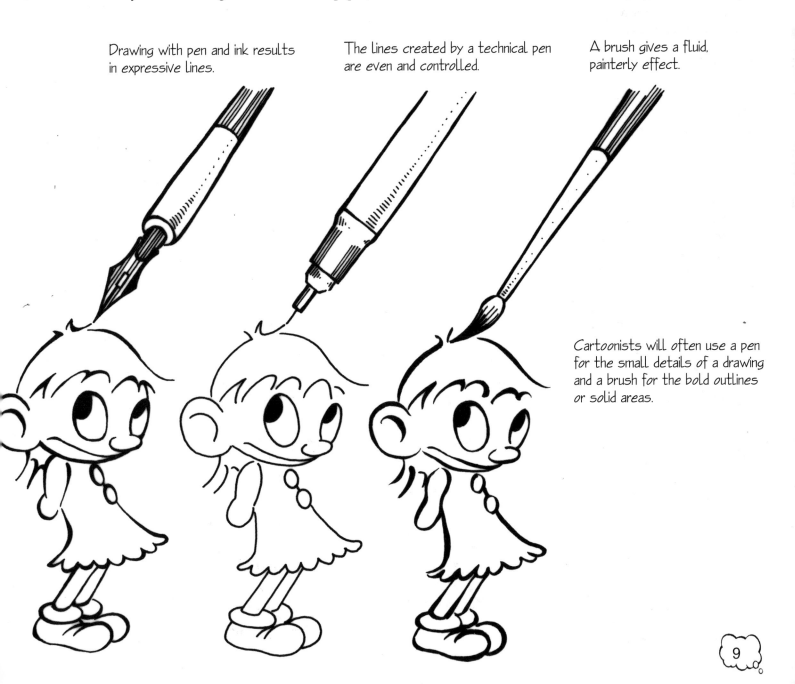

Drawing with pen and ink results in expressive lines.

The lines created by a technical pen are even and controlled.

A brush gives a fluid, painterly effect.

Cartoonists will often use a pen for the small details of a drawing and a brush for the bold outlines or solid areas.

PUT IT IN PERSPECTIVE

The farther away something is, the smaller it looks. So the back end of an object appears smaller than the front. **Perspective** drawing means using converging lines to show the depth of an object, or its relative distance from the viewer, to make an object appear three-dimensional. This allows you to confidently give depth to any image, whether it's a house, a birthday present, or a loaf of raisin bread.

One-Point Perspective

One simple way to give dimension to a basic box is through the use of one-point perspective. In one-point perspective, one flat side is closest to the viewer.

Draw a horizontal line at eye level; this is the horizon. Draw a box below and parallel to the horizon. Centered above the box, place a dot; this is the vanishing point (VP).

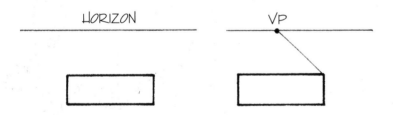

Draw guidelines from the top corners of the box to the vanishing point. Add another horizontal line to form the back of the box.

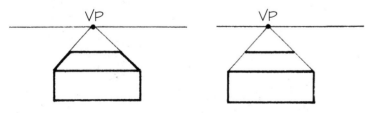

This allows you to draw a perfect box in perspective that can be the basis for a cartoon of any object, such as a suitcase, a table, or a radio.

Two-Point Perspective

In two-point perspective, a corner of the object, rather than a flat side, is closest to the viewer, and so two vanishing points are needed. Nothing is parallel to the horizon. The sides of the object (the vertical lines) are parallel to the sides of the picture plane.

Draw a horizon line at eye level. Place a dot for a vanishing point at each end. Draw a vertical line that represents the corner of the object that is closest to the viewer.

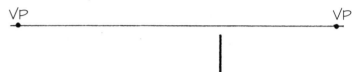

Draw guidelines from the top and bottom of the vertical line to each vanishing point. Add two more vertical lines to form the four corners of the box.

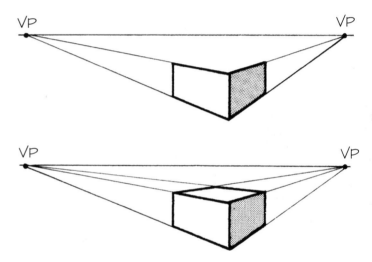

Draw guidelines as shown to form the top of the box.

If you don't want to see the flat top of a box, draw your first vertical line so that it overlaps the horizon. Then go through the same steps to draw your guidelines as before.

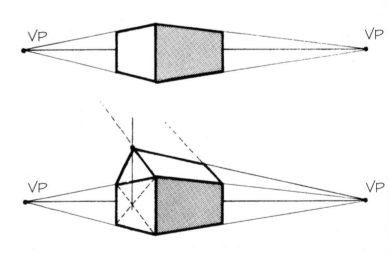

You can use this technique to draw a house simply by adding a peaked roof and aligning the foreground peak with the opposite vanishing point. For more information, see the Walter Foster book *Perspective* (AL13).

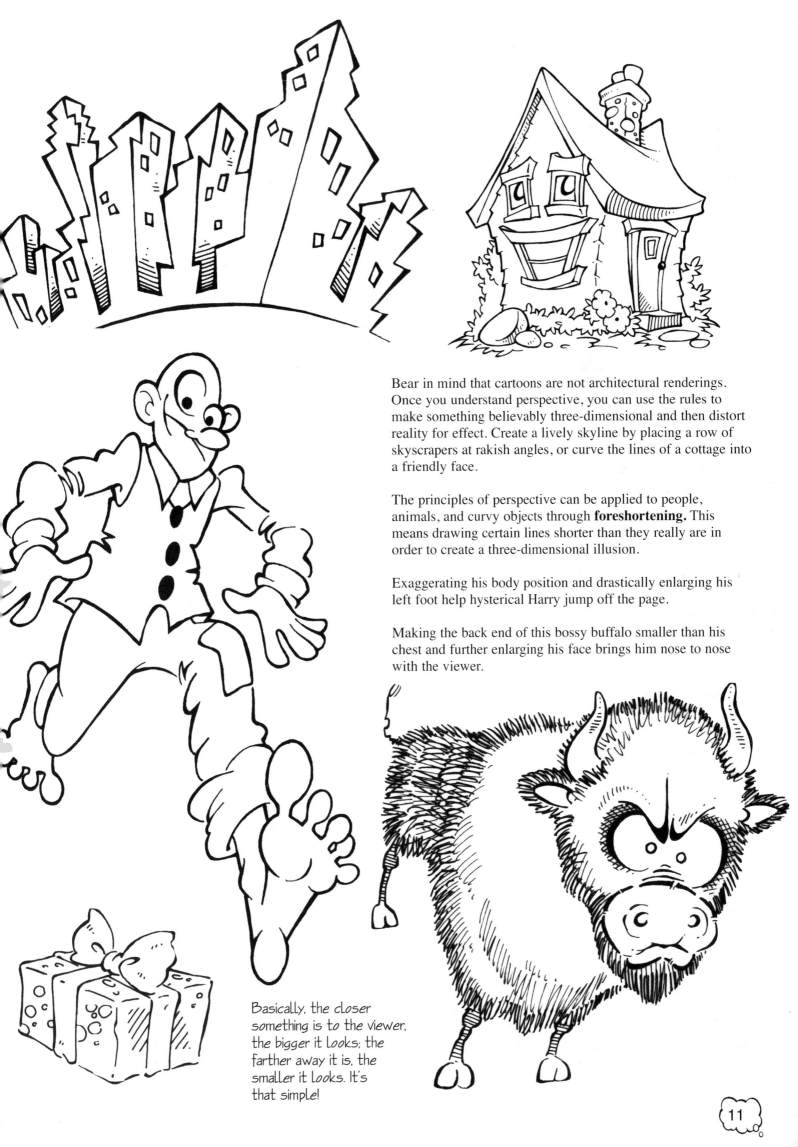

Bear in mind that cartoons are not architectural renderings. Once you understand perspective, you can use the rules to make something believably three-dimensional and then distort reality for effect. Create a lively skyline by placing a row of skyscrapers at rakish angles, or curve the lines of a cottage into a friendly face.

The principles of perspective can be applied to people, animals, and curvy objects through **foreshortening.** This means drawing certain lines shorter than they really are in order to create a three-dimensional illusion.

Exaggerating his body position and drastically enlarging his left foot help hysterical Harry jump off the page.

Making the back end of this bossy buffalo smaller than his chest and further enlarging his face brings him nose to nose with the viewer.

Basically, the closer something is to the viewer, the bigger it looks; the farther away it is, the smaller it looks. It's that simple!

BLACK AND WHITE

A few strokes of pen or brush that add a little shading and vary the weight of an object's outline can transform a wimpy shape into a solid form.

This flirtatious fruit is cute in both examples. With the addition of some shading, a stronger outline, and a drop shadow, she's just peachy.

Old black-and-white movies made strong use of light and shadow, enhancing the mood of the picture. You can do the same thing with a bottle of ink. Dramatic shading hollows out the cheeks and eyes of this monster, making him far more of a menace.

The feathery lines used to draw the front of the vicious witch are replaced by bold ones at her back, identifying where the light is coming from and creating a spooky effect.

Biff and Betty Ann are drawn in a bold, simple style. The mood is made more ominous by the graphic cookie-cutter shadow.

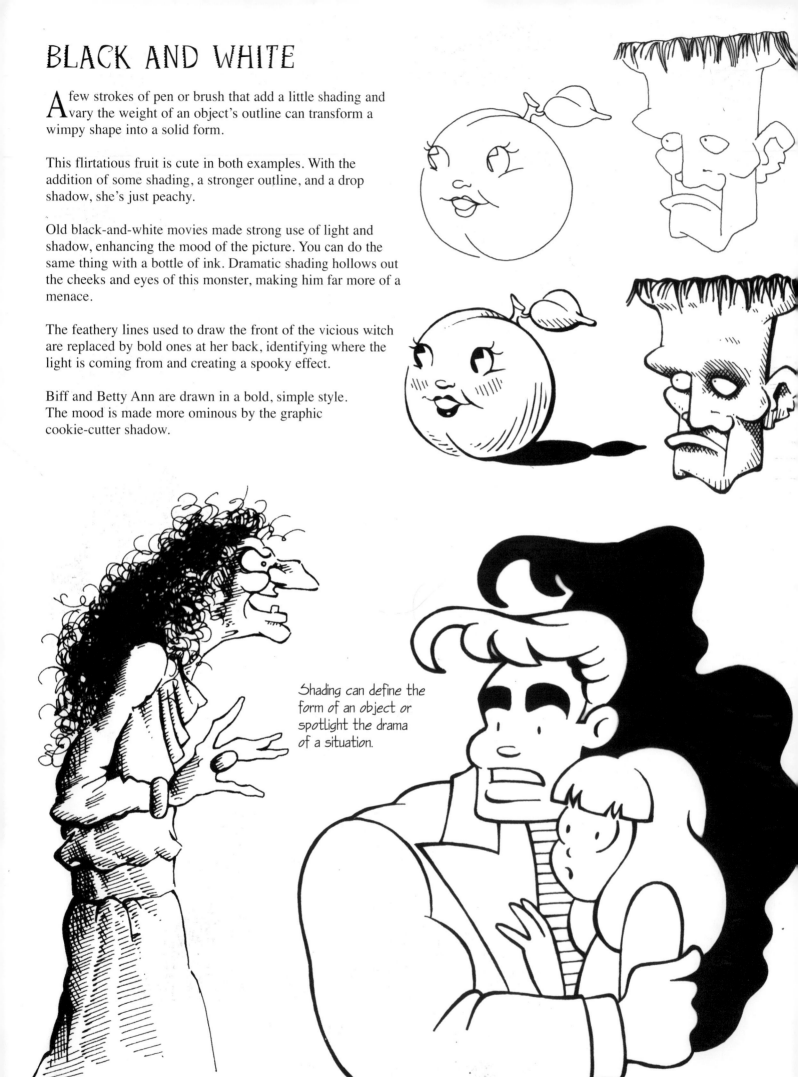

Shading can define the form of an object or spotlight the drama of a situation.

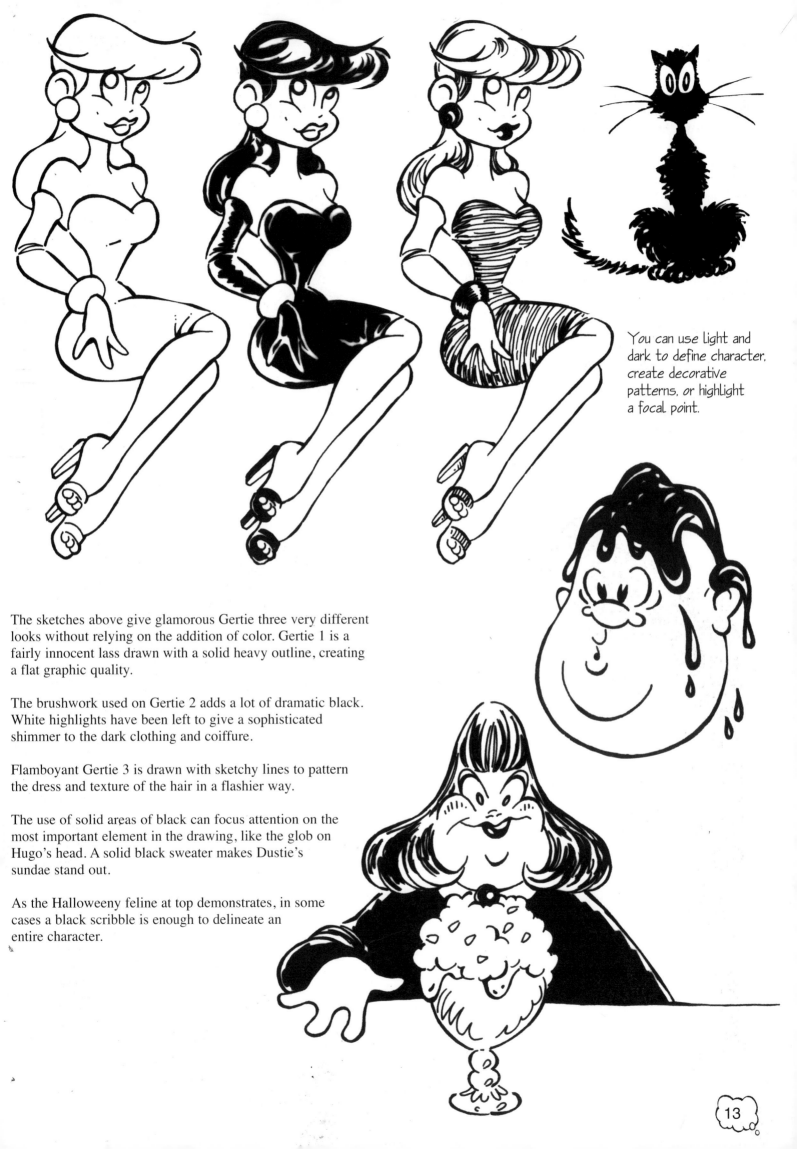

You can use light and dark to define character, create decorative patterns, or highlight a focal point.

The sketches above give glamorous Gertie three very different looks without relying on the addition of color. Gertie 1 is a fairly innocent lass drawn with a solid heavy outline, creating a flat graphic quality.

The brushwork used on Gertie 2 adds a lot of dramatic black. White highlights have been left to give a sophisticated shimmer to the dark clothing and coiffure.

Flamboyant Gertie 3 is drawn with sketchy lines to pattern the dress and texture of the hair in a flashier way.

The use of solid areas of black can focus attention on the most important element in the drawing, like the glob on Hugo's head. A solid black sweater makes Dustie's sundae stand out.

As the Halloweeny feline at top demonstrates, in some cases a black scribble is enough to delineate an entire character.

TYPECAST

Vain society dames, plucky little girls, and bucktoothed twits are among the endless types of faces that are so much fun to draw because they can be so wildly **exaggerated.** A character's personality should be able to be perceived at a glance, and certain visual cues clue in the viewer.

Here the square jaw, amiable smile, close-set eyes, and small cranium of the lovesick sailor help convey the impression of a tough guy with a heart of gold. In contrast, the extended skull and rubbery sneer of the alien mastermind make it clear that he's up to no good. Equally evil is the nosy old witch with the winged hat. Her sharp features and popping eyes show she's a bad egg in spite of her incongruously fashionable accessories and lipstick.

The effects of time are shown in the gentle, careworn face of the little old lady. Her pie-faced sweetness gives her an appeal that her persnickety bow-tied boyfriend lacks in spite of his wavy toupee.

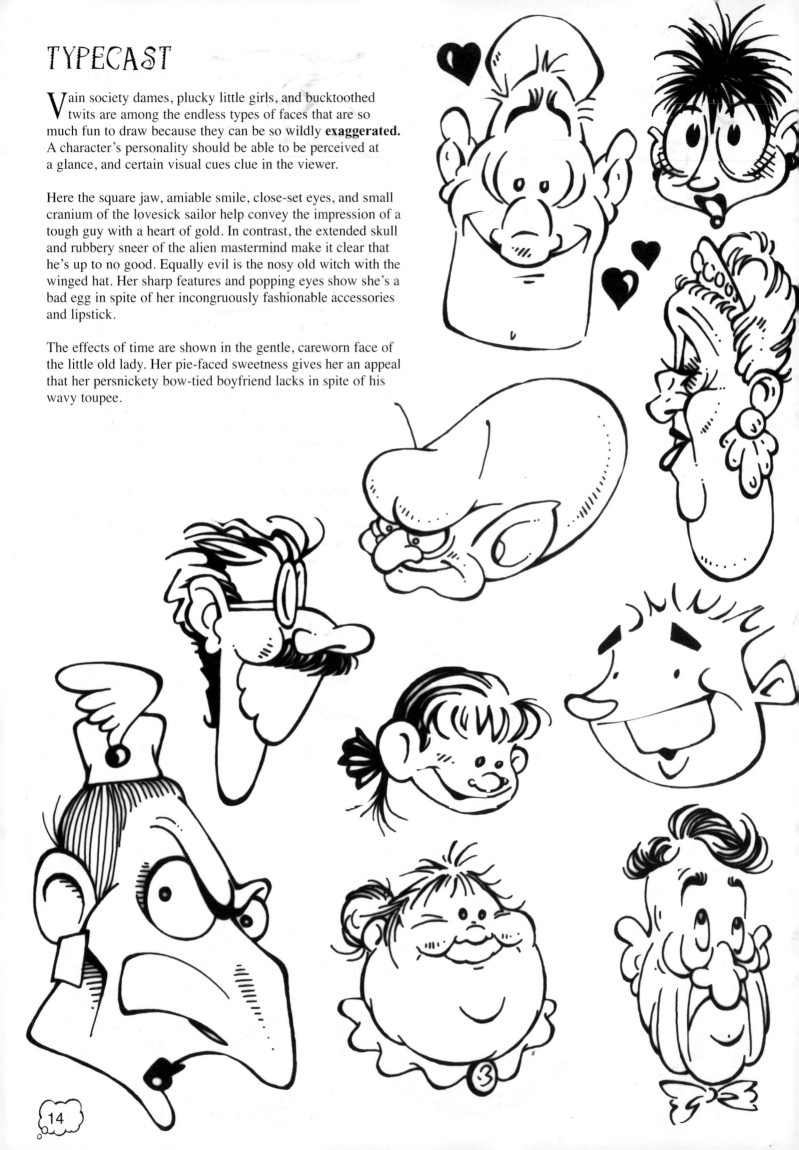

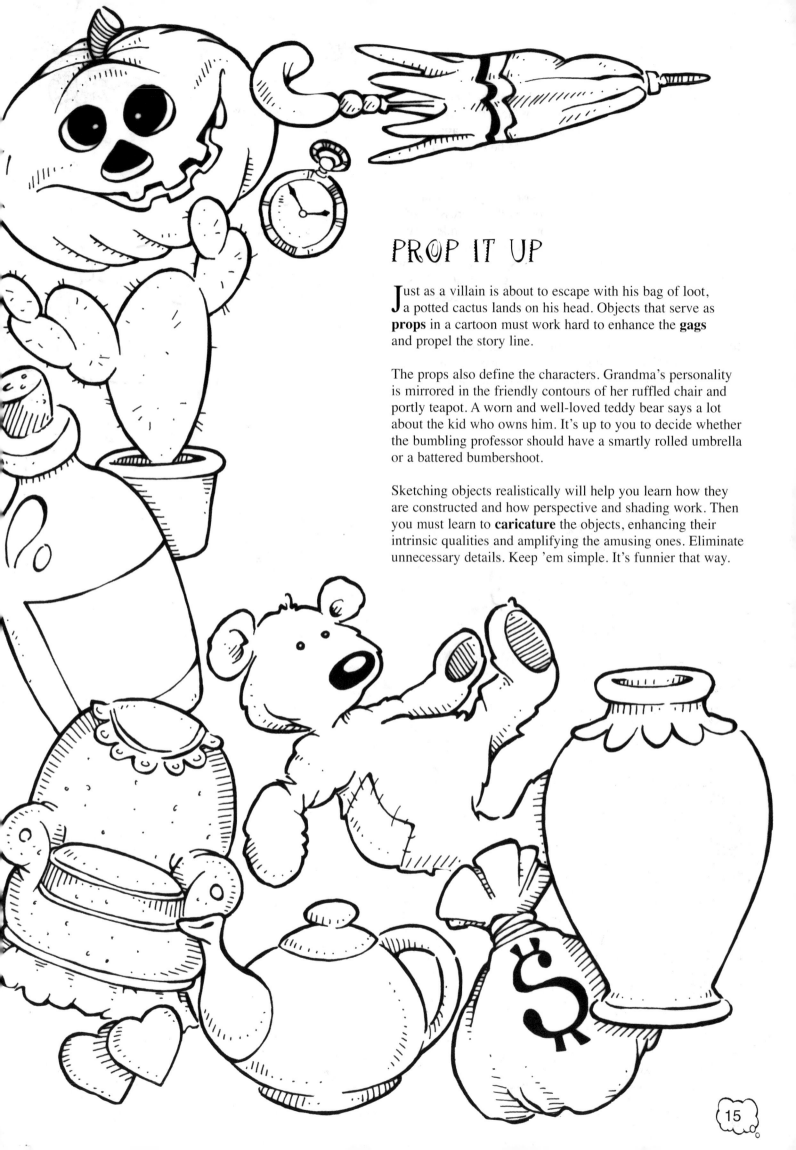

PROP IT UP

Just as a villain is about to escape with his bag of loot, a potted cactus lands on his head. Objects that serve as **props** in a cartoon must work hard to enhance the **gags** and propel the story line.

The props also define the characters. Grandma's personality is mirrored in the friendly contours of her ruffled chair and portly teapot. A worn and well-loved teddy bear says a lot about the kid who owns him. It's up to you to decide whether the bumbling professor should have a smartly rolled umbrella or a battered bumbershoot.

Sketching objects realistically will help you learn how they are constructed and how perspective and shading work. Then you must learn to **caricature** the objects, enhancing their intrinsic qualities and amplifying the amusing ones. Eliminate unnecessary details. Keep 'em simple. It's funnier that way.

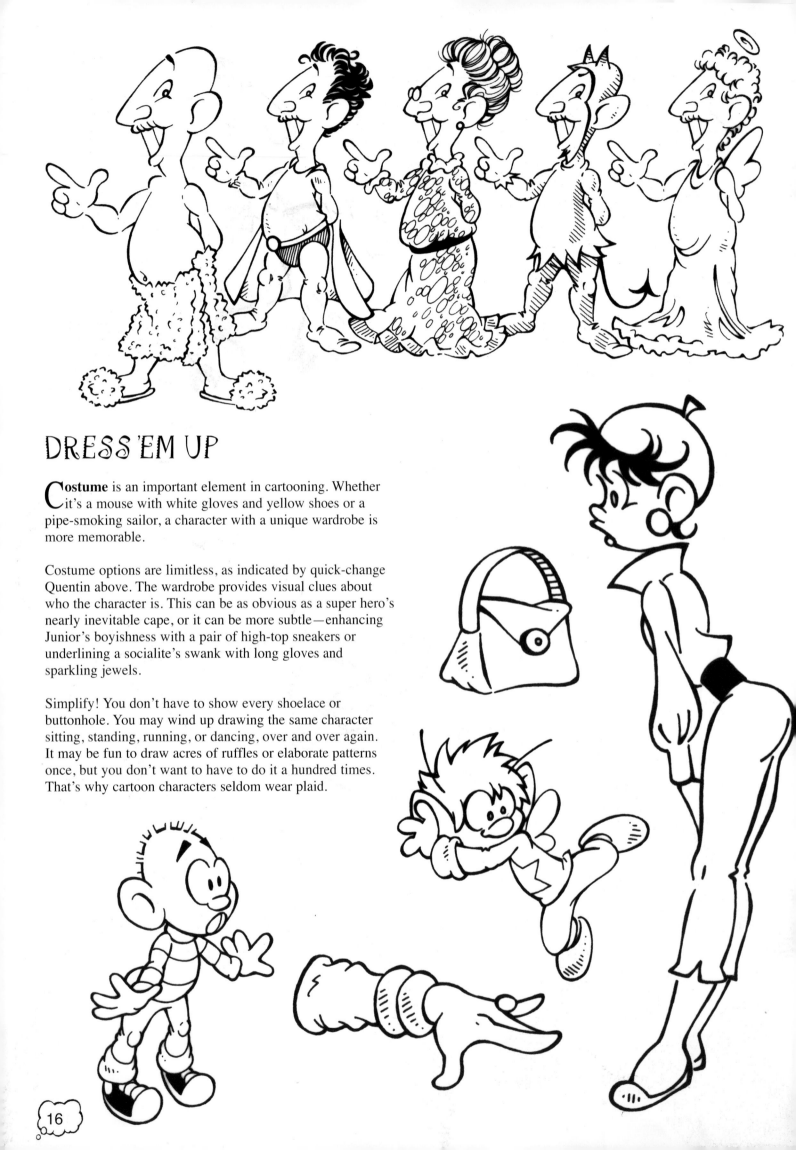

DRESS 'EM UP

Costume is an important element in cartooning. Whether it's a mouse with white gloves and yellow shoes or a pipe-smoking sailor, a character with a unique wardrobe is more memorable.

Costume options are limitless, as indicated by quick-change Quentin above. The wardrobe provides visual clues about who the character is. This can be as obvious as a super hero's nearly inevitable cape, or it can be more subtle—enhancing Junior's boyishness with a pair of high-top sneakers or underlining a socialite's swank with long gloves and sparkling jewels.

Simplify! You don't have to show every shoelace or buttonhole. You may wind up drawing the same character sitting, standing, running, or dancing, over and over again. It may be fun to draw acres of ruffles or elaborate patterns once, but you don't want to have to do it a hundred times. That's why cartoon characters seldom wear plaid.

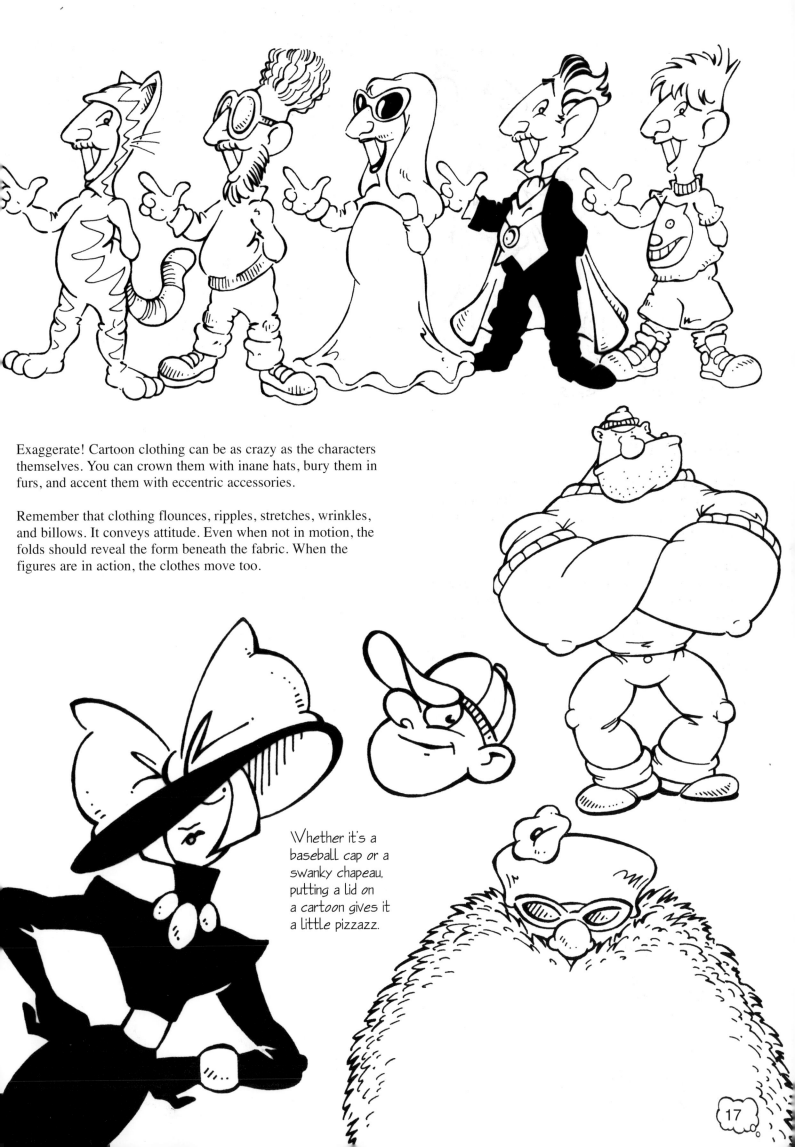

Exaggerate! Cartoon clothing can be as crazy as the characters themselves. You can crown them with inane hats, bury them in furs, and accent them with eccentric accessories.

Remember that clothing flounces, ripples, stretches, wrinkles, and billows. It conveys attitude. Even when not in motion, the folds should reveal the form beneath the fabric. When the figures are in action, the clothes move too.

Whether it's a baseball cap or a swanky chapeau, putting a lid on a cartoon gives it a little pizzazz.

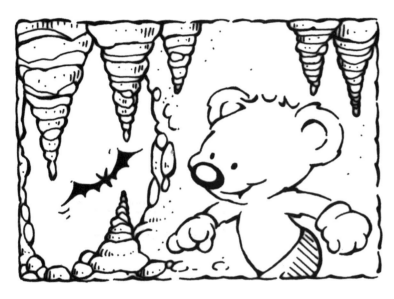

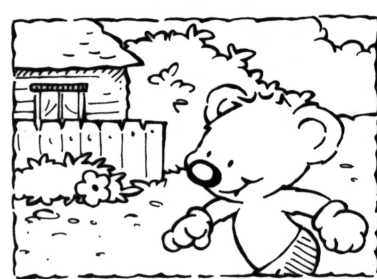

BACKGROUND CHECK

Once you have the cast of characters and a story idea, it's time to set the stage. In a cartoon, you can fly to Mars, explore the bottom of the sea, or travel back to the days of knights in armor.

Whether your scene unfolds in a castle, a cave, or a hamburger joint, you can take the reader there with just a few lines. The bear-foot boy above is the focal point of his picture in spite of the changing locales. It is important to include enough detail to identify where the story is unfolding, but not so much that it overwhelms the action.

You can create interest and heighten the mood by using an intriguing point of view. This little lost mouse is all alone in the world. The stairs make a simple yet somewhat imposing background and create a sense of scale. Looking down on at her makes her seem even smaller and more vulnerable.

In the same way, if we were looking up at our heroine trapped in a tower, the angle could make the structure seem even more imposing.

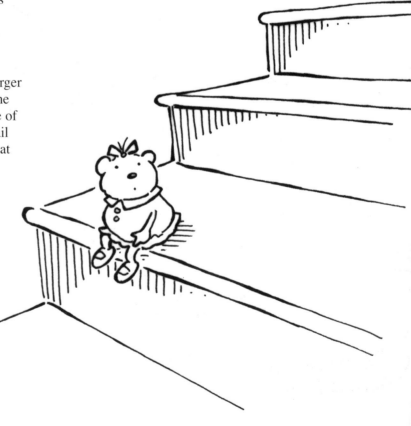

One element can be enough to set the scene. For example, a single window can take the action indoors. The appropriate prop can further pinpoint the scene. Place a pie on the window sill and you're in the kitchen. Add some swanky draperies or a ratty shade and it's obvious whether you're on Easy Street or Skid Row.

With a few sketchy lines to support this grumpy old bear, you don't need all the trees to see the forest. Since many cartoons are printed fairly small, and most readers spend very little time looking at any one image, this type of visual shorthand is valuable.

YOUR TURN

The experts who have put this book together each have a unique point of view and personal drawing style. You'll find their tips on character development, newspaper cartoons, animation, lettering, composition, and a lot more.

Remember, every rule was made to be broken, so let this book be a help and not a straitjacket. You are the final authority.

Have fun!

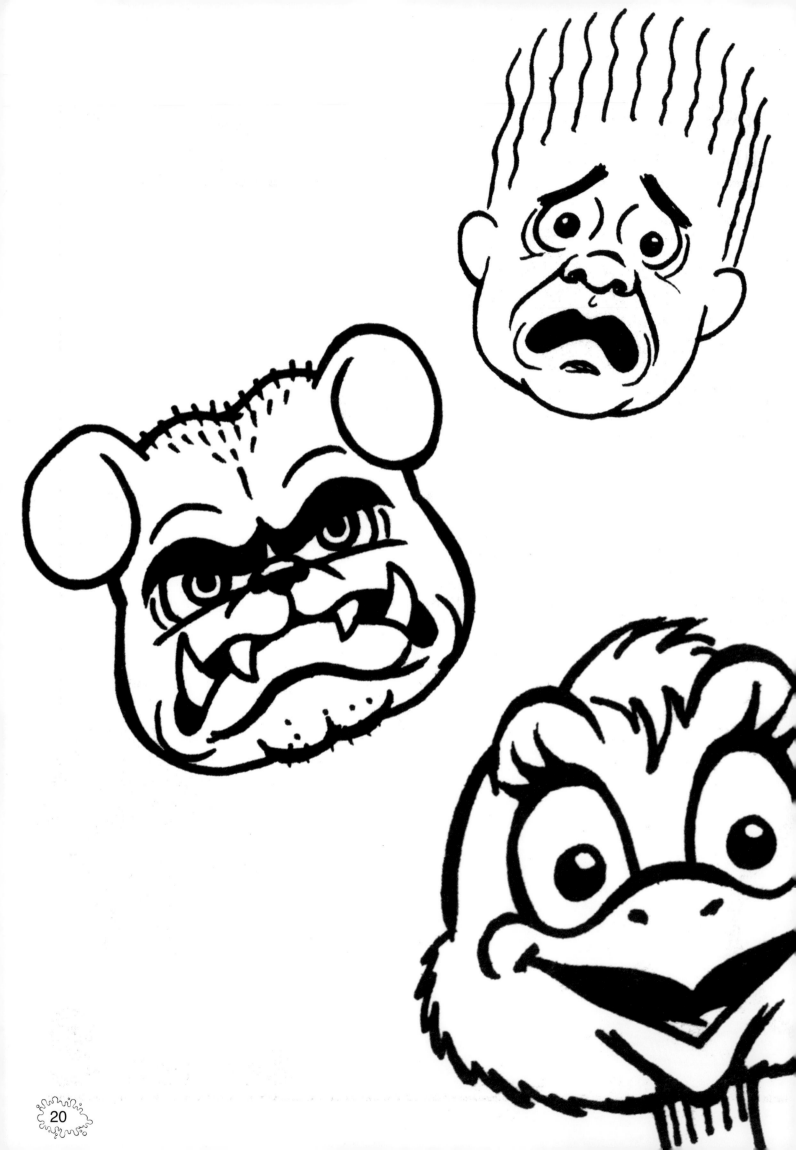

Creating Cartoon Animals and People by Don Jardine, Ph.D.

Don Jardine has taught art in several art schools and colleges. He has also been a professor of art at the University of Minnesota for 15 years. Jardine has taught drawing, cartooning, art history, landscape painting, portraiture, package design, calligraphy, fashion illustration, anatomy, sculpture, art appreciation, association design, advertising art and illustration, and lettering.

Jardine graduated twice magna cum laude from Weber College in Ogden, Utah, where he earned an associate of science title and a certificate of completion in art. He went on to earn a bachelor of science degree in secondary art education and a master of science degree in education administration (with emphasis in art) from the University of Utah, where he also graduated magna cum laude. Jardine earned his doctorate degree in educational administration (with research in art and art-related dissertation) from the University of Minnesota.

A writer and illustrator of numerous art books, Jardine also edited *Illustrator Magazine* for more than 25 years. He has been a judge at many local, state, regional, national, and international art competitions. A past president of the Utah Art Educator's Association, Jardine also served as an art expert for the National Education Association in Washington, D.C. He is listed in *Who's Who in the Midwest* and *International Who's Who in Art and Antiques*.

Section 2

DON JARDINE
STRAIGHT FROM THE HORSE'S MOUTH

Don Jardine became interested in drawing cartoons relatively late in life—when he was between 40 and 45 years "young." Although he has long been involved with other types of art, especially painting, he finds that cartooning can be done much more quickly and easily. In addition, Jardine comments, "Cartooning is entertaining. People enjoy it."

Jardine also appreciates the fact that cartooning lends itself to many commercial applications. He explains that, as director of education for Art Instruction Schools, the world's oldest and largest home-study art school, his cartoons were used for many promotions. The most famous examples are the "Draw Me" characters. These characters were used for advertisements that challenged readers to "draw me" for the chance to win a scholarship to Art Instruction Schools. Jardine relates an amusing story about the contest. As he recalls, the school received a drawing of "Cubby" the bear from a "Chuck Jones." Because the drawing was exceptionally well done, Jardine wondered if it could have been submitted by *the* Chuck Jones—one of the greatest animators of all time. It was! When Jardine called to tell Jones he had won, Jones's daughter, who answered the phone, relayed her father's confession: he just wanted to make sure that he hadn't lost his touch!

When asked about his favorite comic strip, Jardine had a hard time choosing. "I love them all, but I would have to say Hank Ketchum's *Dennis the Menace*. The art is head and shoulders above the rest, and the story line is interesting to read and study," Jardine comments. "The use of black and white and of silhouettes is excellent." He also names *Beetle Bailey* by Mort Walker and mentions that Charles Schulz is a very good friend of his—and that *Peanuts* is probably the most popular comic strip in the world. Although Jardine doesn't have a favorite cartoon, he finds many of them delightful, especially those with the Disney characters or Bugs Bunny.

Jardine believes that the most important characteristic of cartoons, as distinct from other art forms, is their entertainment value. "Most people seem to enjoy cartoons because they are cute. And they are expressive." He adds, "Cartooning is also a very individualistic art form. A cartoonist puts his personality into his cartoons."

Many professional cartoonists begin with a story line and then draw the characters around the theme. But Jardine doesn't operate this way, because his cartoons are usually done for specific clients for a particular purpose. For example, a client may ask the artist to draw a cartoon for a holiday or other special occasion. He begins with pencil sketches, doing a variety until he has something he thinks the customer will be pleased with. He then presents the roughs and lets the client choose which one he should complete.

When asked what tips he would give to aspiring cartoonists, Jardine replies that he has been asked this question so many times that he now has a stock answer: "Always remember to exaggerate size, shape, and location. Now you know everything you need to know for becoming a cartoonist." Then he adds, "But also study art. Learn the other aspects of art such as composition, subordination, perspective, line, rhythm, color, shape, size, and so forth. The principles of fine art are also important for cartooning."

"CUBBY"

The artist sums up his advice as follows: "I believe that if you enjoy cartooning, there's probably no better pursuit because all you need is pencil and paper. And the more cartoons you do, the better you will be. And the better you are, the more fun you will have. And the more fun you have, the more you will do. I call this the 'happy merry-go-round.'"

DRAWING CARTOON ANIMAL FACES

It is important to learn to draw characters in many different positions. You must learn to draw their heads and faces to match various body positions. Begin by deciding the direction your animal will face, and draw the basic shapes. Then add the details, step by step. Start with these frontal views. Draw your lines lightly so that once your pencil drawing is complete, you can ink over it with a brush or pen. When the ink is completely dry, erase any pencil lines that show.

MOUSE

BEAR

CAT

RABBIT

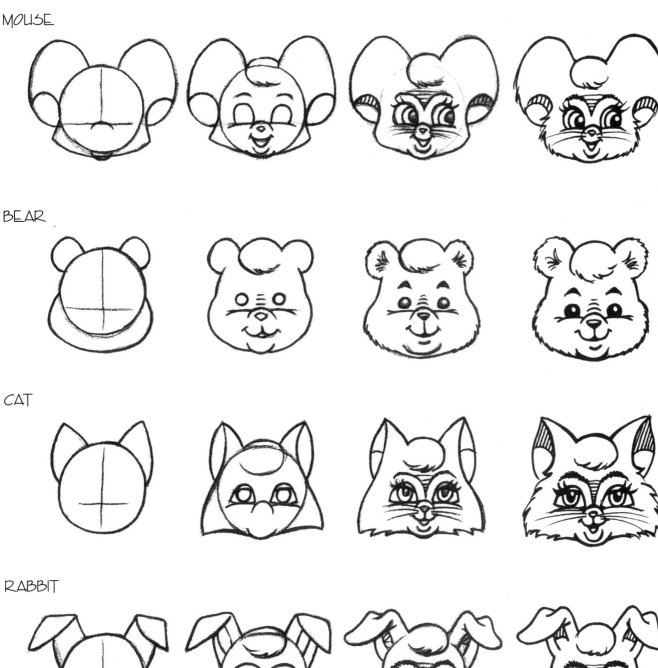

PIG

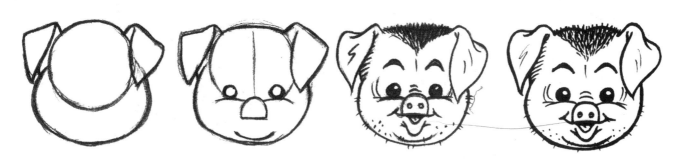

PROFILE VIEWS

Profiles also start with basic shapes, and then details are added. Remember to take your time, and try not to become discouraged. Draw each character several times until you are satisfied with it. With practice, you will be able to draw any animal you wish!

Try changing the features or details of the examples to make your own characters. For instance, change the shapes and sizes of the eyes, noses, mouths, and ears.

TURTLE

BEAR

DOG

RAT

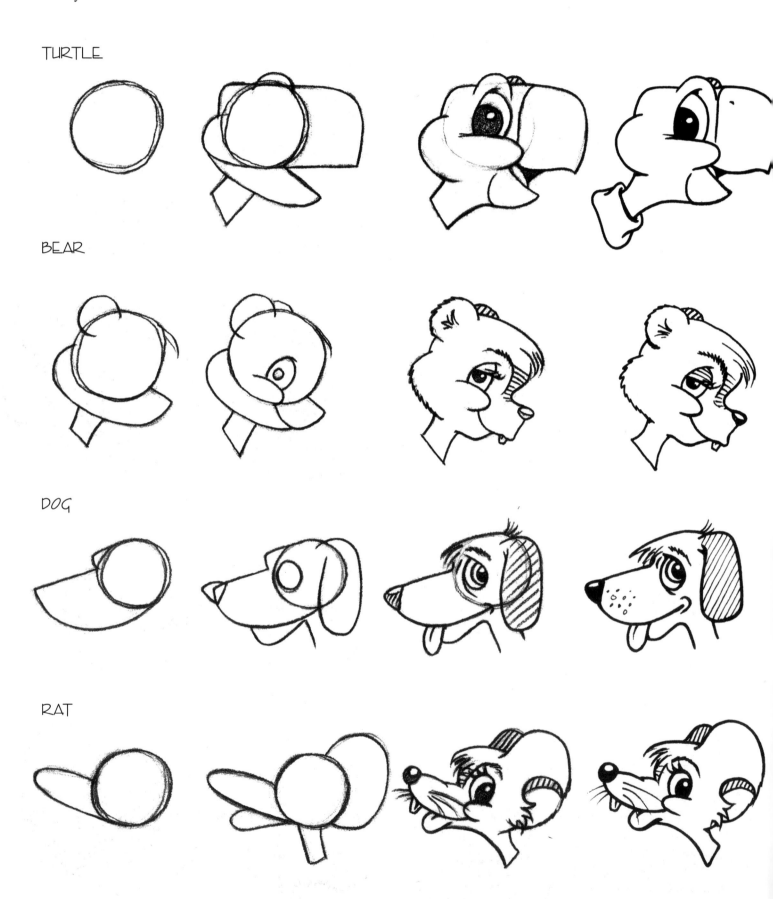

FACIAL EXPRESSIONS

You can easily transform a character's entire personality by altering its facial expression. This can be done by changing one feature, such as the mouth, eyes, or the hair. However, making a change in one feature, such as the mouth, will affect the cheek, which will affect the eye, and so forth.

One good way to practice is to make faces in a mirror and draw what you see. Study the expressions shown below, and try to determine which features help create the character's expression. Practice by copying the cartoon faces here, but alter their features to change their expressions.

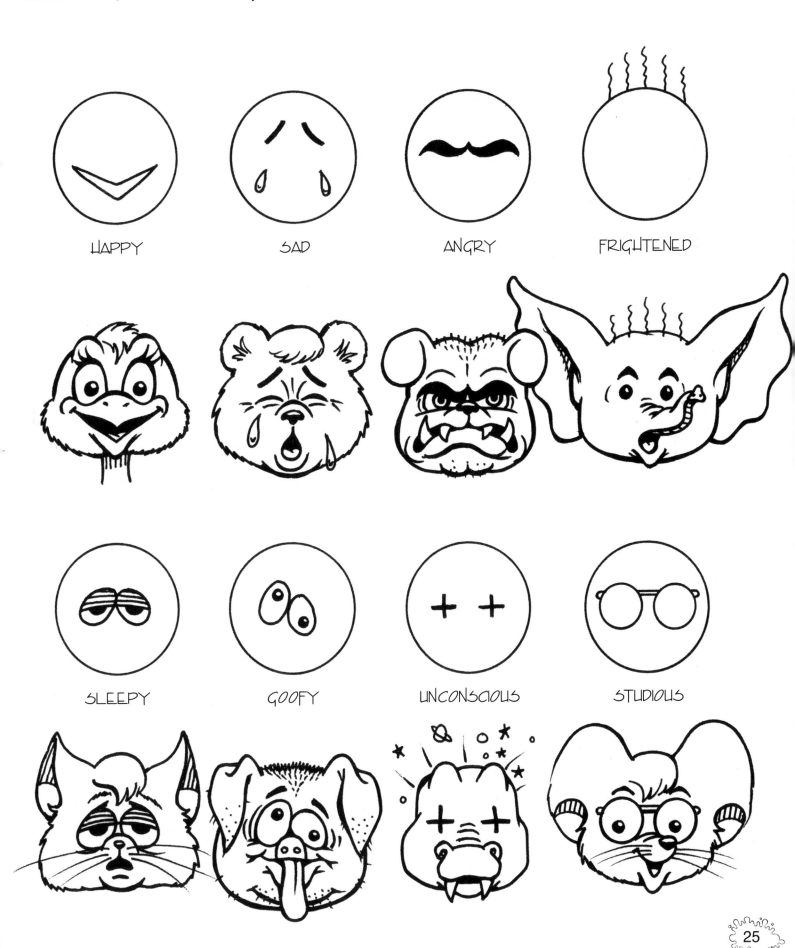

HAPPY

SAD

ANGRY

FRIGHTENED

SLEEPY

GOOFY

UNCONSCIOUS

STUDIOUS

EXAGGERATING SHAPES AND SIZES

Anyone who has even the slightest ability to draw can create cartoons. All you have to do is *exaggerate* sizes and shapes. Compare the three cartoon alligators below. Although they all face the same direction, have the same basic features, and are about the same height, they are totally different characters. This is because the sizes and shapes of each one have been exaggerated in different ways. Exaggeration is one of the most important factors of cartooning.

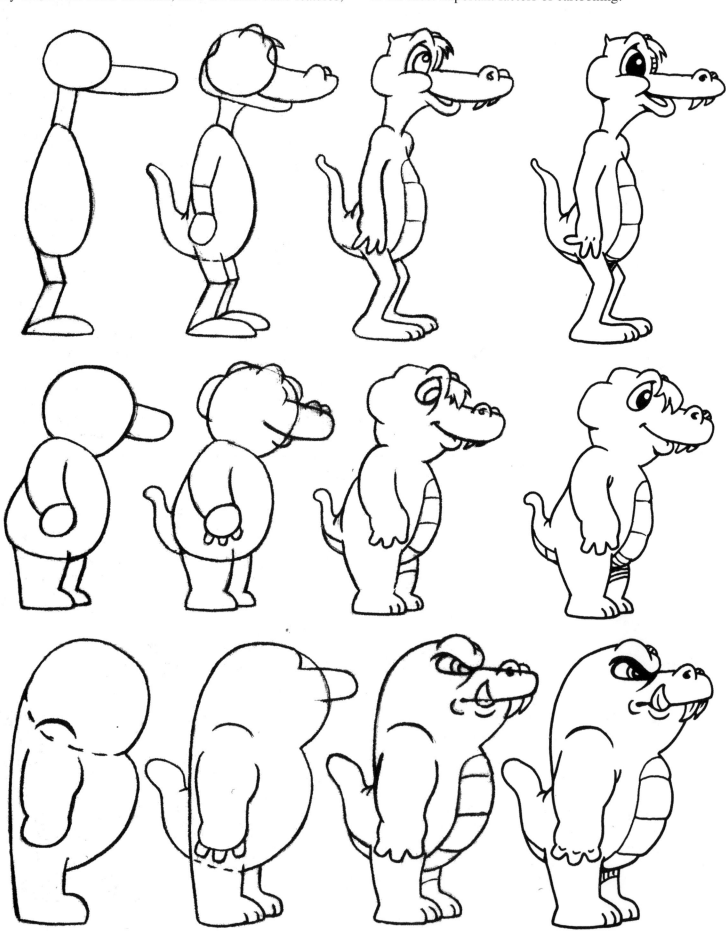

CREATING FORM

A good cartoon drawing should also have **form.** In other words, it should create the impression of height, width, and depth (bulk). To create bulk, use a method known as **drawing through.** This means that you keep in mind the three-dimensional shapes of a character—even when you can't see them—and draw as if the shapes continue. Notice how dotted lines are used to show the three-dimensional shapes of the duck below. This technique helps make the character appear solid and have depth.

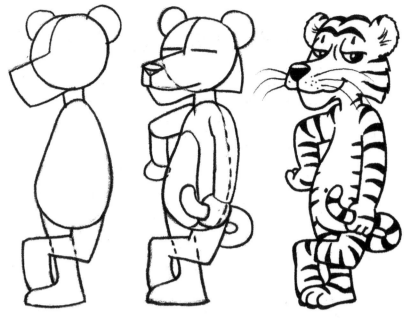

Begin each drawing by using basic shapes, such as circles, squares, rectangles, and ovals, to build your character. This is referred to as a **basic-shapes figure.**

Then consider form. To make the character appear solid, think of the circles as spheres, the rectangles as cylinders, and so forth.

To complete the character, add facial features and other details. Remember that the expression creates the personality!

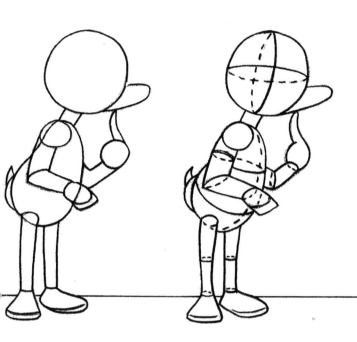

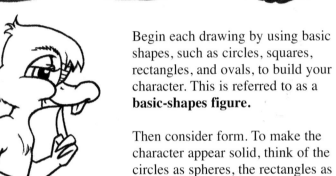

When drawing a four-legged animal, the feet should be placed so the animal is balanced.

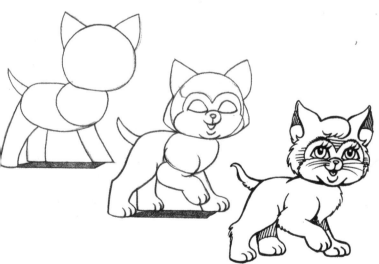

Once you develop a sense of form, you won't need to start with a basic-shapes drawing for each character you draw. However, until then, you will probably find them extremely helpful.

LINES OF ACTION AND FORM

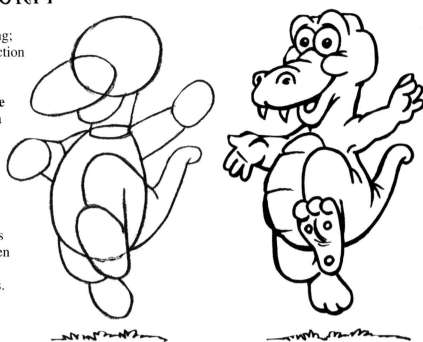

The alligator at right could be either skipping or jumping; it could even be running toward you. Notice that its action appears to be vertical.

Look at the two characters below; notice the diagonal **line of action** that passes through each one. This line acts as a guide for the character's movement; it helps increase the illusion of action, making it more dramatic. Sometimes this line is exaggerated to further emphasize the movement.

The overall shape or form of a character also affects the action. Sometimes it is helpful to imagine the character as simply a shape rather than as a detailed character. It is then easier to design action and movement poses successfully by stretching, squeezing, squashing, or bending the forms. Details can be added later.

The line of action generally follows the character's spine and often continues through one of its legs.

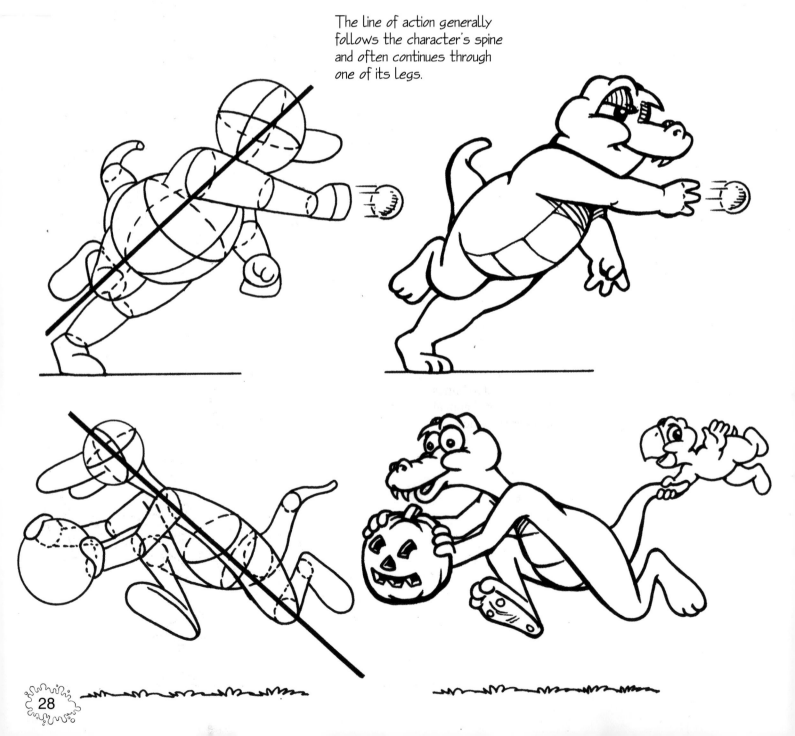

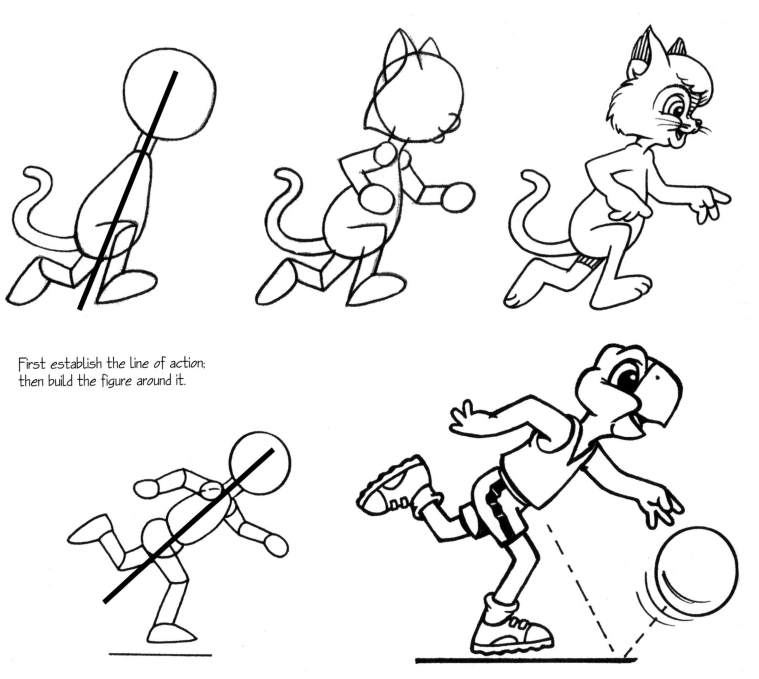

First establish the line of action;
then build the figure around it.

The body types on these two pages were started with
basic-shapes drawings. Notice that most of these examples
are based on the human body; they simply have animal
heads and features.

The diagonal lines shown here indicate the characters' lines
of action. In order to heighten your animal cartoons' appeal,
draw them engaged in popular sports or other activities.
Be sure to dress them appropriately too!

DRAWING CARTOON PEOPLE FACES

Drawing cartoon people isn't much different from drawing cartoon animals. Here are a variety of head shapes, hair styles, and features to choose from. See if you can come up with some of your own!

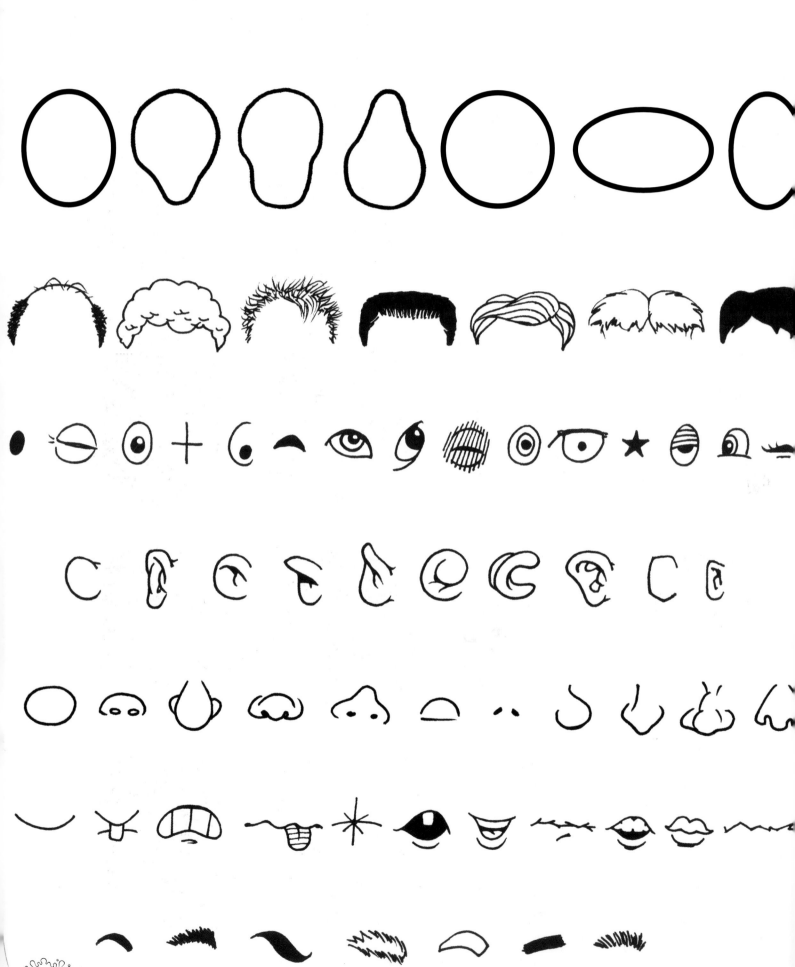

Draw a few head shapes on scratch paper; then draw in features of your choice. The various combinations drawn in different sizes and in different locations enable you to create literally thousands of faces. And you can add more exaggerated eyes, noses, mouths, and hair styles for an infinite number of cartoon faces.

Each of the cartoon faces below was created by first drawing an oval and then adding some features selected from the previous page. Every new combination you use to produce a cartoon face makes it *your* cartoon! Keep practicing—the more faces you draw, the easier drawing them will become.

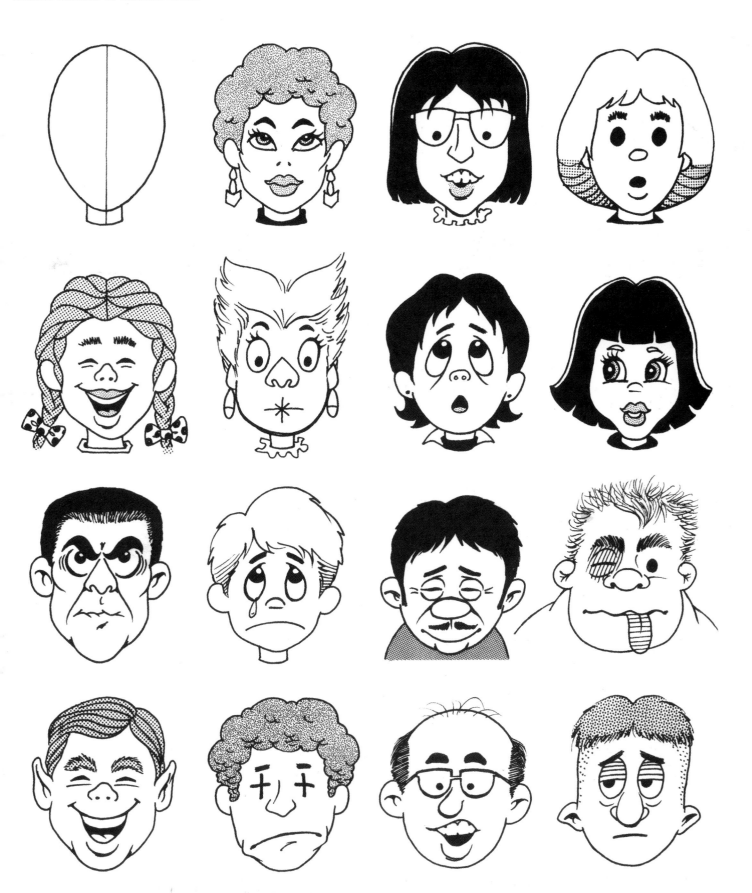

PROFILES AND THREE-QUARTER VIEWS

Develop the habit of really looking at the many people you see every day. Each, obviously, has two eyes, a nose, and a mouth—but, except for the hair, what makes them different? Their age? Size? Location of features? Slight variations in shape? Whatever it is, exaggerate! That is the way to develop your own cartoons! Choose and use from the variety of head shapes, hair styles, and features on page 30. Practice!

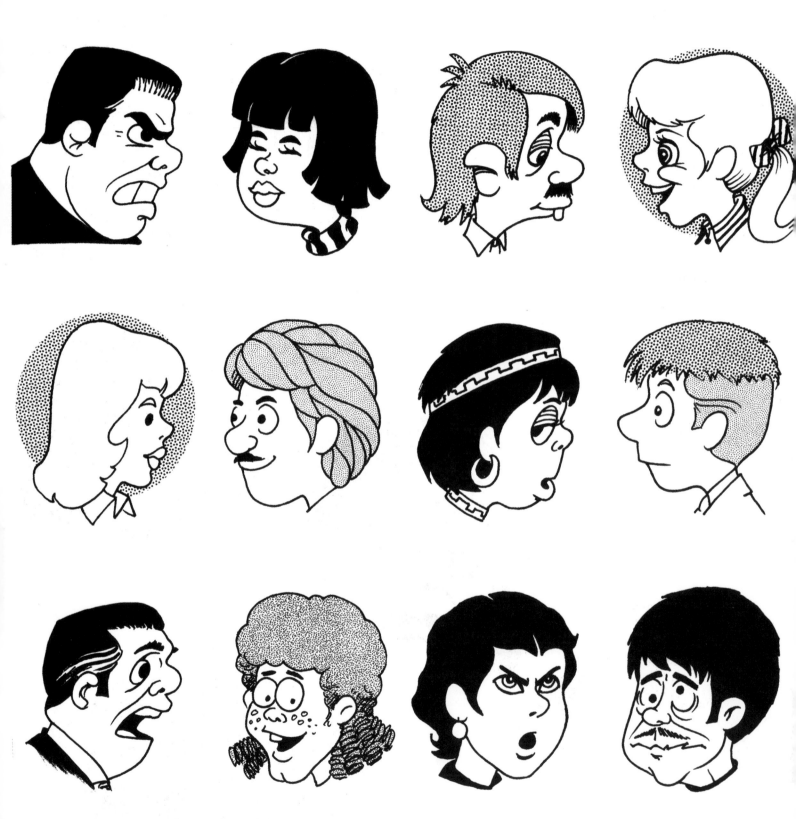

Study the examples above. Which features have been exaggerated? Which features have been simplified? Think about the details and how they make each character unique.

FACIAL EXPRESSIONS

Laughing, crying, angry, frightened, sleepy, and stupid are basic cartoon facial expressions. Other expressions are usually variations of these six. Make up a list of facial expressions, and try to create a cartoon face for each one.

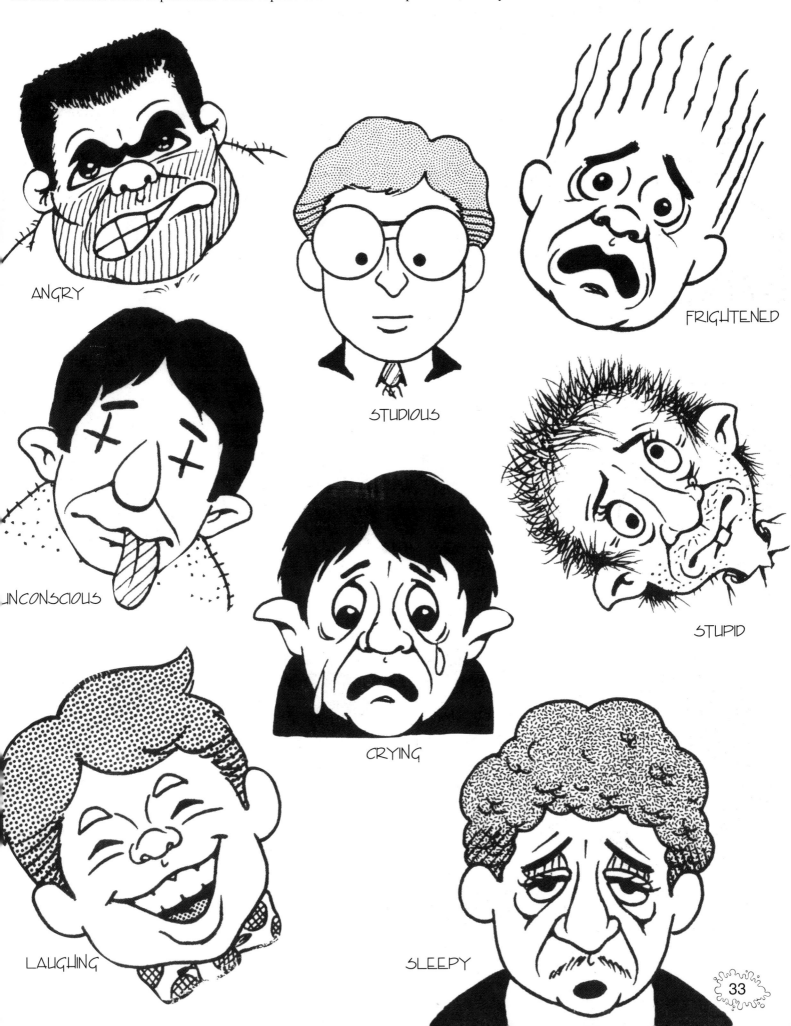

ANGRY

STUDIOUS

FRIGHTENED

INCONSCIOUS

STUPID

CRYING

LAUGHING

SLEEPY

33

DRAWING AND DRESSING THE CHARACTER

To develop a cartoon, professionals usually begin with a stick, skeletal, or basic-shapes figure to establish the correct **proportions;** that is, how the shape and size of the parts relate to each other and to the whole. I recommend using basic-shapes figures, but stick with whatever method works best for you.

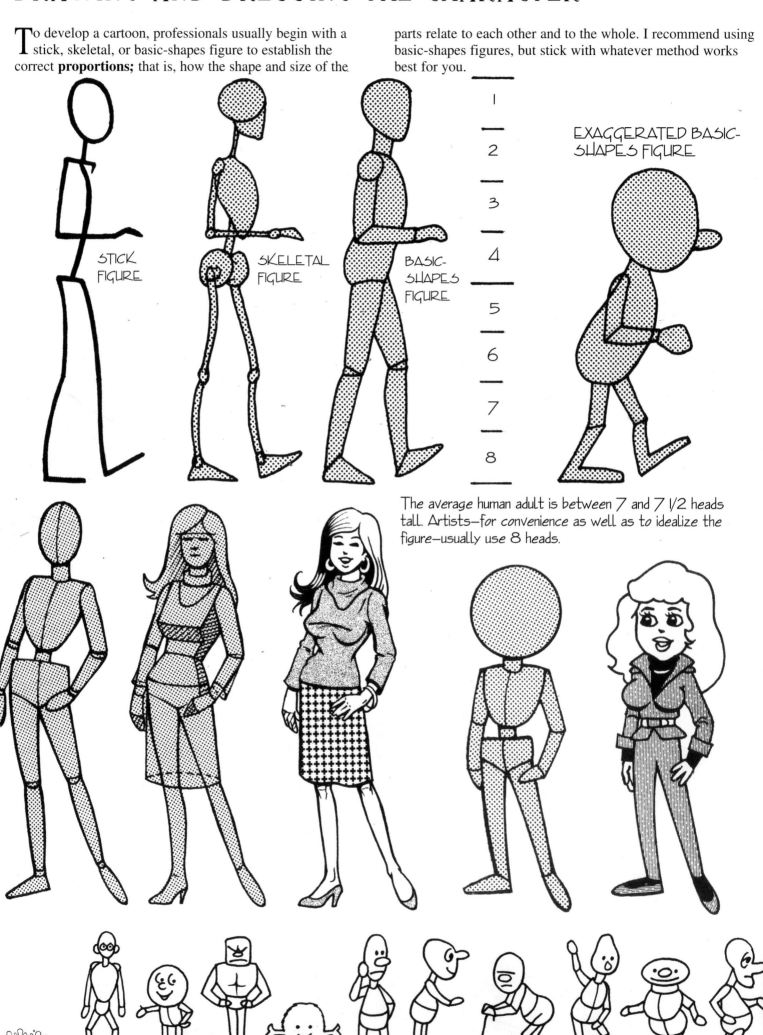

STICK FIGURE

SKELETAL FIGURE

BASIC-SHAPES FIGURE

EXAGGERATED BASIC-SHAPES FIGURE

1 2 3 4 5 6 7 8

The average human adult is between 7 and 7 1/2 heads tall. Artists—for convenience as well as to idealize the figure—usually use 8 heads.

Pencil cartoons can be inked quickly. **Inking** means using ink to define the lines and shadows of the final drawing. You can add textures and/or patterns with pen or brush strokes, or you can use commercial **shading sheets**, as shown in the basic-shapes figures on these pages.

Now think of a character . . . a clown, perhaps. Put some basic shapes together and add the kind of clothing the character might be expected to wear. Draw some **props;** make the character *do* something.

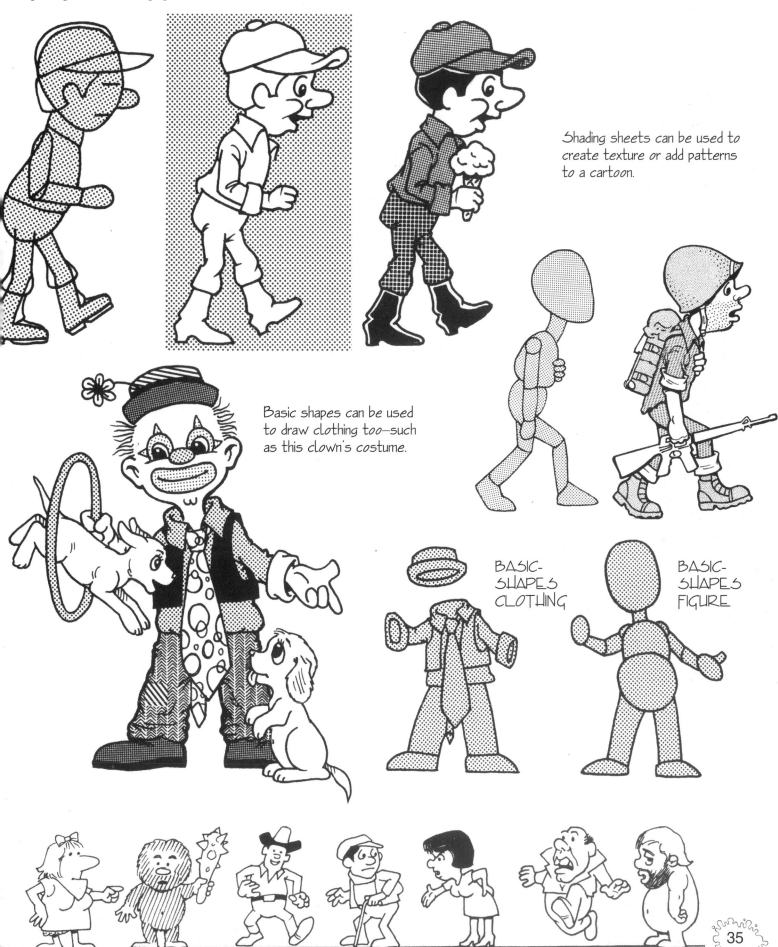

Shading sheets can be used to create texture or add patterns to a cartoon.

Basic shapes can be used to draw clothing too—such as this clown's costume.

BASIC-SHAPES CLOTHING

BASIC-SHAPES FIGURE

PLAN...DRAW...ACTION!

Most action figures are drawn on a diagonal line of action, or movement, just as animal cartoons are. Plan the action before you begin to draw. A **mannequin** can help you work out the action involved; the two cartoon figures at the bottom of the page were drawn from the same mannequin pose, and literally hundreds more are easily possible.

Like all other cartoons in this section, the action figures on these pages were developed from basic-shapes figures, and then details were added. For action figures, added details such as **movement lines** enhance the action involved, and they are often used to help dramatize the action in cartoons.

MOVEMENT LINES

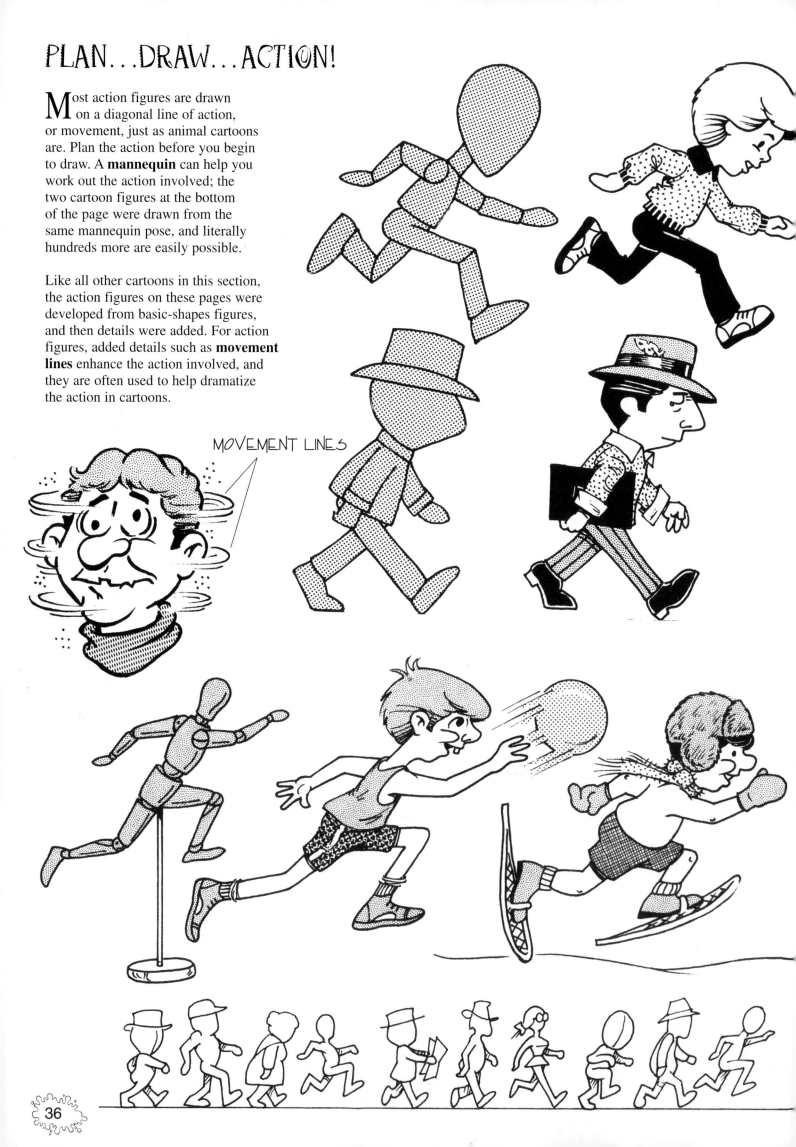

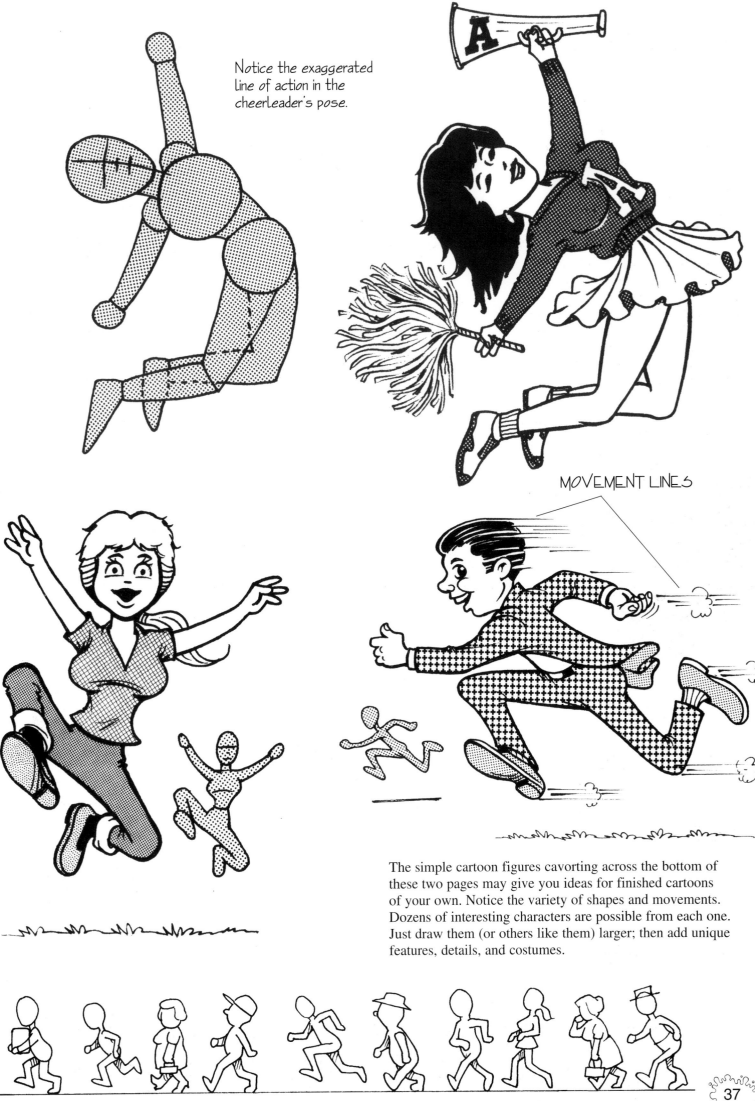

Notice the exaggerated line of action in the cheerleader's pose.

MOVEMENT LINES

The simple cartoon figures cavorting across the bottom of these two pages may give you ideas for finished cartoons of your own. Notice the variety of shapes and movements. Dozens of interesting characters are possible from each one. Just draw them (or others like them) larger; then add unique features, details, and costumes.

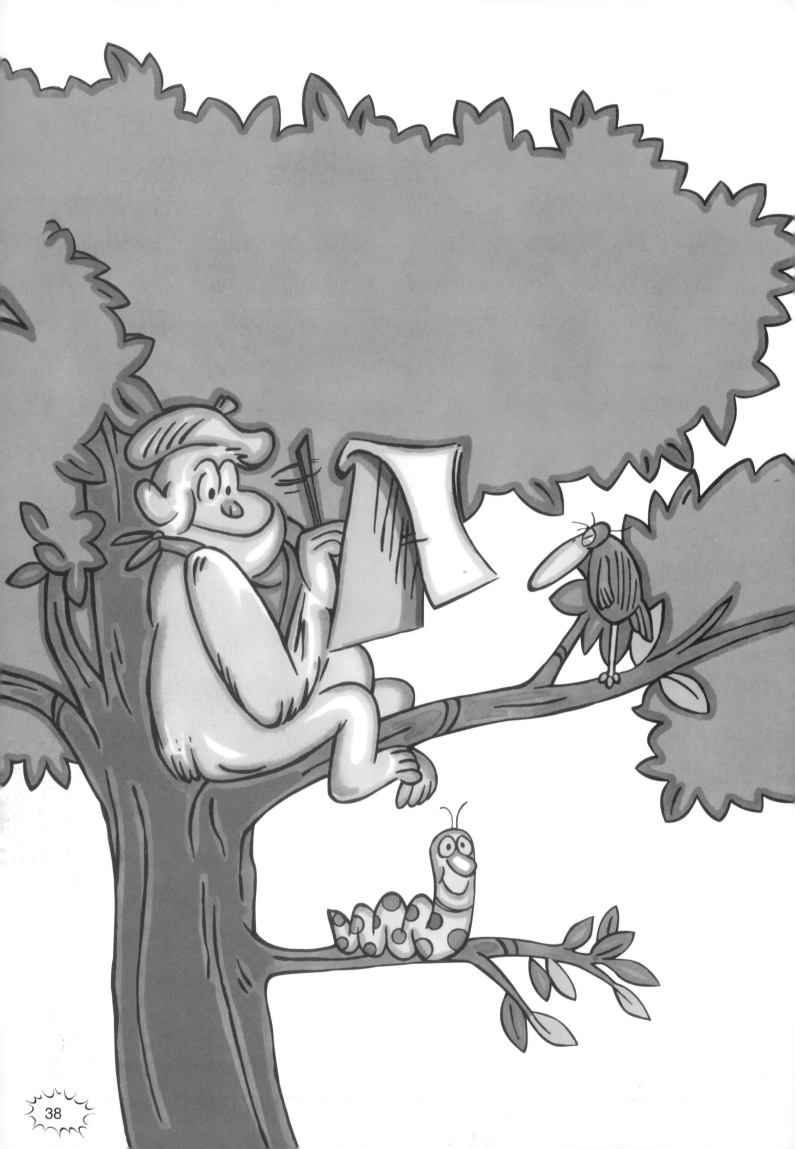

Cartoon Critters by Ed Nofziger

Ed Nofziger attended the University of California, Los Angeles, where he majored in art and education.

As a freelance cartoonist for many years, his work included illustrations for the *Saturday Evening Post*, *Mister Magoo* for UPA Studio story departments, and stories and storyboards for foreign Disney comic books. He taught cartooning at the Cartoonists and Illustrators School in New York, and he also developed his own comic strips, *Buenos Dias* and *Animalogic*, for syndication.

Nofziger lives in Ojai, California, with his wife and fellow artist, Peggy Sheppard.

Section 3

ED NOFZIGER
STRAIGHT FROM THE HORSE'S MOUTH

The man who helped bring Mr. Magoo into millions of homes says that cartooning still starts with a willing artist and a blank piece of paper. "No matter what aspect of cartooning you go into—animation, advertising, products, or editorial cartoons, you still have to start with a piece of paper," says Ed Nofziger.

"The secret to succeeding in cartoons is to draw all the time. It's as simple as that," Nofziger adds. "When I was in college, I would draw for a haircut or a meal. I drew during every class and after school."

Nofziger notes, however, that cartoonists entering the business today have to be aware of much more than drawing on one plane. "You need to be able to conceive of your character in three dimensions and in products. And you must be able to do your character in motion. Successful cartoons must be adaptable to animation, stuffed animals, and computer-generated art. If you aren't ready for that, you aren't ready for the wave of the future."

Nevertheless, Nofziger returns to the basics when offering advice to newcomers. "Draw—all the time. You need both practice and training," he says. "But mostly you need to draw and draw and draw."

"Keep your eyes open and observe people," he adds. "Draw what you see. You'll use up a lot of sketch pads before you're ready to move on to other types of cartooning."

But Nofziger encourages beginners as well. "Anyone who hangs in there can get a job," he says. "It's best to go to school and get the technical training that covers animation and computer technology. But after that, you'll still have that blank piece of paper waiting for you!"

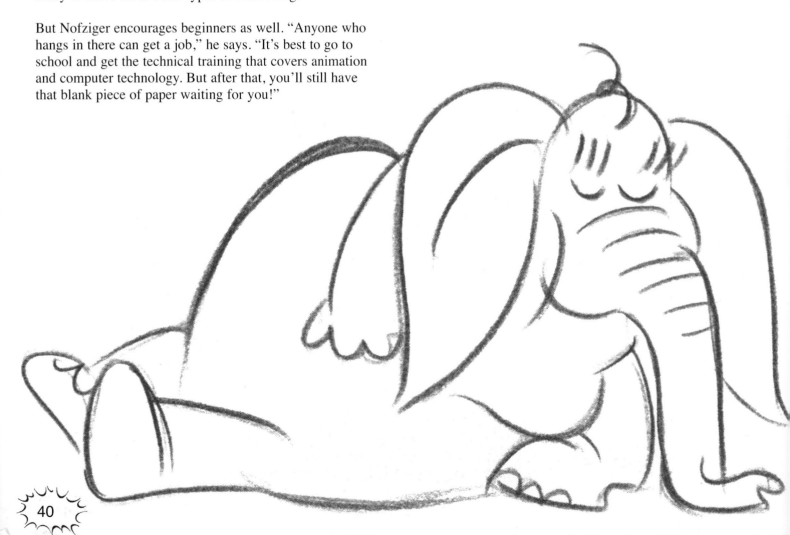

IF YOU CAN DRAW A CIRCLE AND A STRAIGHT LINE - AND IF YOU CAN UNLEASH YOUR IMAGINATION - - -

- - - THERE'S NO LIMIT TO WHAT YOU CAN CREATE WITH ANIMALS - - -

- - - AND IT'S FUN!

YOU COULD EVEN DRAW A "PEOPLE" ANIMAL.

ENTERING THE JUNGLE

Look out! Don't let these docile creatures fool you—the whole animal kingdom's gone **BONKERS!** And so will you. Come on a wild escapade of cartooning, if you dare! When you learn how to cartoon animals, you monkey around with animal caricature. What's **caricature?** It means you exaggerate animal parts or characteristics. But it's not as scary as it sounds. Because once you chase these critters through the following pages, you'll see that every animal starts with a simple shape. A single shape can be used to create an octopus, a lion, an ostrich—or even you!

Cartooning is as unique as you, the artist. When two people think of the same animal and then draw it as a cartoon, the resulting drawings don't look anything alike.

How would *you* draw the ostrich and the explorer on the run below?

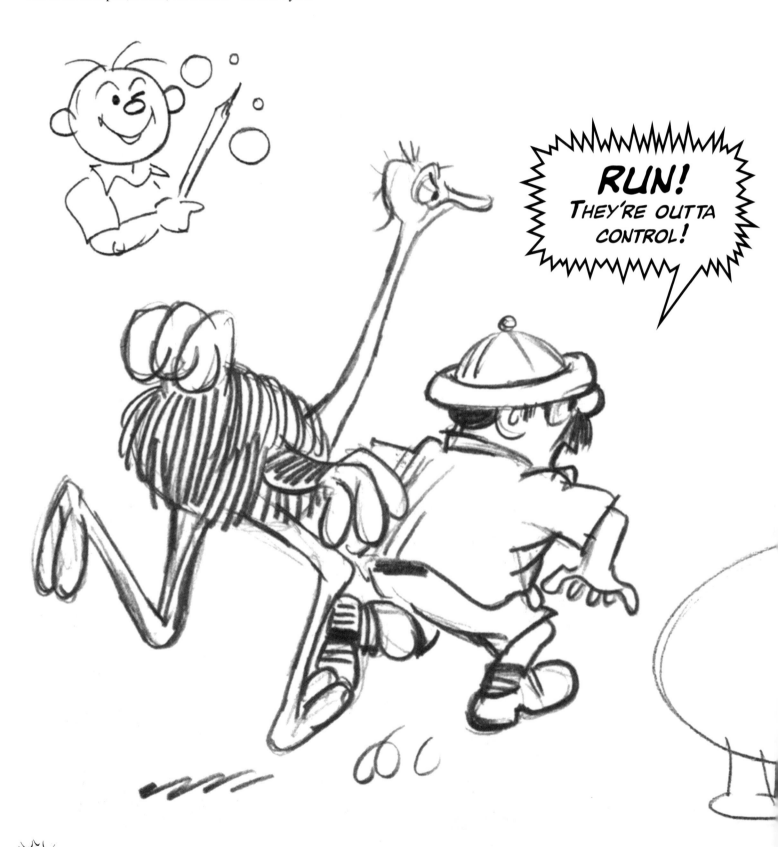

RUN! THEY'RE OUTTA CONTROL!

RUNNING IN CIRCLES!

As a beginning cartoonist, you'll find circles and ovals the most versatile body shapes for any animal (or person). Try drawing one of the animals below with a circle for the head and a circle for the body. (An elephant's big backside would also get a circle.) Then add the details.

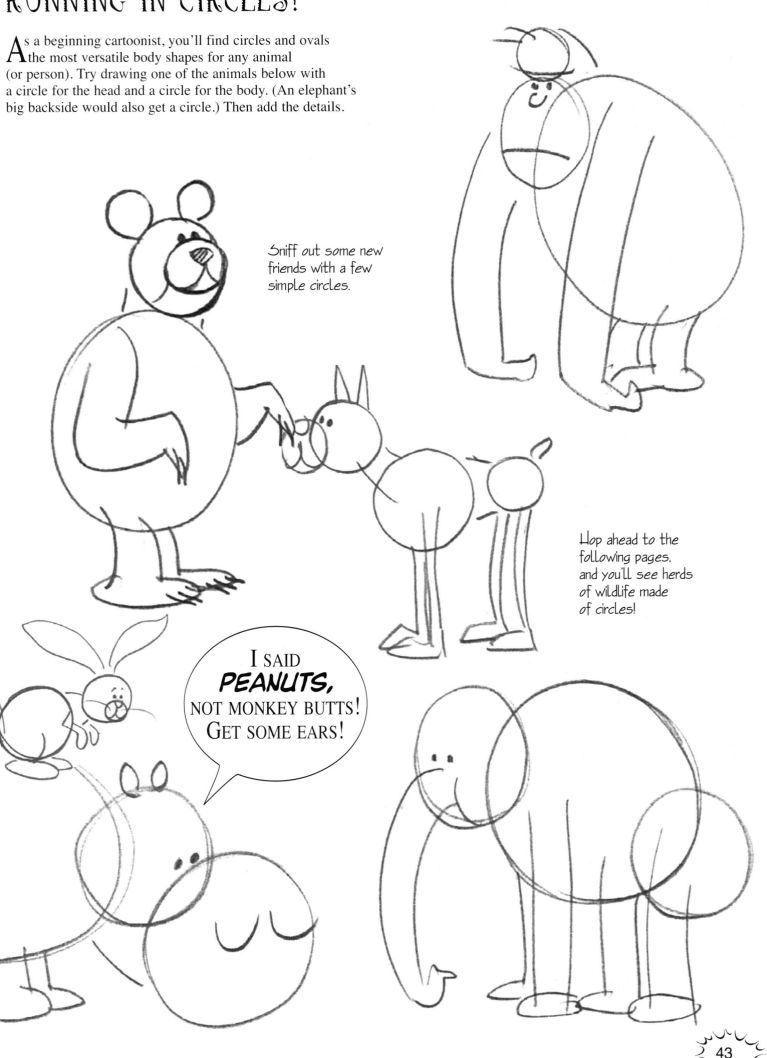

Sniff out some new friends with a few simple circles.

Hop ahead to the following pages, and you'll see herds of wildlife made of circles!

I SAID **PEANUTS,** NOT MONKEY BUTTS! GET SOME EARS!

43

COCKEYED CRITTERS

Before you jump into animal cartoons and caricature, you need to know how animals look in the real world. All cartoonists learn how to draw real animals before they start to abstract or caricature them. For example, a realistic animal usually has eyes on either side of its head, but in caricature you can tweak the eyes—make them as **big** as plates, as *flat* as pancakes, or as thin as sticks. Just open your imagination!

These before and after shots show how funny eyes can give your animals different expressions.

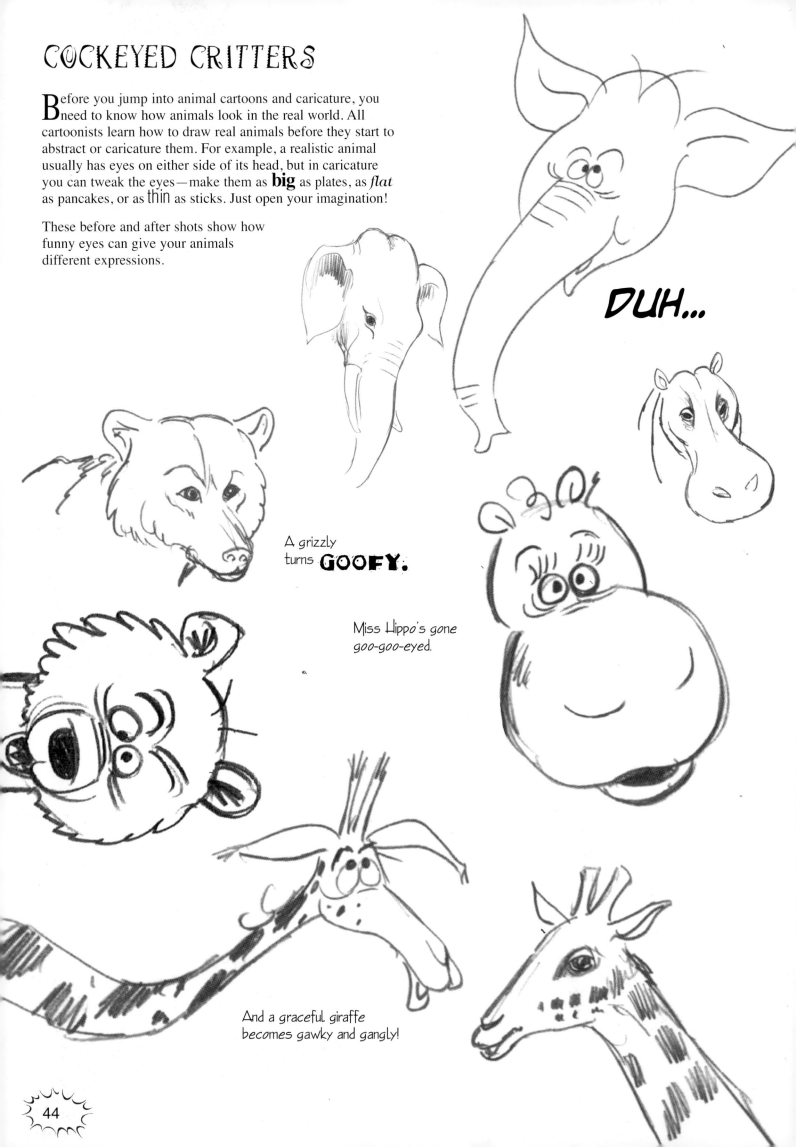

DUH...

A grizzly turns GOOFY.

Miss Hippo's gone goo-goo-eyed.

And a graceful giraffe becomes gawky and gangly!

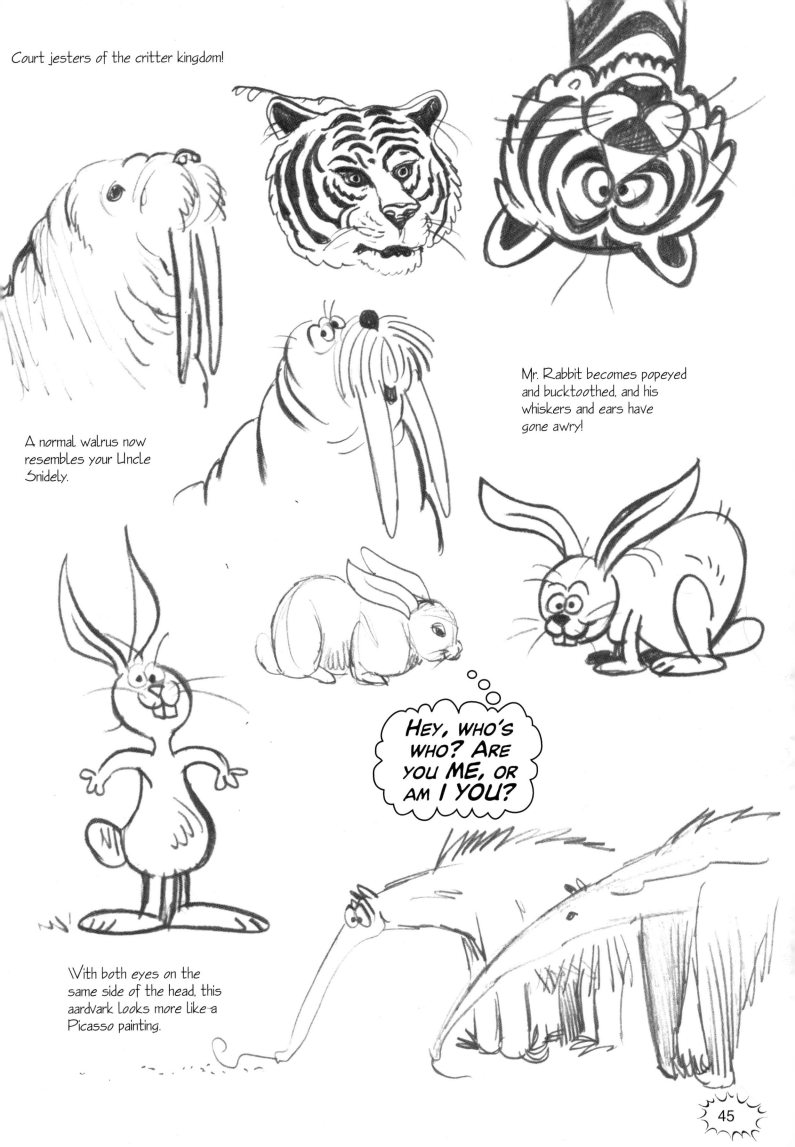

Court jesters of the critter kingdom!

A normal walrus now resembles your Uncle Snidely.

Mr. Rabbit becomes popeyed and bucktoothed, and his whiskers and ears have gone awry!

HEY, WHO'S WHO? ARE YOU ME, OR AM I YOU?

With both eyes on the same side of the head, this aardvark looks more like a Picasso painting.

HOOVES OR HANDS?

Another caricature trick is to make an animal stand up like a person and turn the two front feet into human hands with fingers. Below, dog paws have been converted into waving hands. Cartoon animal hands often have only three fingers and a thumb.

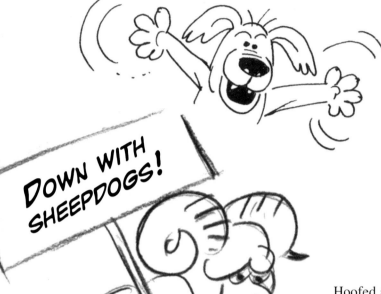

Hoofed animals, such as the ram and the zebra, can use their hooves as hands without fingers, to gesture and hold objects.

Even short, **stubby** toenails on a hippo's front feet can be fingers.

46

Using his front paws as hands, the king of the jungle royally addresses his subjects.

A goat **digests** a book.

Substituting human hands for paws or hooves is not always successful; the goat to the right looks a little awkward with fingers. Remember to keep some of the animal's original features. You don't have to alter all of them for well-drawn cartoons.

ABRACADABRA!

With a wave of your pencil, a posy-picking hand can grow from the end of an elephant's trunk. Use these techniques to help your critters "get a handle" on things.

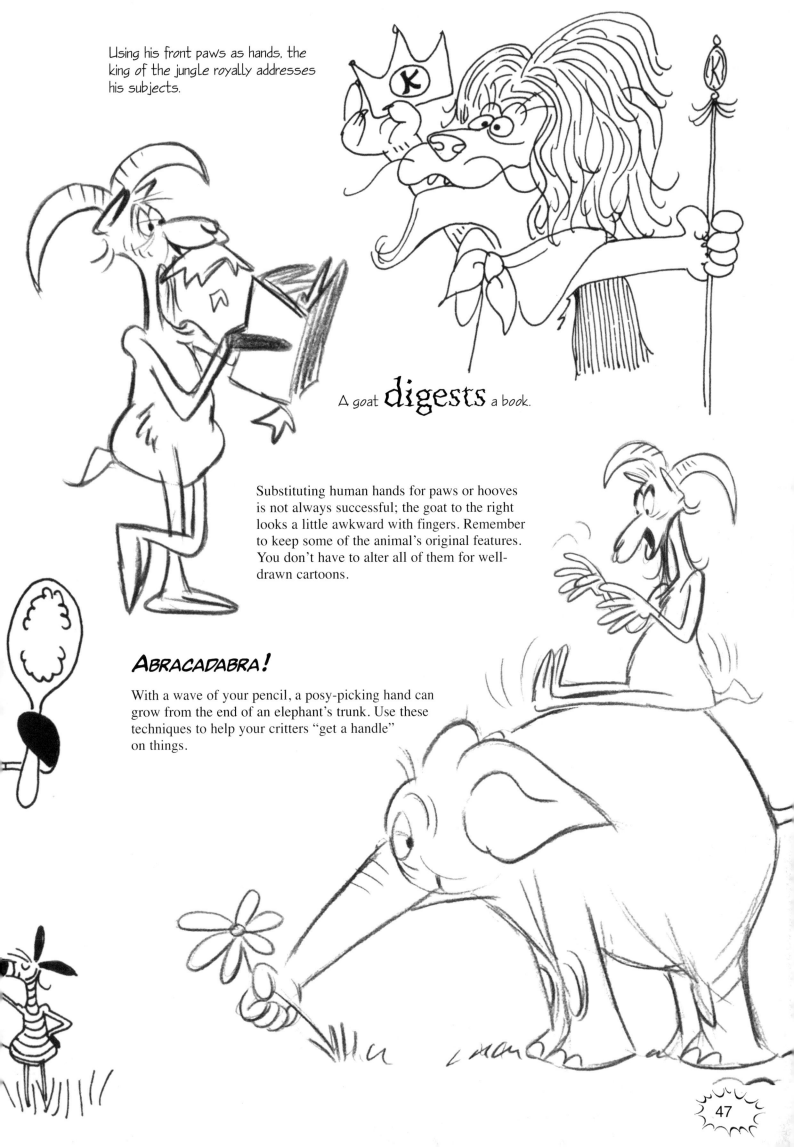

PECULIAR SHAPES

You can use all kinds of odd shapes for your cartoon animal bodies. Sketch any shape you want for the body; then attach the body parts in the right places. Remember to exaggerate them. You can even draw many different animals from the very same shape. For example, what animals can be drawn from a triangle?

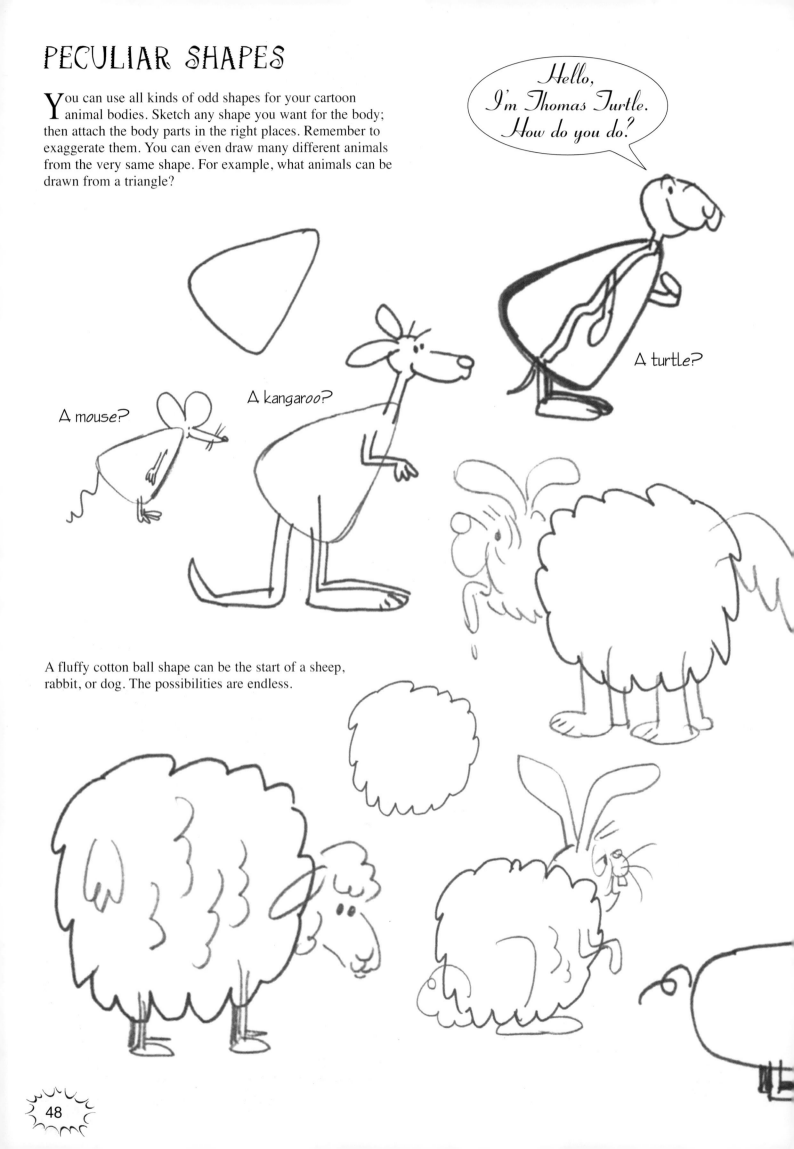

A mouse?

A kangaroo?

A turtle?

A fluffy cotton ball shape can be the start of a sheep, rabbit, or dog. The possibilities are endless.

48

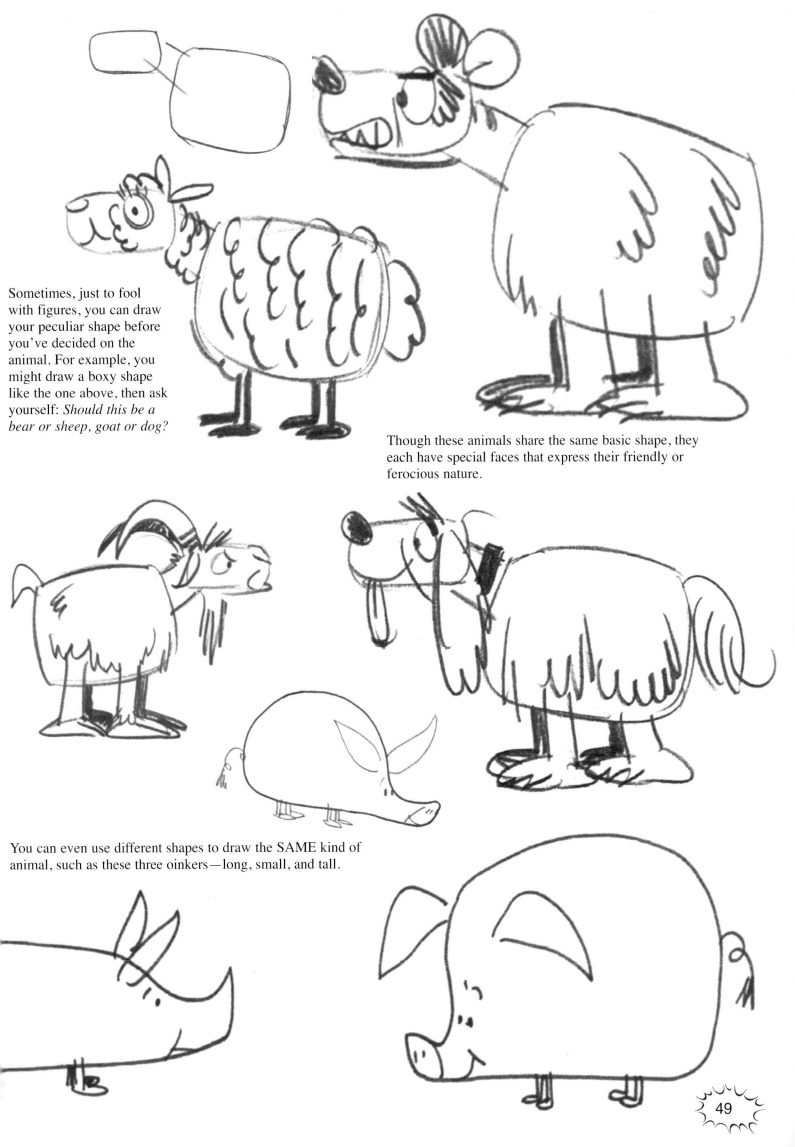

Sometimes, just to fool with figures, you can draw your peculiar shape before you've decided on the animal. For example, you might draw a boxy shape like the one above, then ask yourself: *Should this be a bear or sheep, goat or dog?*

Though these animals share the same basic shape, they each have special faces that express their friendly or ferocious nature.

You can even use different shapes to draw the SAME kind of animal, such as these three oinkers—long, small, and tall.

DOPEY DOGS

Dogs get a big circle for the chest and a smaller one for the hindquarters. It's a matter of proportion, or how one part relates to another part—or to the whole dog. It's important to know the proportions of the real animal—they will help you determine which parts of the animal should be exaggerated.

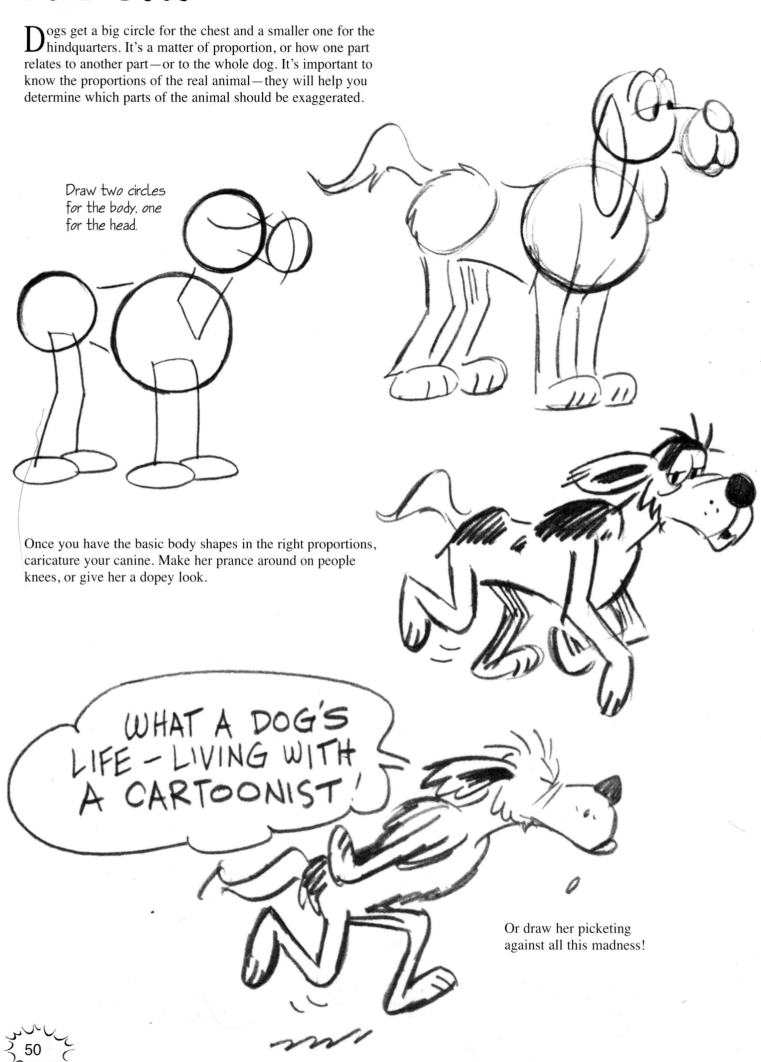

Draw two circles for the body, one for the head.

Once you have the basic body shapes in the right proportions, caricature your canine. Make her prance around on people knees, or give her a dopey look.

WHAT A DOG'S LIFE — LIVING WITH A CARTOONIST!

Or draw her picketing against all this madness!

ZANY ZEBRAS

Start a zebra with an oval body, and add a round head, oval nose, and oval ears. It's as simple as 1, 2, 3!

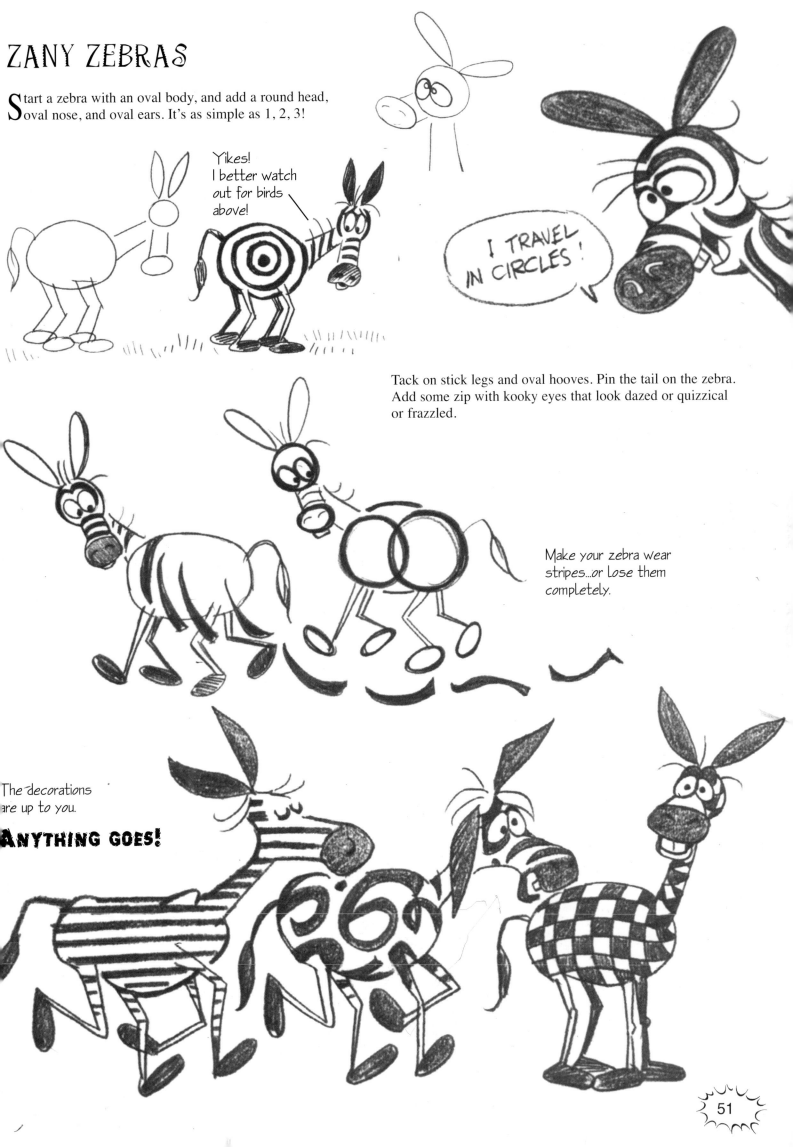

Yikes! I better watch out for birds above!

I TRAVEL IN CIRCLES!

Tack on stick legs and oval hooves. Pin the tail on the zebra. Add some zip with kooky eyes that look dazed or quizzical or frazzled.

Make your zebra wear stripes...or lose them completely.

The decorations are up to you.

ANYTHING GOES!

ECCENTRIC ELEPHANTS

Elephants can start with a circle or a funny shape. But a circle elephant is easier to draw in different poses because when you turn the circle shape around, it stays **ROUND**.

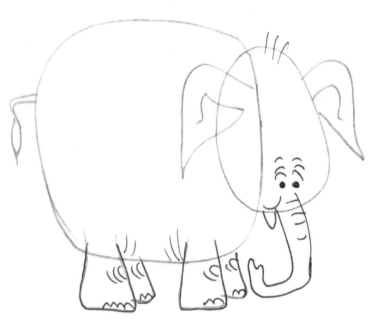

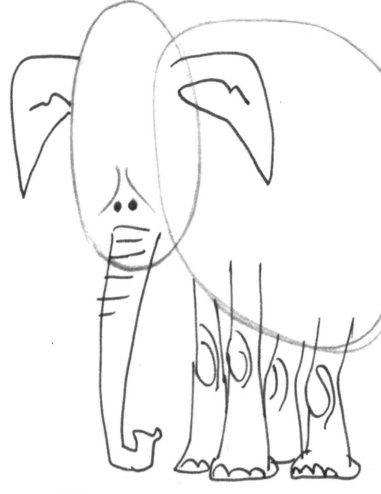

An odd-shaped elephant is harder to draw in different poses because when you turn an odd shape around, it changes.

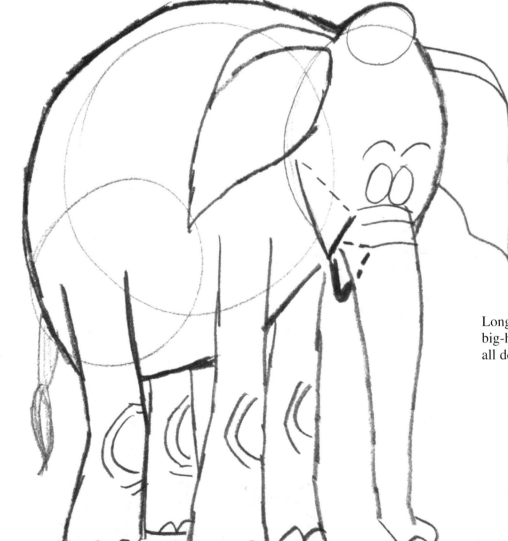

Long-legged or short-legged, big-headed or pin-headed? It all depends on *you!*

An elephant's trunk is a feature that's just waiting to be exaggerated! Tie it in a knot, or SQUISH it like an accordian, or S-T-R-E-T-C-H it out!

How **Long** is an elephant's trunk, anyway?

I FORGET. HOW LONG IS IT?

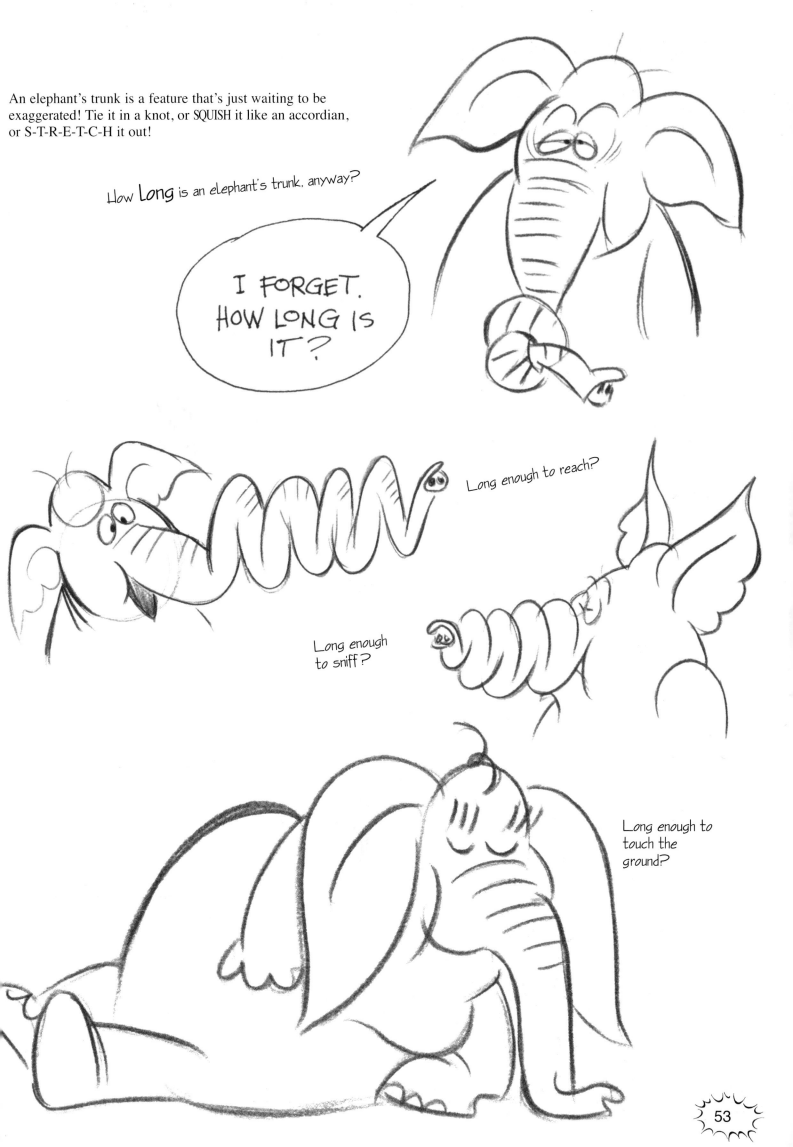

Long enough to reach?

Long enough to sniff?

Long enough to touch the ground?

Bear Essentials

Our grizzly bear friends can easily be drawn with circles and ovals. Draw a circle and oval together for a bear body; then add thin ovals for arms and legs. You can draw a stout gent who walks upright (perfect for people situations) or a clumsy polar who stumbles on all fours.

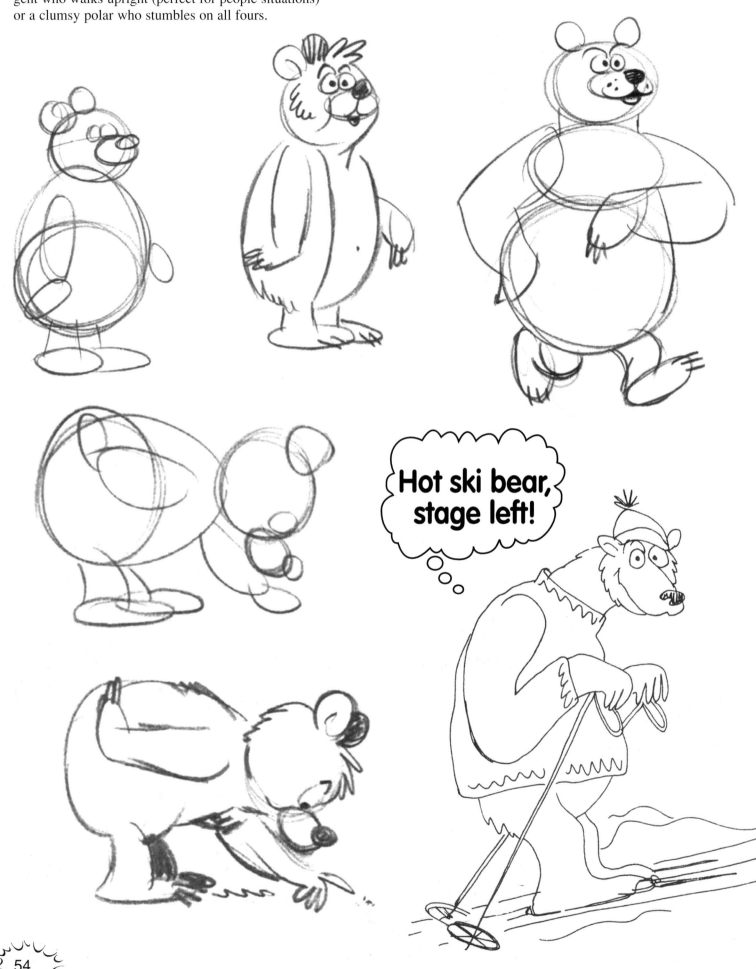

Hot ski bear, stage left!

Polar bears are sturdy-looking creatures with tapered shoulders, heavy rumps, and big, flat feet. They're longer-necked and more slender than other bears, and they lend themselves well to winter sports.

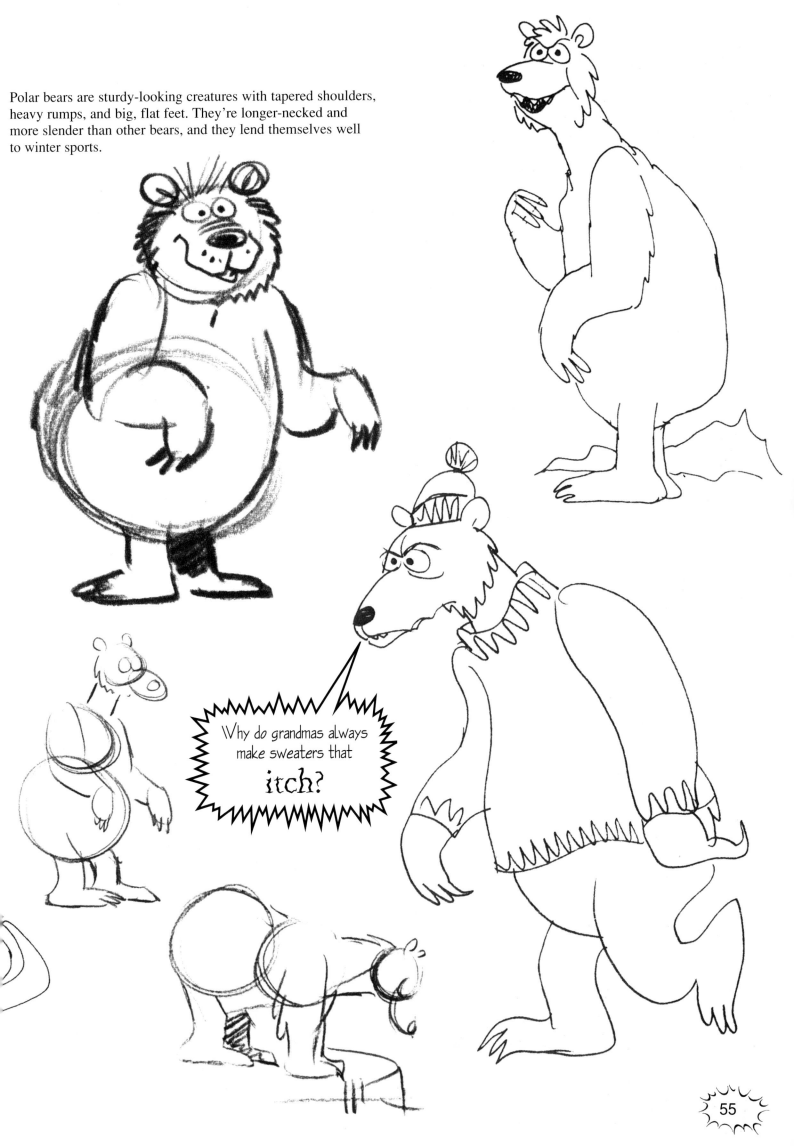

Why do grandmas always make sweaters that **itch?**

JIVIN' GIRAFFES

A giraffe has a very **LONG** neck that not only serves as a crane for reaching high into the trees but also provides a perfect feature for cartooning. First make circles for the body and head. Attach them with long lines for the neck and legs (with tiny ovals for knees) and leaf shapes for the ears and tail.

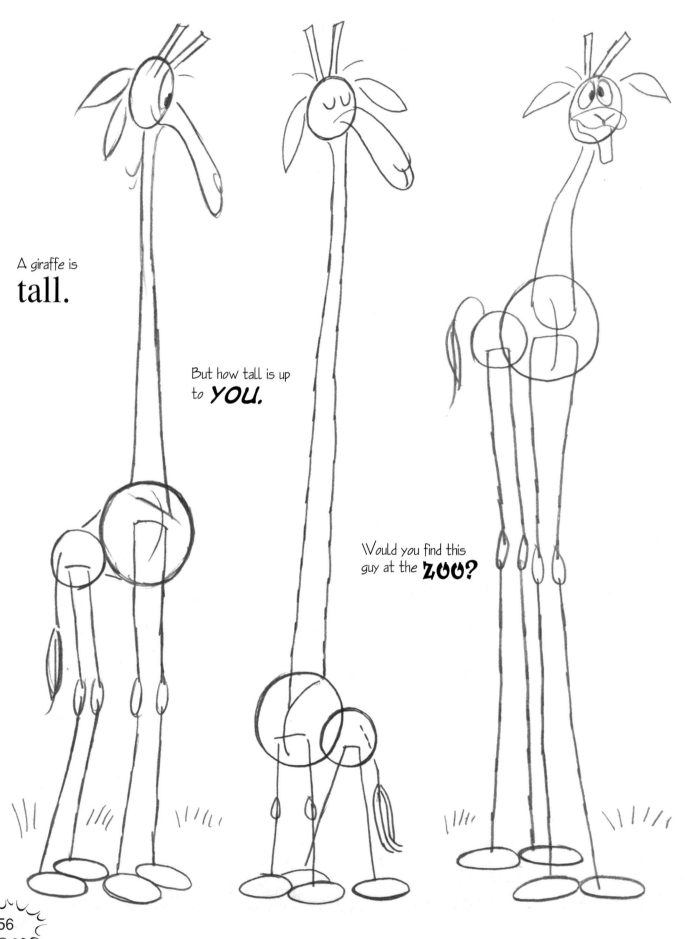

A giraffe is
tall.

But how tall is up
to **YOU.**

Would you find this
guy at the **ZOO?**

56

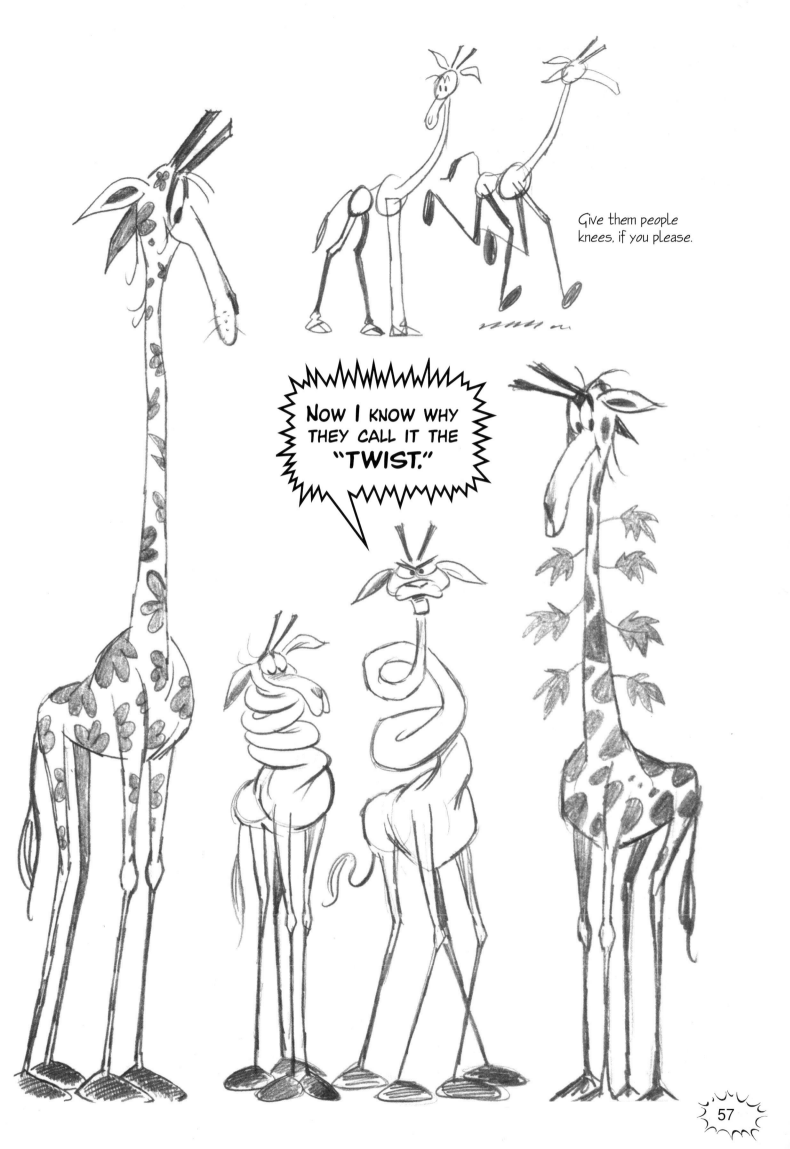

Give them people knees, if you please.

NOW I KNOW WHY THEY CALL IT THE "TWIST."

MONKEY MADNESS

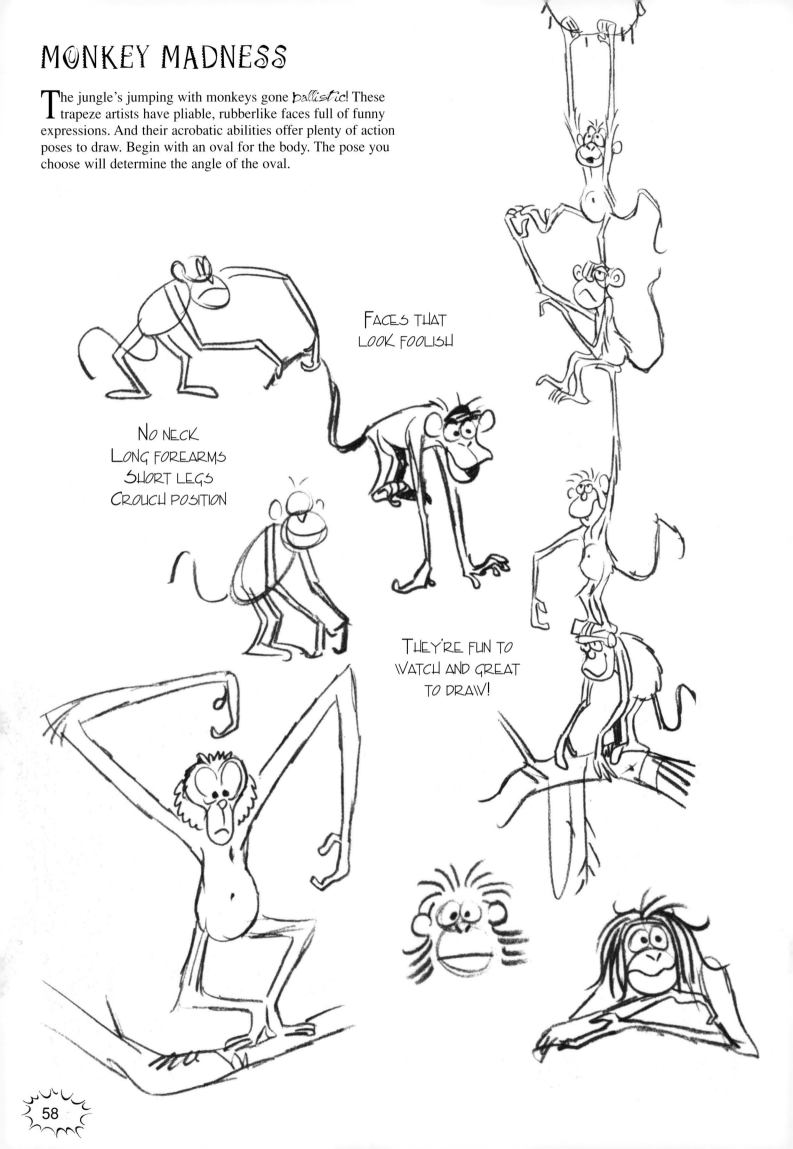

The jungle's jumping with monkeys gone *ballistic*! These trapeze artists have pliable, rubberlike faces full of funny expressions. And their acrobatic abilities offer plenty of action poses to draw. Begin with an oval for the body. The pose you choose will determine the angle of the oval.

FACES THAT LOOK FOOLISH

NO NECK
LONG FOREARMS
SHORT LEGS
CROUCH POSITION

THEY'RE FUN TO WATCH AND GREAT TO DRAW!

GRUMPY GORILLAS

A gorilla is bigger and huskier than a monkey. Make the head by drawing a circle on top of a circle, but, unlike the monkey's, let it drop low between the massive shoulders. Put in little circles for eyes, ears, and nose. Add the heavy brow and pouty mouth.

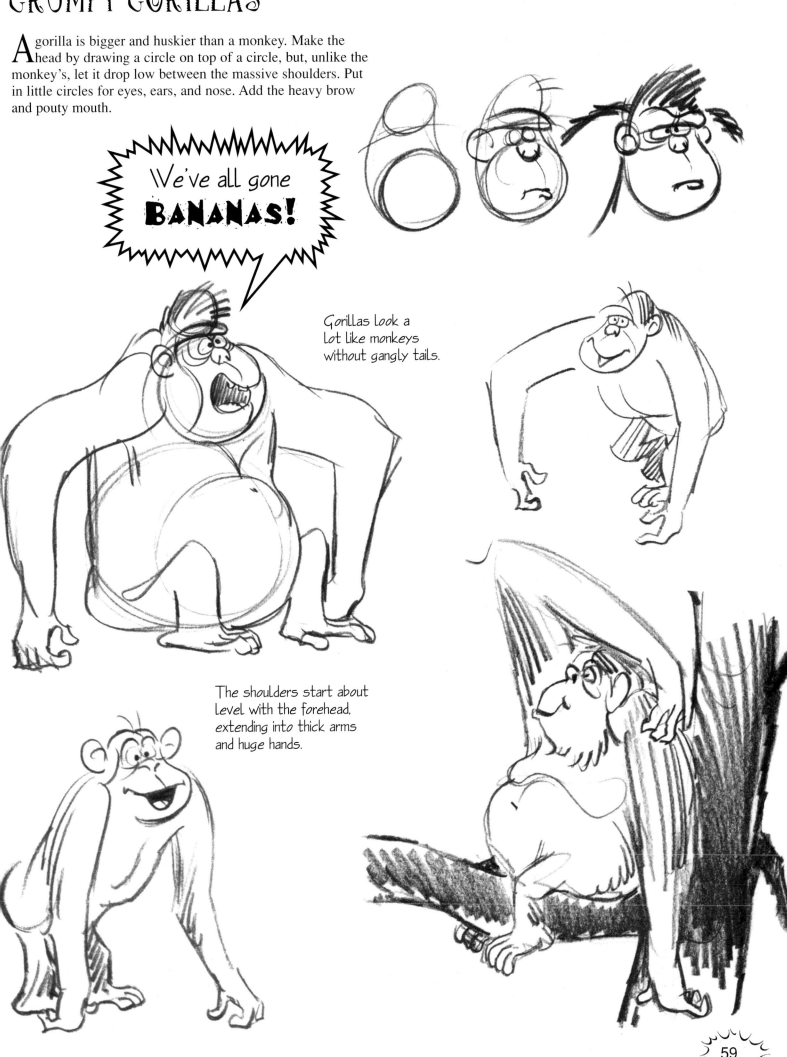

We've all gone BANANAS!

Gorillas look a lot like monkeys without gangly tails.

The shoulders start about level with the forehead, extending into thick arms and huge hands.

LITTLE CRITTERS

The forest is abuzz with busy little critters who make terrific cartoon candidates. Their body shapes are similar, so sometimes one animal's circles will adapt for another animal, such as the potbellied porcupine below and the busy beaver on the opposite page.

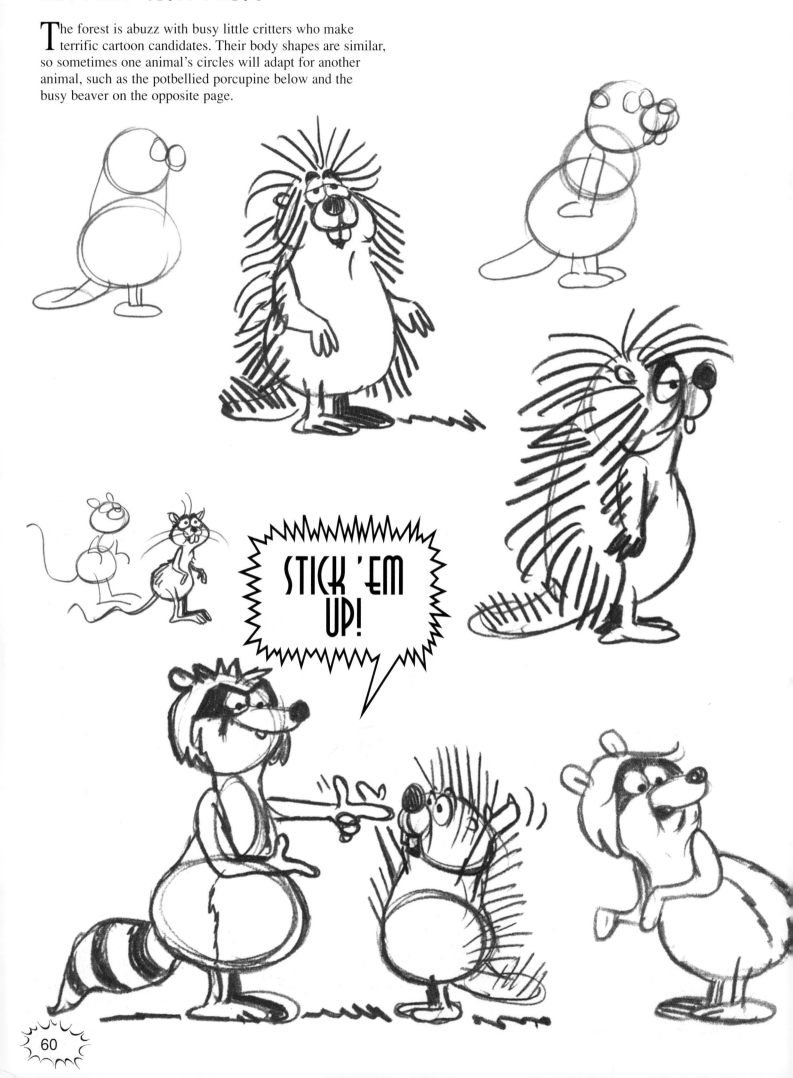

STICK 'EM UP!

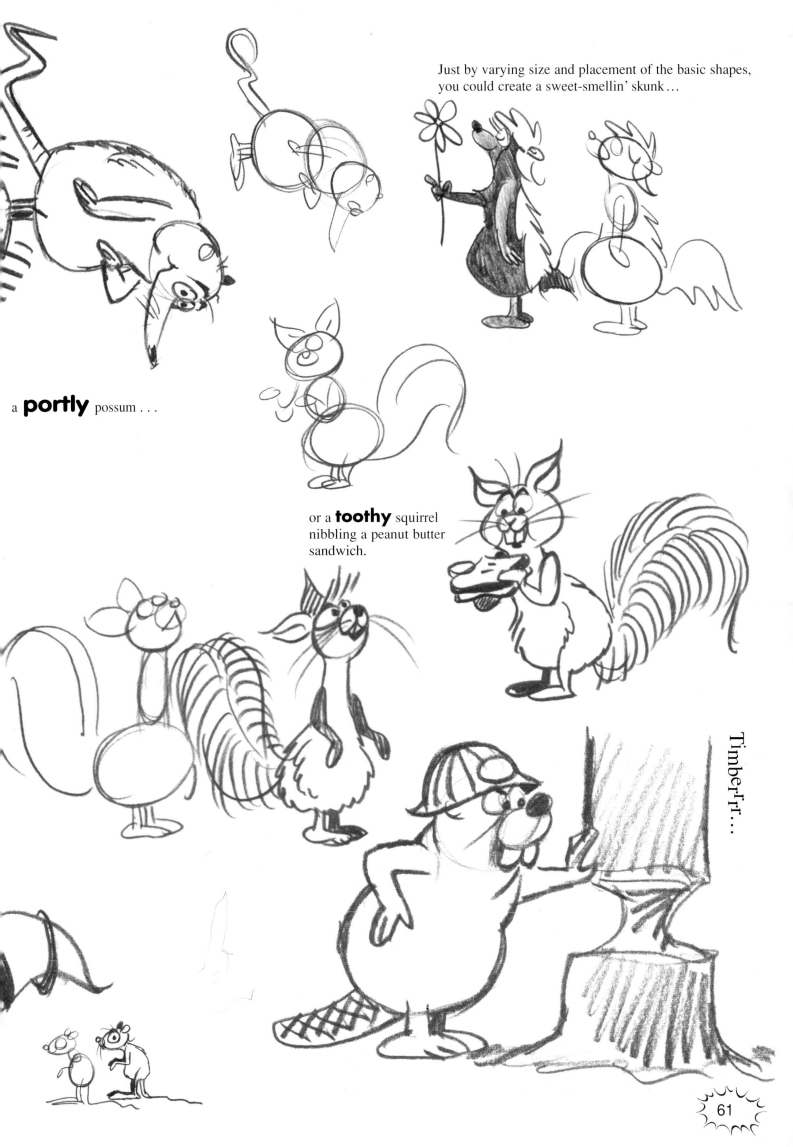

Just by varying size and placement of the basic shapes, you could create a sweet-smellin' skunk...

a **portly** possum . . .

or a **toothy** squirrel nibbling a peanut butter sandwich.

Timber'rr...

WILD 'N' WOOLLY!

For these drawings, think about each animal's unique features and overstate them. Give the deer a spooked look by making its big eyes bigger, skinny legs skinnier, and tiny hooves tinier.

A moose is a big **HULK** with heavy shoulders. Making his legs too thin and his antlers too big exaggerates his great height and weight.

Overemphasize the mountain goat's heaviness with massive shoulders and feet planted firmly on the rock. But remember, how YOU caricature is always a matter of personal choice!

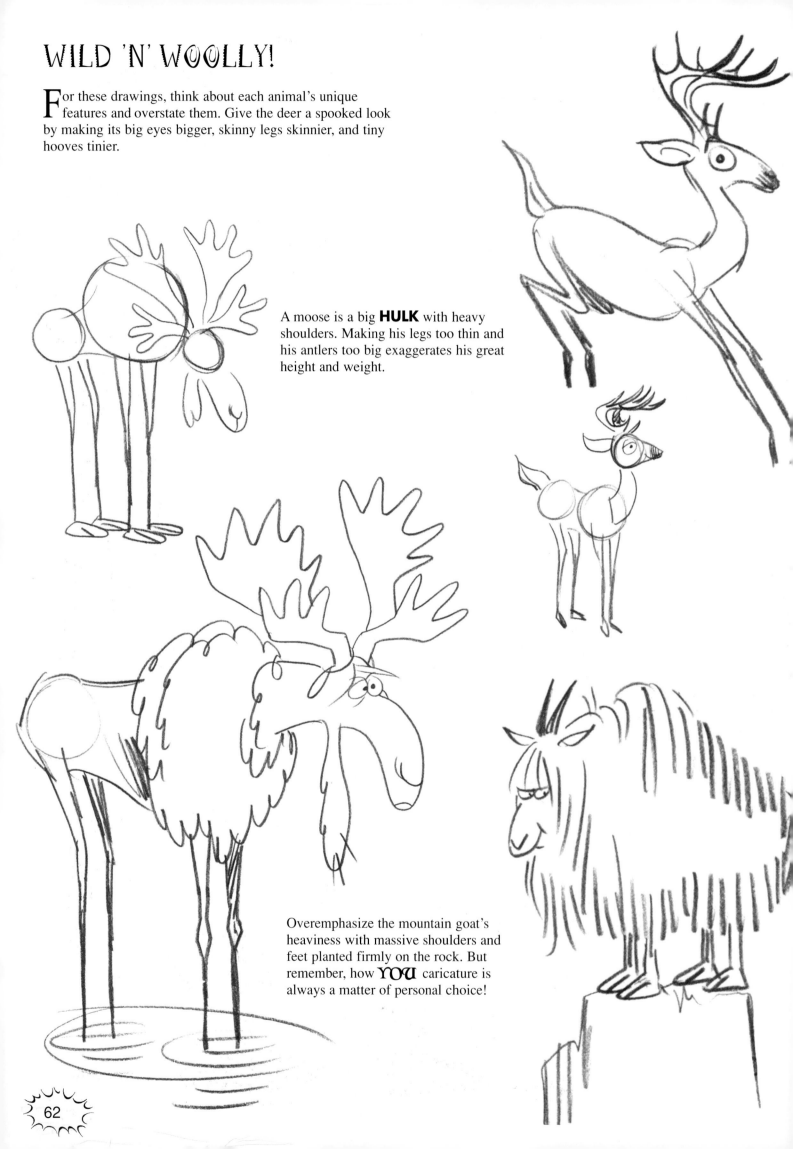

The bighorn sheep's most striking feature is, of course, his big horns. Drawing them even bigger makes the sheep more top-heavy.

Or you might put your animal in an unlikely situation—like teetering atop a musk ox.

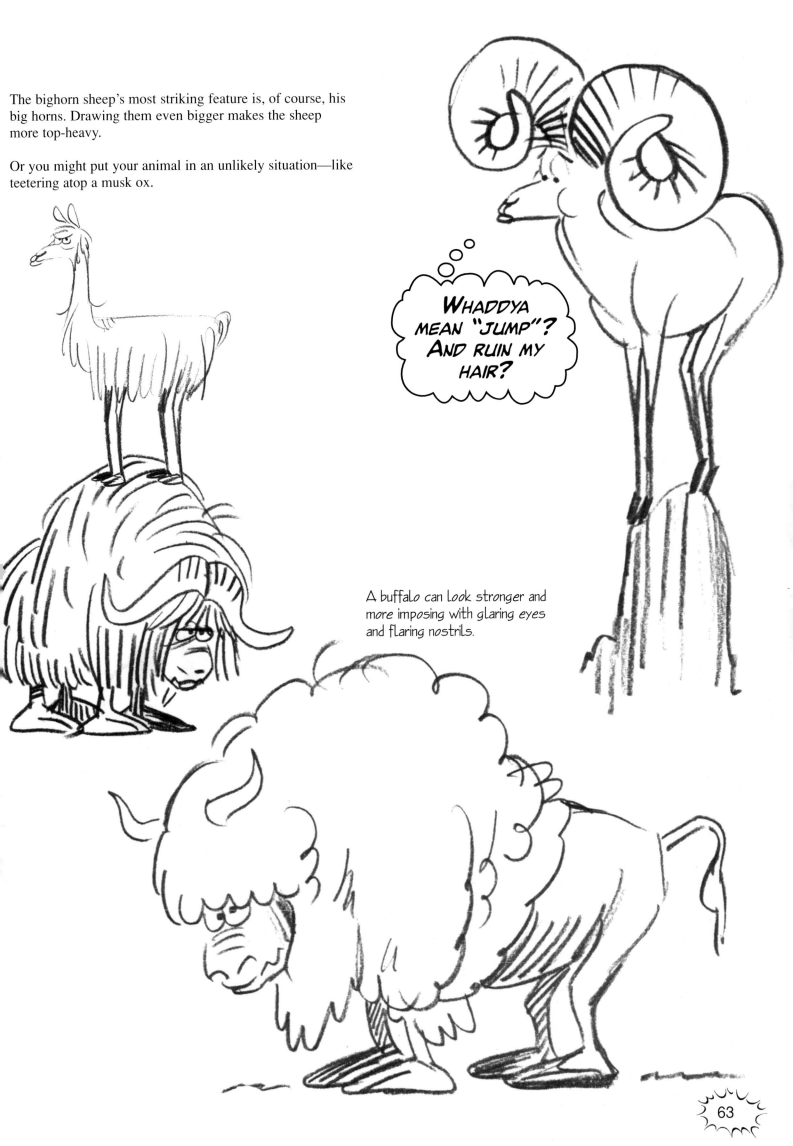

WHADDYA MEAN "JUMP"? AND RUIN MY HAIR?

A buffalo can look stronger and more imposing with glaring eyes and flaring nostrils.

LOOK-ALIKES

It's weird, but have you noticed how people and animals can look the same? It's hard to tell who's imitating whom. As far as drawing goes, they start with circles and ovals. Compare the man with the bear. They both have two circles for the body and one for the head, just differently sized and placed. See?

Sometimes people look like their pets too. Do you? It's fun to draw people and pets together, like the businessman and his boxer.

THAT LADY LOOKS LIKE MY COUSIN HELGA.

HE ALWAYS GETS THE COUCH!

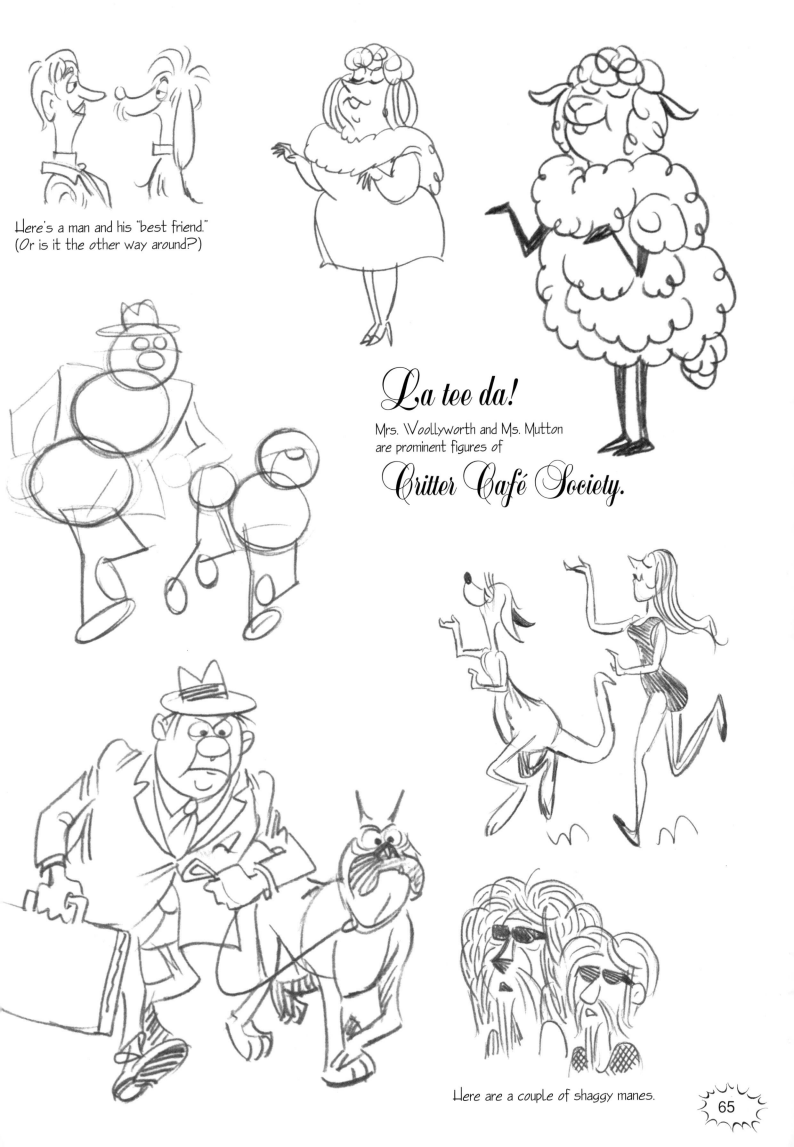

Here's a man and his "best friend." (Or is it the other way around?)

La tee da!

Mrs. Woollyworth and Ms. Mutton are prominent figures of

Critter Café Society.

Here are a couple of shaggy manes.

CRAZY COMICS

Before your critters escape, round 'em up into funny situations and stories. Give your characters names. Have them tell jokes. Or cast them in comedic roles. Make a single cartoon or a whole comic strip like *Chloe*.

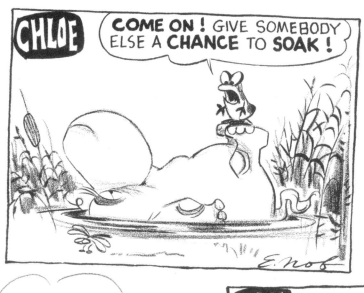

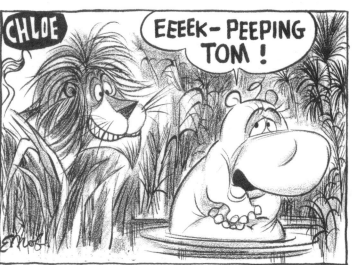

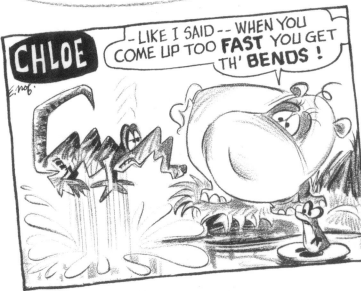

See how you can still use simple shapes to create the animals in a comic strip? It's just a matter of combining what you have learned with your imagination—let it run **WILD!**

You have the skills and know-how to take your talent as far as you want.

IT'S UP TO YOU!

Here are some more ways to turn your cartoons into amusing comics. It helps to incorporate all the quirky things you know about animal behavior when thinking of your own jokes. Animals can do the darndest things if you let them!

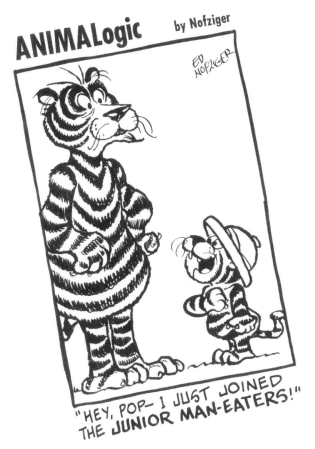

"HEY, POP— I JUST JOINED THE **JUNIOR MAN-EATERS!**"

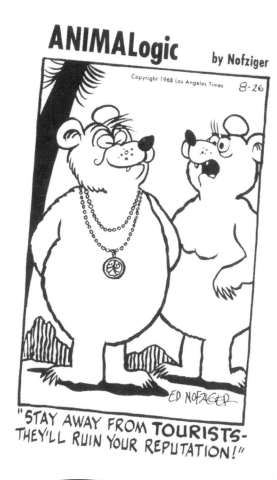

"STAY AWAY FROM **TOURISTS**— THEY'LL RUIN YOUR REPUTATION!"

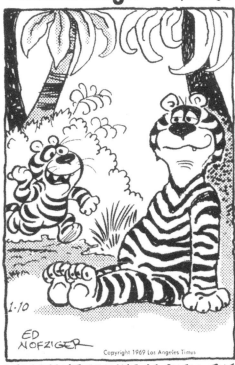

"*ELEPHANT COMING!* I SMELL THE **PEANUTS** ON HIS BREATH!"

WHEN YOU MONKEY WITH CARTOONS AND COMICS, THERE ARE NO BOUNDARIES. SO KEEP ON CARTOONING!

U Can Cartoon! by Jack Keely

Jack Keely is a graduate of Rhode Island School of Design and Cranbrook Academy of Art. He has illustrated more than 20 popular children's books, as well as magazine articles, puzzles, advertisements, and book jackets. His cartoon characters have been translated into plush toys, plastic figures, and puppets. Keely currently resides in Los Angeles with his dog, Hugo.

Section 4

JACK KEELY
STRAIGHT FROM THE HORSE'S MOUTH

When Jack Keely was a kid, he was so nearsighted he would get double vision when he read standard books. But the larger blocks of type in comic books were the right size and quantity of words for him. "By the time I was 7 years old, I could draw my favorite characters from comic books," he says. "That was my first training in cartoons." Today, the successful cartoonist and children's book illustrator has more than enough work as an artist. But his career road was a curvy one through advertising agencies, college art departments, and training in graphic design.

"When I went to college, there was no cartooning major, so I went for illustration and graphic design," Keely recalls. "I would have liked to have stepped out of college and begun the work I am doing now, instead of waiting 20 years to build up to this. My work kept taking me other places, and working as a design and art director definitely enhanced my use of color, composition, and sensitivity to typography. And these skills have strengthened my ability as an illustrator."

One project leads to another now for Keely, and he spends only a minimal amount of time marketing his work. But earlier in his career and during his slow times now, he markets by sending out packets containing a brochure about his work and samples of things he is proud of. No more than a total of one week a year is spent marketing, and an additional number of hours is spent with client contact and billing matters. The rest is creative work, which is fine with Keely.

"What I did to amuse myself as a boy, I do now professionally and get paid to do it!" he laughs. And he says that should encourage other aspiring artists and cartoonists. "I think that if you like something and enjoy doing it, you can make a success of it as a career," he says. "If you like it that much, you will keep at it until you excel at it."

Keely's advice to beginners is to draw all the time. "Learn as much as you can from others," he suggests. "But don't forget that in cartoons, there's no rule that can't be broken. Trust yourself. Respect and enjoy the personal quirks that make your work unique. If you draw to amuse yourself, you are certain to amuse others as well."

TOMAYTO, TOMAHTO
A Personal Point of View

When creating your own cartoon character, you call the shots. There's no right or wrong way to do it. As you create cartoons, you'll find you like to draw a certain way. Do you prefer loose, sketchy lines, or tight controlled detail? Do you like loony characters or realistic ones? It's up to you.

Be true to your natural preferences, and you'll inevitably develop a personal style over time.

Studying the greats and copying their masterpieces might also help you develop a personal style. Look through the funnies and comic books, or study animation on video.

It's also important to practice drawing realistically to gain knowledge of anatomy, perspective, light, and shadow—all of which you'll need in cartoon drawing. Cartoons simplify and abstract reality. You have to understand the real in order to create a convincing abstraction.

In some ways, cartooning is more challenging than realistic drawing. For example, it's fairly easy to draw an ordinary teapot, but as a cartoonist you might draw a singing teapot dancing in platform shoes. Strong drawing and observation skills will help convey attitude, personality, and "teapottiness" in your cartoons.

While tried-and-true methods for drawing cartoons are covered in this book, remember—rules are made to be broken.

As a cartoonist, your options are unlimited.

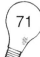

71

FROM THE TOP
The Human Head

Knowing how to draw a realistic head gives you a reference point for creating cartoons with fantastic faces. Practice by drawing heads of models and celebrities from magazine photos. Soon you'll begin to notice wide, innocent eyes and squinty ones, button noses and crooked ones, oval faces and square ones. The variations are endless and quite fascinating.

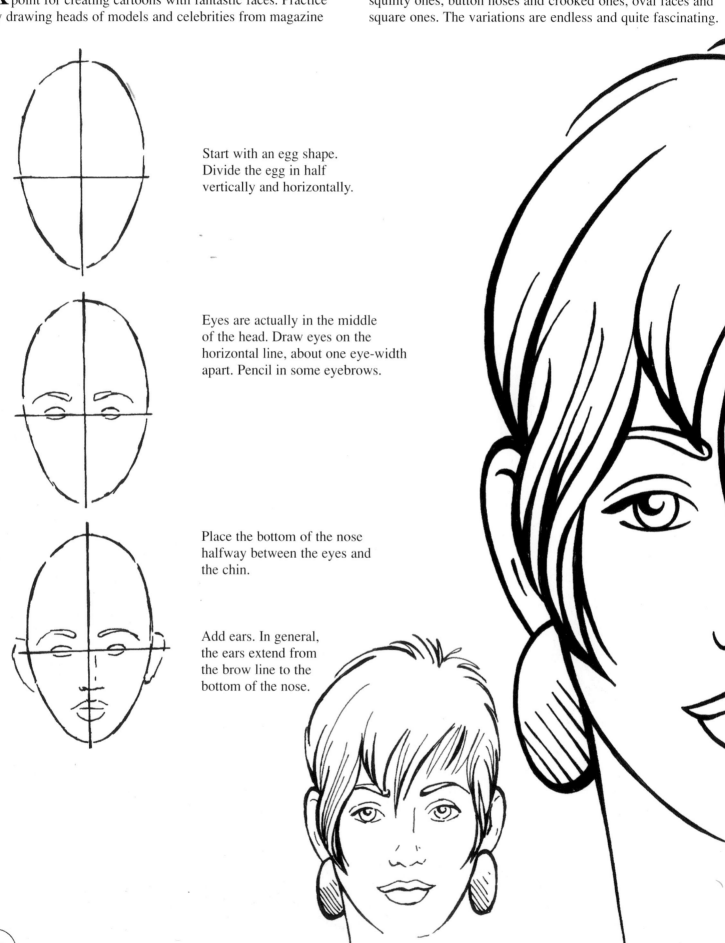

Start with an egg shape. Divide the egg in half vertically and horizontally.

Eyes are actually in the middle of the head. Draw eyes on the horizontal line, about one eye-width apart. Pencil in some eyebrows.

Place the bottom of the nose halfway between the eyes and the chin.

Add ears. In general, the ears extend from the brow line to the bottom of the nose.

FUNNY FACE
The Cartoon Head

There are no rules or limits for drawing a cartoon face. Heads can be spheres, cubes, or carrots. Eyes can be as big as plates or as small as pinholes. You can draw a huge honking nose or a pixieish point. It depends on how wild, wacky, or real you want your character to be.

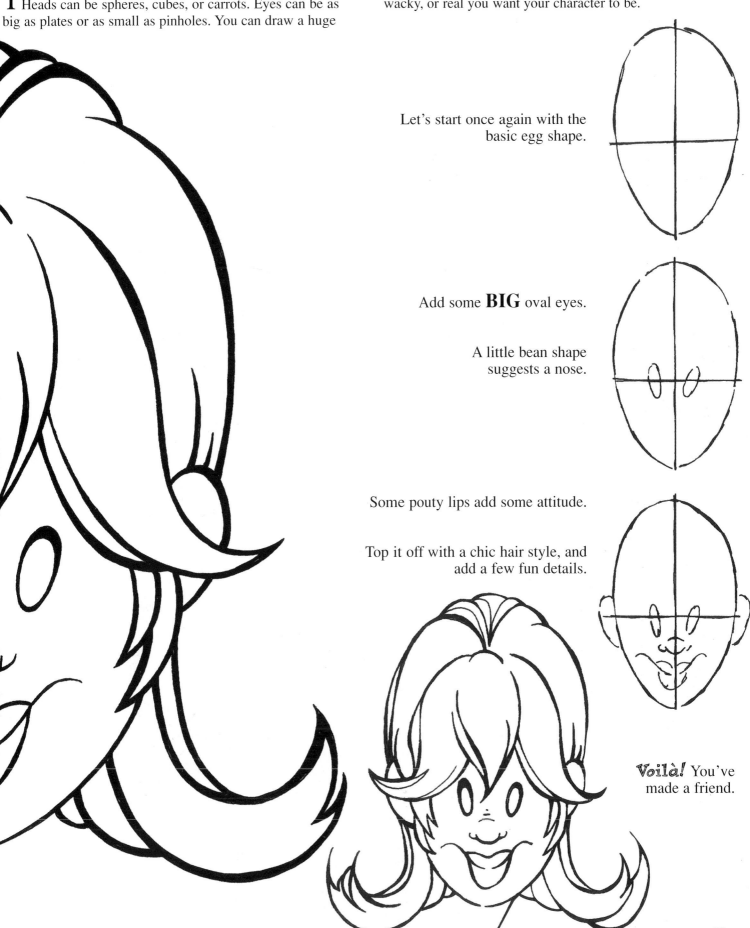

Let's start once again with the basic egg shape.

Add some **BIG** oval eyes.

A little bean shape suggests a nose.

Some pouty lips add some attitude.

Top it off with a chic hair style, and add a few fun details.

Voilà! You've made a friend.

FEELINGS...WO, WO, WO
Showing Emotion

Catch an old episode of *I Love Lucy* or a Jerry Lewis or Jim Carrey film. Study the actors as their eyes widen in surprise, mouths drop open in terror, and faces crumple in tears. Look in the mirror, and study your own face in expressions of anger, happiness, fear, sadness, and shock.

Notice how your facial muscles move in each one. Cartoon characters usually have large or exaggerated features that reveal their emotions. Characters can smile from ear to ear, explode with anger, turn green with envy, be tickled pink, and get the blues.

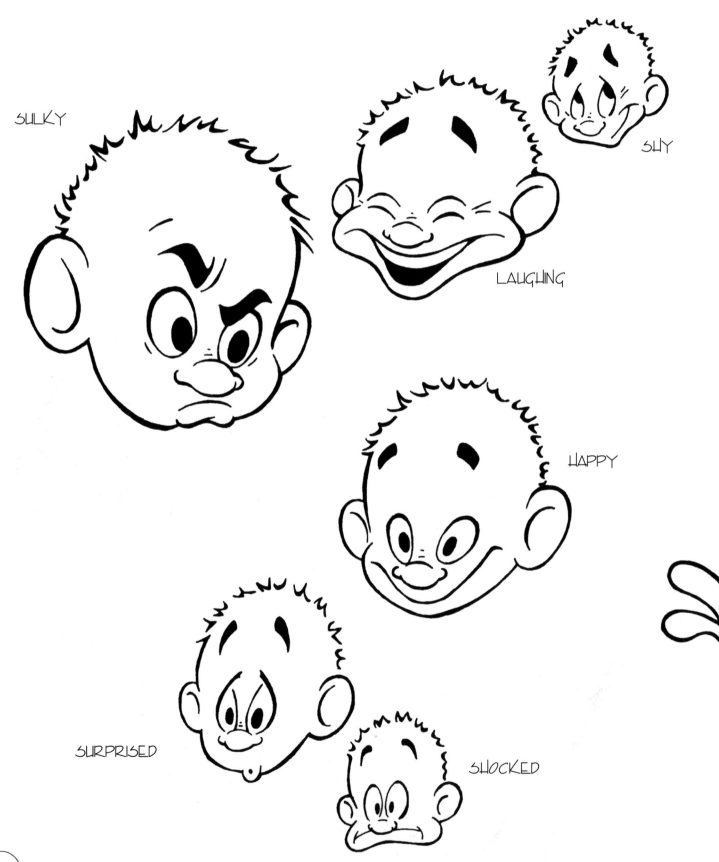

SULKY

SHY

LAUGHING

HAPPY

SURPRISED

SHOCKED

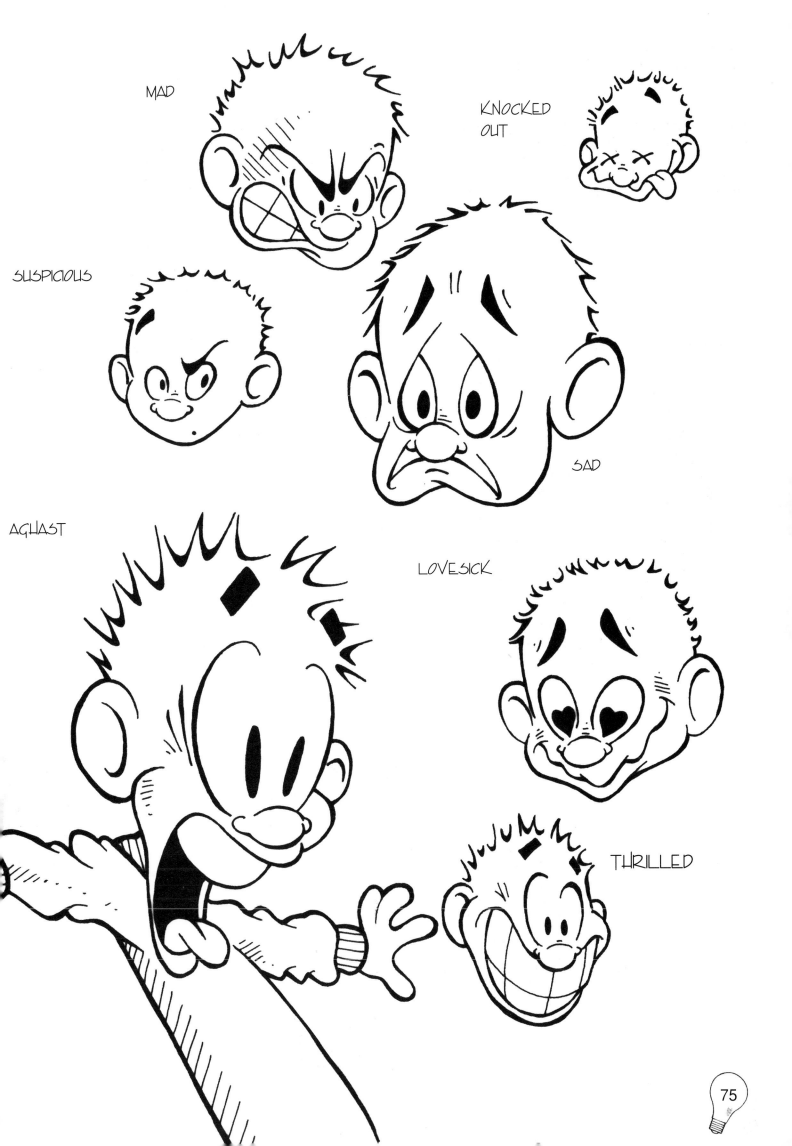

MAD

KNOCKED OUT

SUSPICIOUS

SAD

AGHAST

LOVESICK

THRILLED

LET'S FACE IT
Creating Characters

Some personality traits are associated with certain facial features, and therefore they can help define a cartoon's personality. For example, wide eyes usually denote innocence; square jaws suggest strength; a high forehead implies intelligence; and so forth.

Of course, you can turn convention on its ear by drawing a baby-faced villain, tiny tough guy, or beefy heroine. You might not have envisioned a bald, tattooed, pipe-smoking cartoon hero, and yet Popeye has been a hit with kids and adults since 1929.

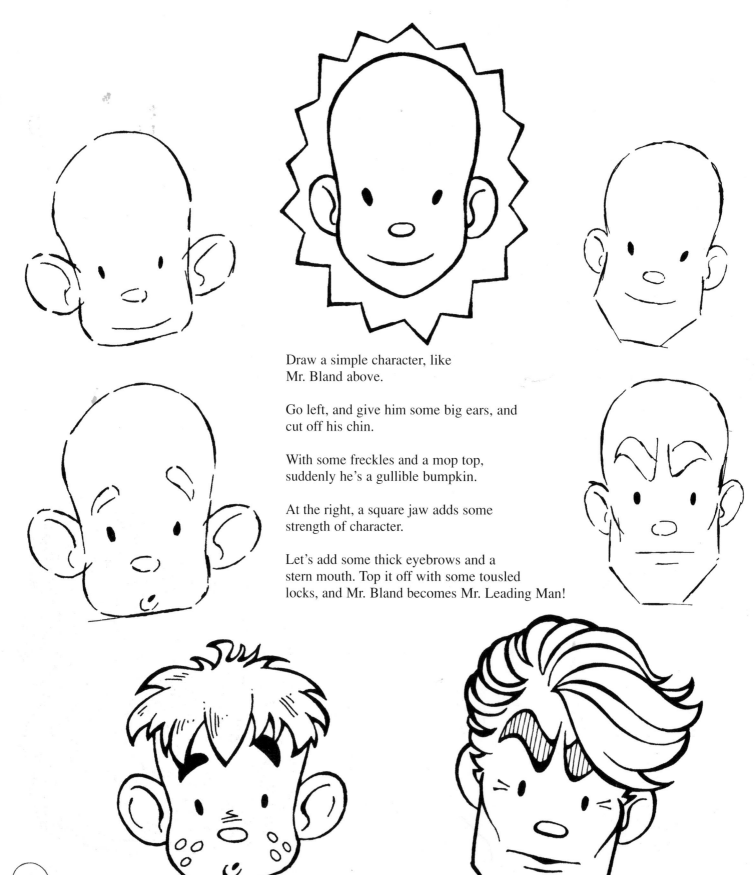

Draw a simple character, like Mr. Bland above.

Go left, and give him some big ears, and cut off his chin.

With some freckles and a mop top, suddenly he's a gullible bumpkin.

At the right, a square jaw adds some strength of character.

Let's add some thick eyebrows and a stern mouth. Top it off with some tousled locks, and Mr. Bland becomes Mr. Leading Man!

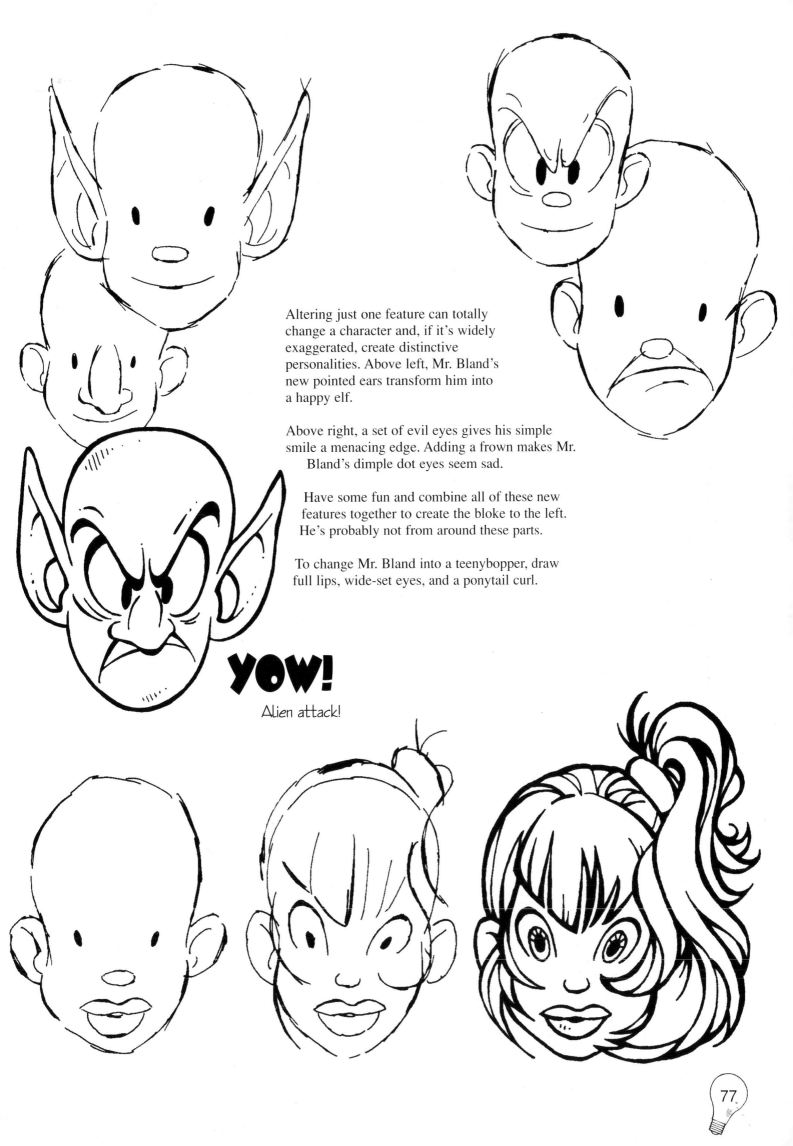

Altering just one feature can totally change a character and, if it's widely exaggerated, create distinctive personalities. Above left, Mr. Bland's new pointed ears transform him into a happy elf.

Above right, a set of evil eyes gives his simple smile a menacing edge. Adding a frown makes Mr. Bland's dimple dot eyes seem sad.

Have some fun and combine all of these new features together to create the bloke to the left. He's probably not from around these parts.

To change Mr. Bland into a teenybopper, draw full lips, wide-set eyes, and a ponytail curl.

YOW!

Alien attack!

BEYOND HUMPTY DUMPTY
Eccentric Head Shapes

We know most people are basically eggheads, but a lot of different facial shapes exist, including round, square, triangular, and heart-shaped. A cartoon head can be shaped like a sphere, cube, pickle, or anything else. Odd-shaped heads accent your characters' personalities.

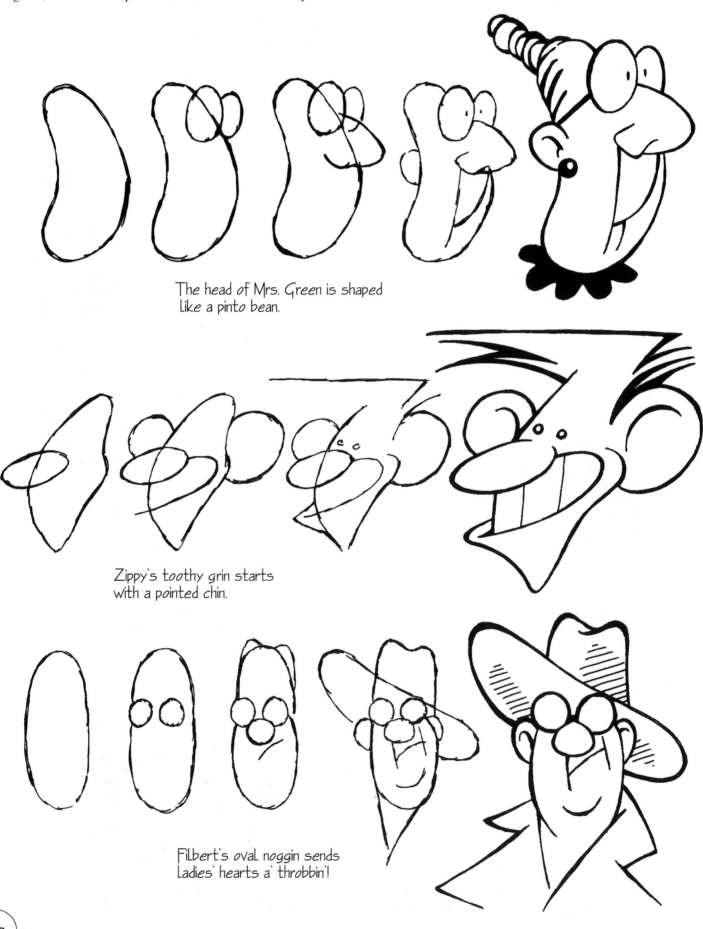

The head of Mrs. Green is shaped like a pinto bean.

Zippy's toothy grin starts with a pointed chin.

Filbert's oval noggin sends ladies' hearts a' throbbin'!

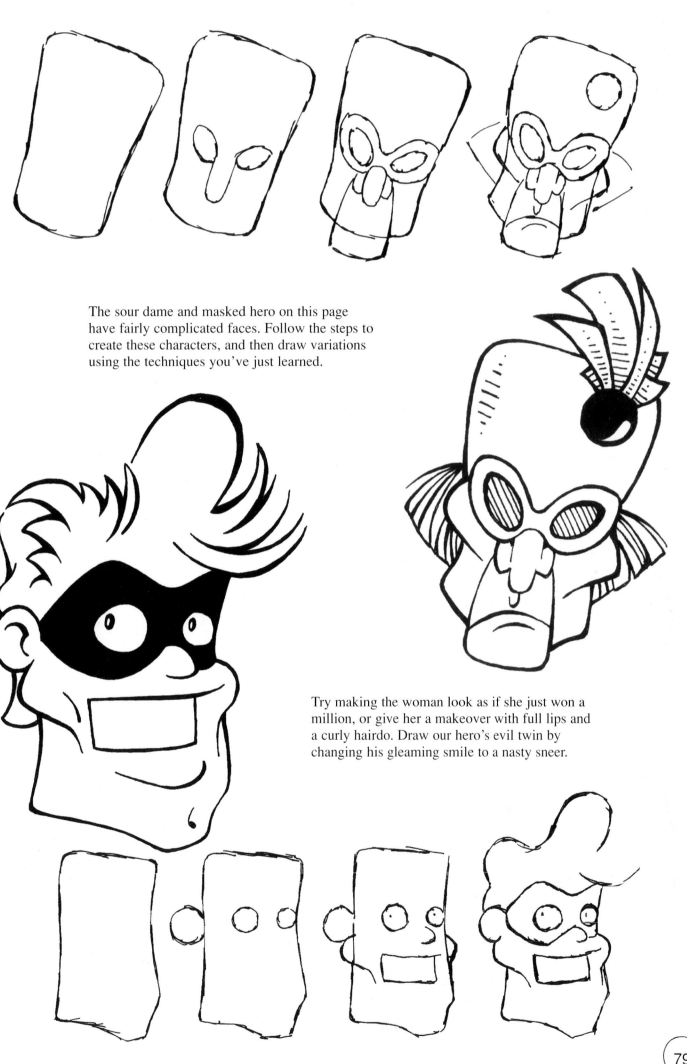

The sour dame and masked hero on this page have fairly complicated faces. Follow the steps to create these characters, and then draw variations using the techniques you've just learned.

Try making the woman look as if she just won a million, or give her a makeover with full lips and a curly hairdo. Draw our hero's evil twin by changing his gleaming smile to a nasty sneer.

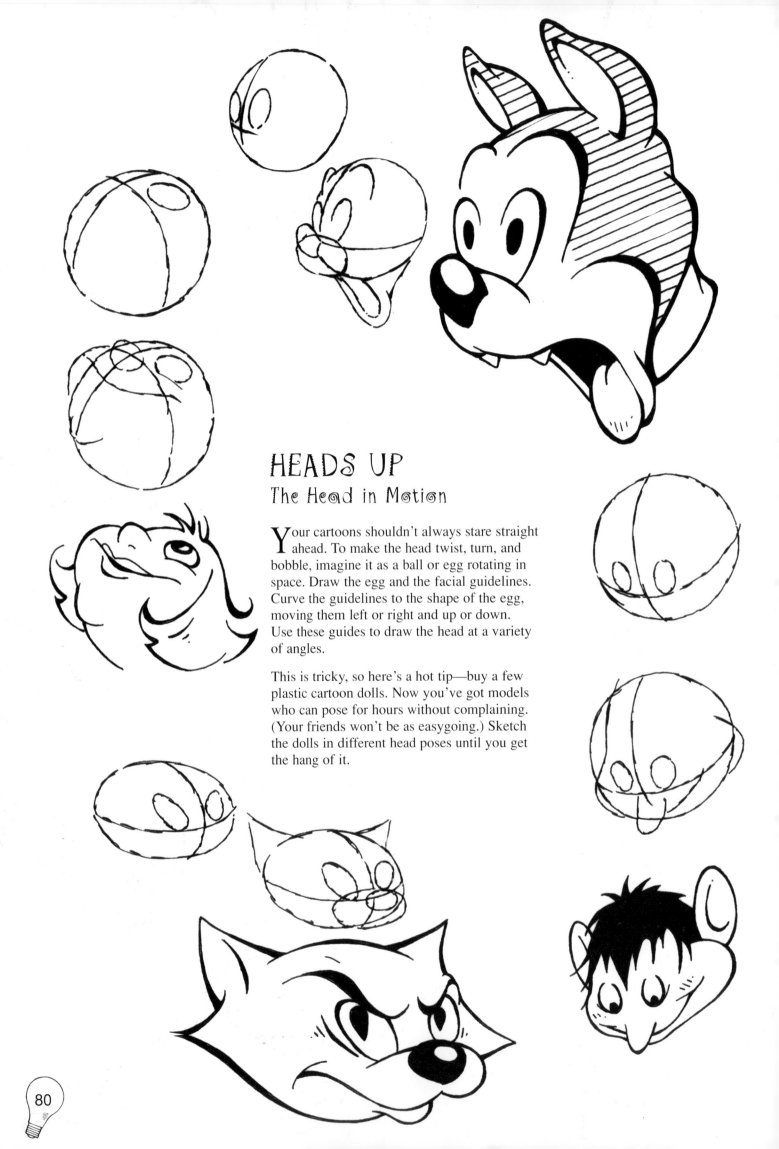

HEADS UP
The Head in Motion

Your cartoons shouldn't always stare straight ahead. To make the head twist, turn, and bobble, imagine it as a ball or egg rotating in space. Draw the egg and the facial guidelines. Curve the guidelines to the shape of the egg, moving them left or right and up or down. Use these guides to draw the head at a variety of angles.

This is tricky, so here's a hot tip—buy a few plastic cartoon dolls. Now you've got models who can pose for hours without complaining. (Your friends won't be as easygoing.) Sketch the dolls in different head poses until you get the hang of it.

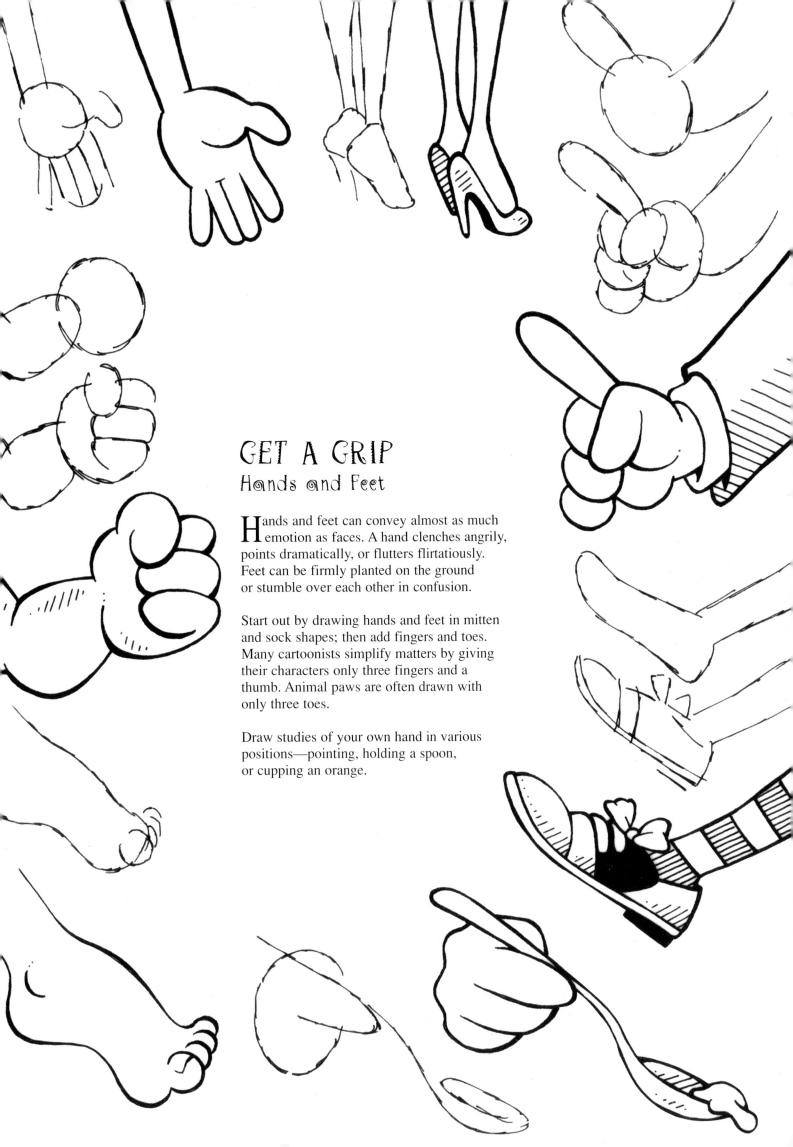

GET A GRIP
Hands and Feet

Hands and feet can convey almost as much emotion as faces. A hand clenches angrily, points dramatically, or flutters flirtatiously. Feet can be firmly planted on the ground or stumble over each other in confusion.

Start out by drawing hands and feet in mitten and sock shapes; then add fingers and toes. Many cartoonists simplify matters by giving their characters only three fingers and a thumb. Animal paws are often drawn with only three toes.

Draw studies of your own hand in various positions—pointing, holding a spoon, or cupping an orange.

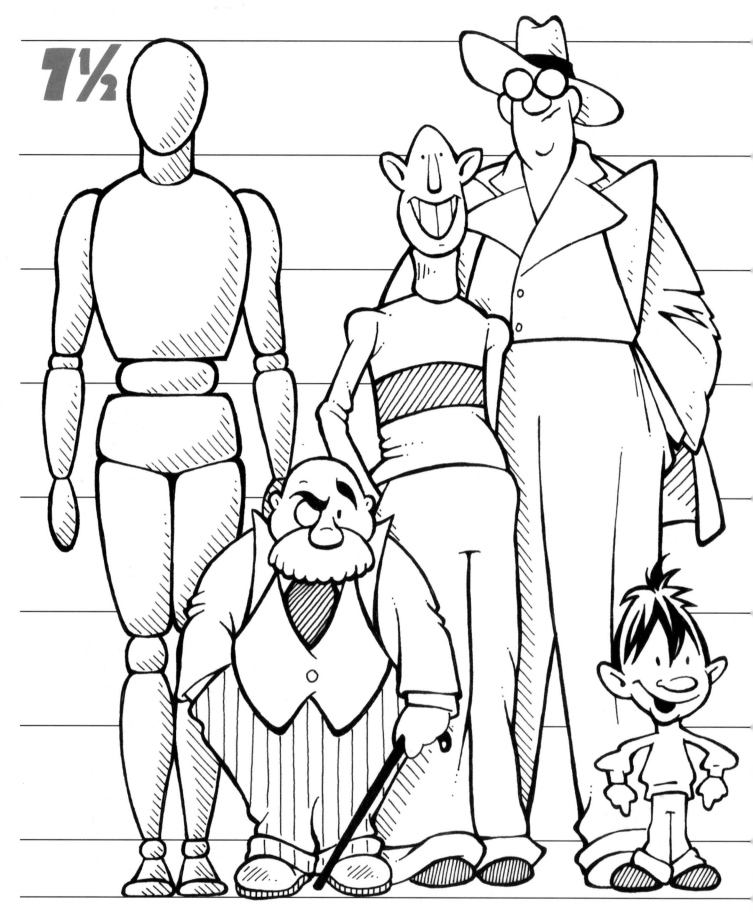

The Human Figure

When drawing a real person, use the height of the head as a unit of measurement. The average human body measures about 7 1/2 heads tall, but for artistic proportions, it's usually drawn 8 heads tall. Fashion illustrators exaggerate the length of their leggy, elegant models even more. Draw a few realistic figures from photographs or life-drawing books.

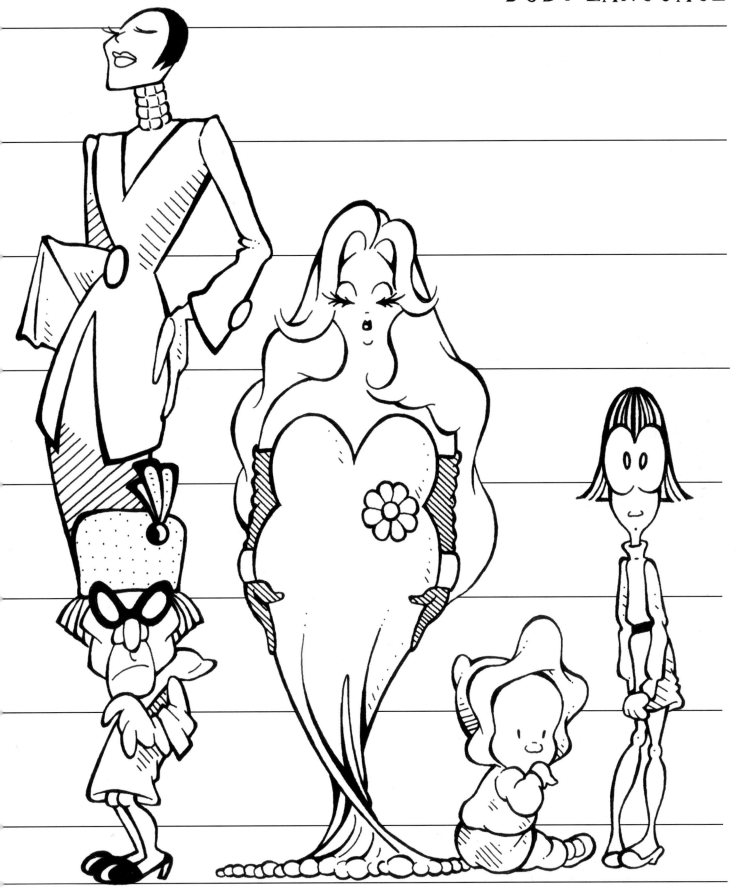

The Cartoon Figure

Cartoonists abstract and exaggerate body parts, accentuating their character's persona. A character in a cartoon may become inflated with air, stretched like a rubber band, or flattened by a steamroller. Making these effects funny and believable depends on your knowledge of anatomy. Once again, you have to know the real before abstracting it.

QUITE A CHARACTER
Personality Types

Start average Joe here as a stick skeleton. Then "flesh it out," or develop the body form. Notice that the basic skeleton results in an average guy.

Now change his personality by altering his body proportions. By drawing a larger V shape for his chest and squaring off his chin, he transforms into Super Joe.

What kind of character can you imagine?

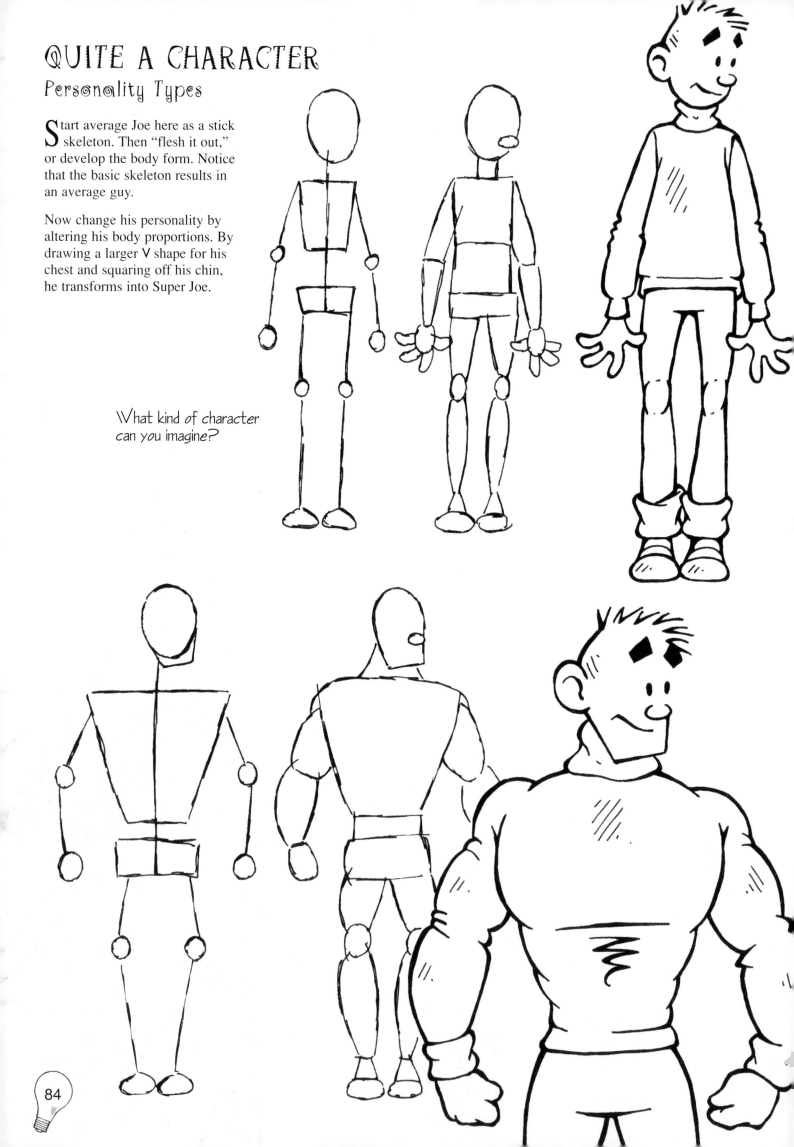

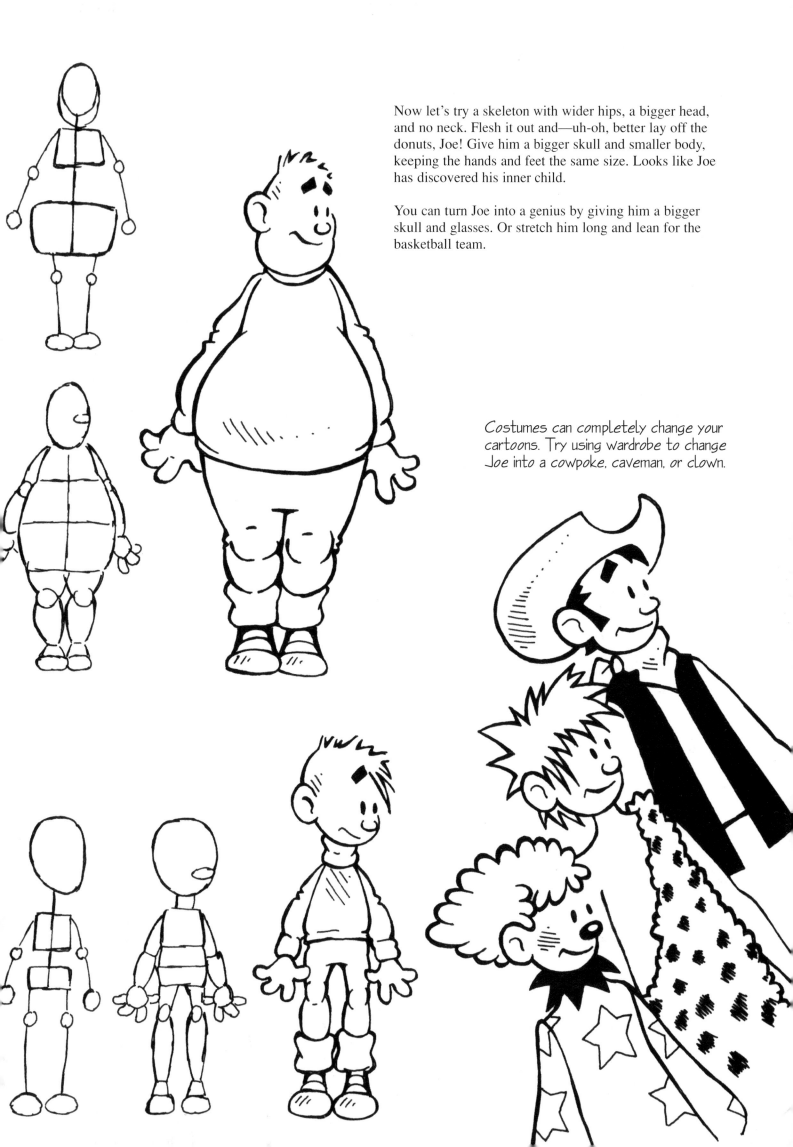

Now let's try a skeleton with wider hips, a bigger head, and no neck. Flesh it out and—uh-oh, better lay off the donuts, Joe! Give him a bigger skull and smaller body, keeping the hands and feet the same size. Looks like Joe has discovered his inner child.

You can turn Joe into a genius by giving him a bigger skull and glasses. Or stretch him long and lean for the basketball team.

Costumes can completely change your cartoons. Try using wardrobe to change Joe into a cowpoke, caveman, or clown.

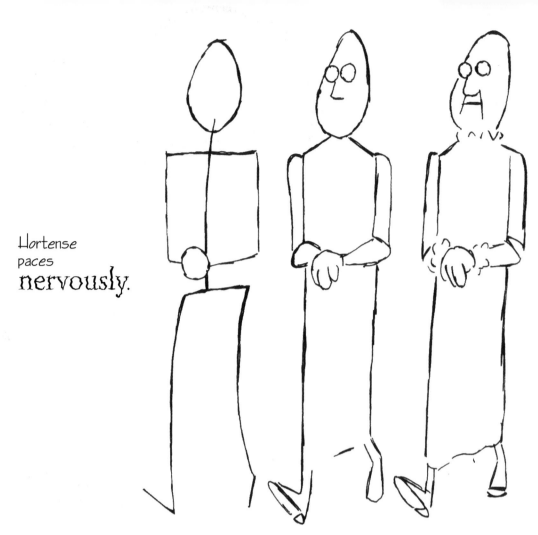

Hortense paces **nervously.**

THERE GOES THE NEICHBORHOOD
More Personality Types

Develop your cast of characters using the techniques you've learned, and interpret their personalities visually by exaggerating certain features.

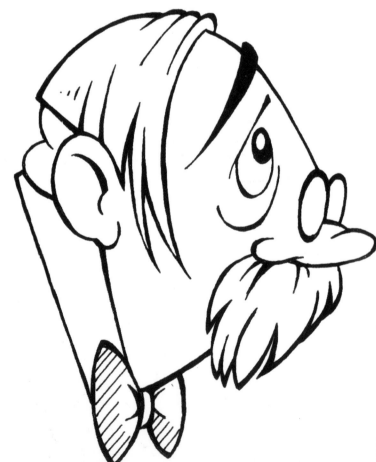

Nothing goes right for Osgood.

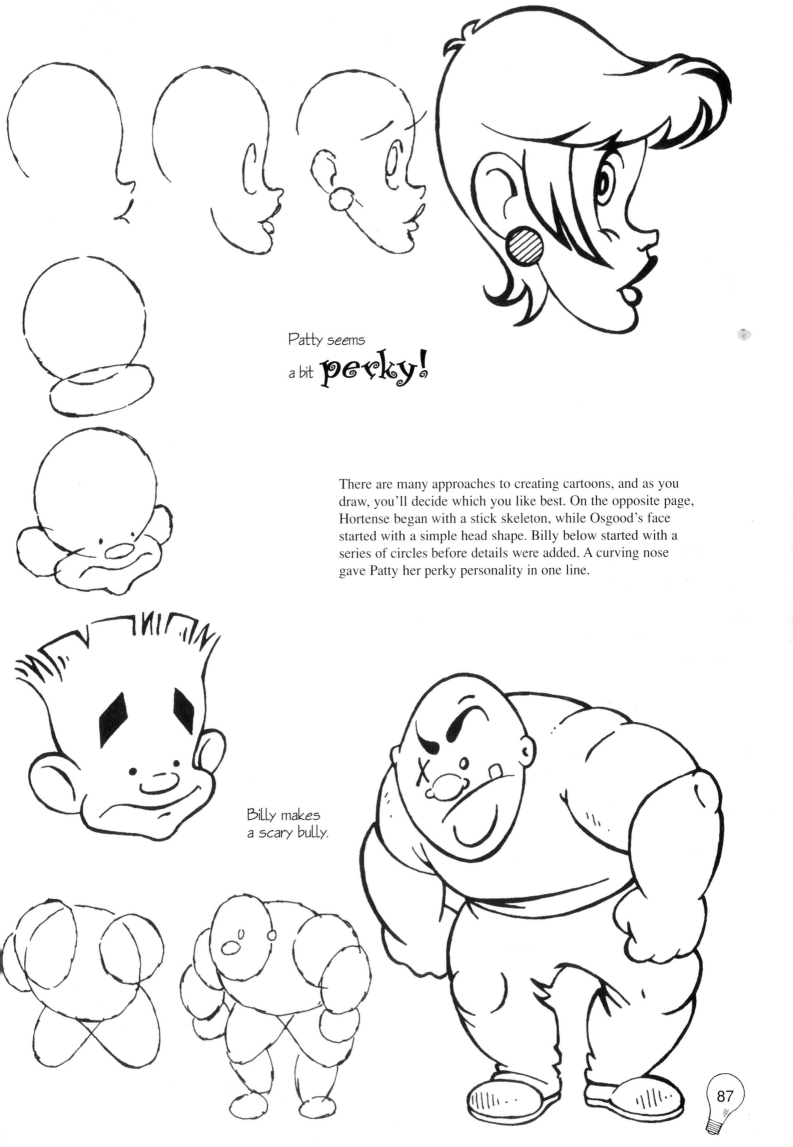

Patty seems
a bit *perky!*

There are many approaches to creating cartoons, and as you draw, you'll decide which you like best. On the opposite page, Hortense began with a stick skeleton, while Osgood's face started with a simple head shape. Billy below started with a series of circles before details were added. A curving nose gave Patty her perky personality in one line.

Billy makes
a scary bully.

GROWING PAINS
From Baby on Up

Creating a believable bouncing baby or a kid with charisma involves more than drawing a miniature adult. As people age, their bodies change.

A baby's head is large in proportion to its body. Babies have short necks and big heads, with large, widely spaced eyes. Because their lower jaws are undeveloped, their eyes are lower on the face than those of an adult. Babies also have full, pudgy cheeks, wispy hair, and light eyebrows.

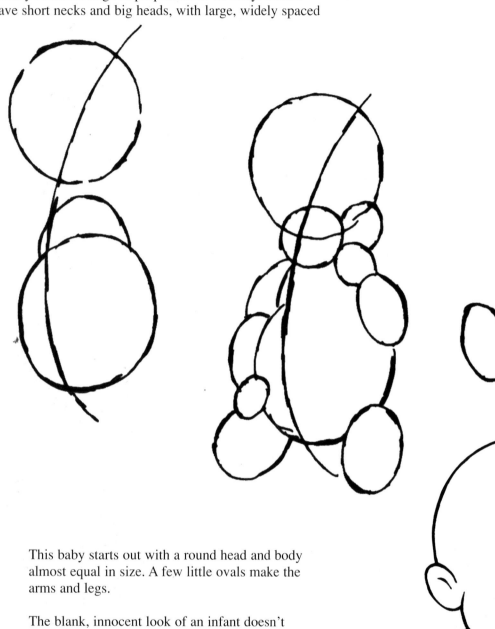

This baby starts out with a round head and body almost equal in size. A few little ovals make the arms and legs.

The blank, innocent look of an infant doesn't require many details. The cute little girl on the opposite page was drawn similarly.

The more angular, gawky teen begins with a stick skeleton. Experiment with these types of characters. Draw her first as she appears there, and then try a dramatic Cinderella transformation, adding soft curls and a pretty dress.

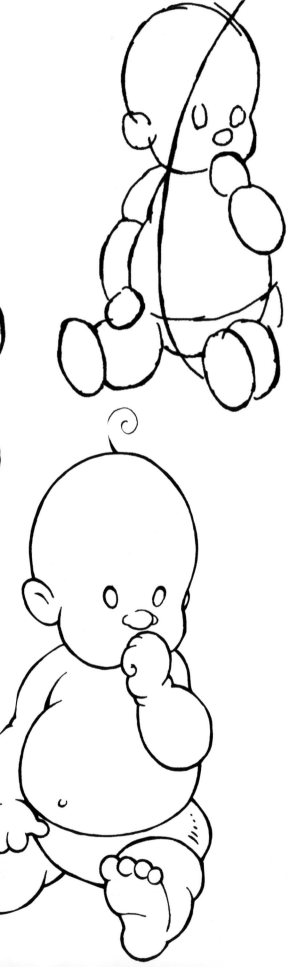

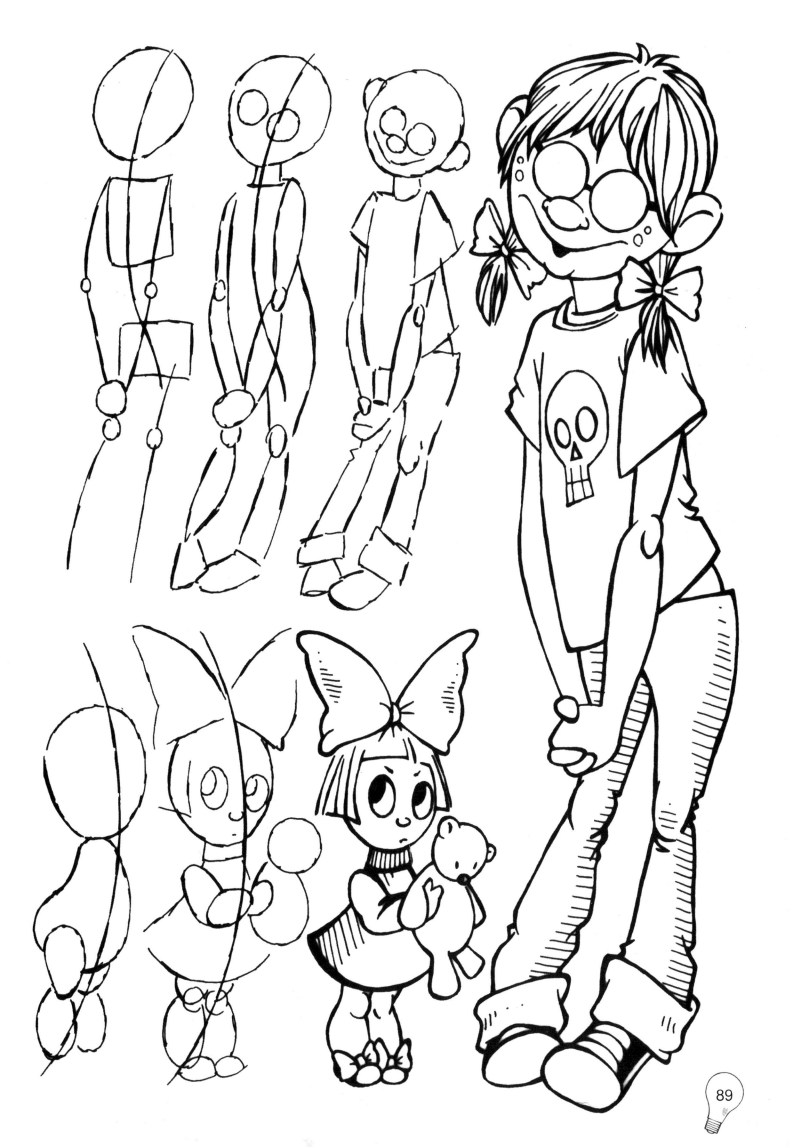

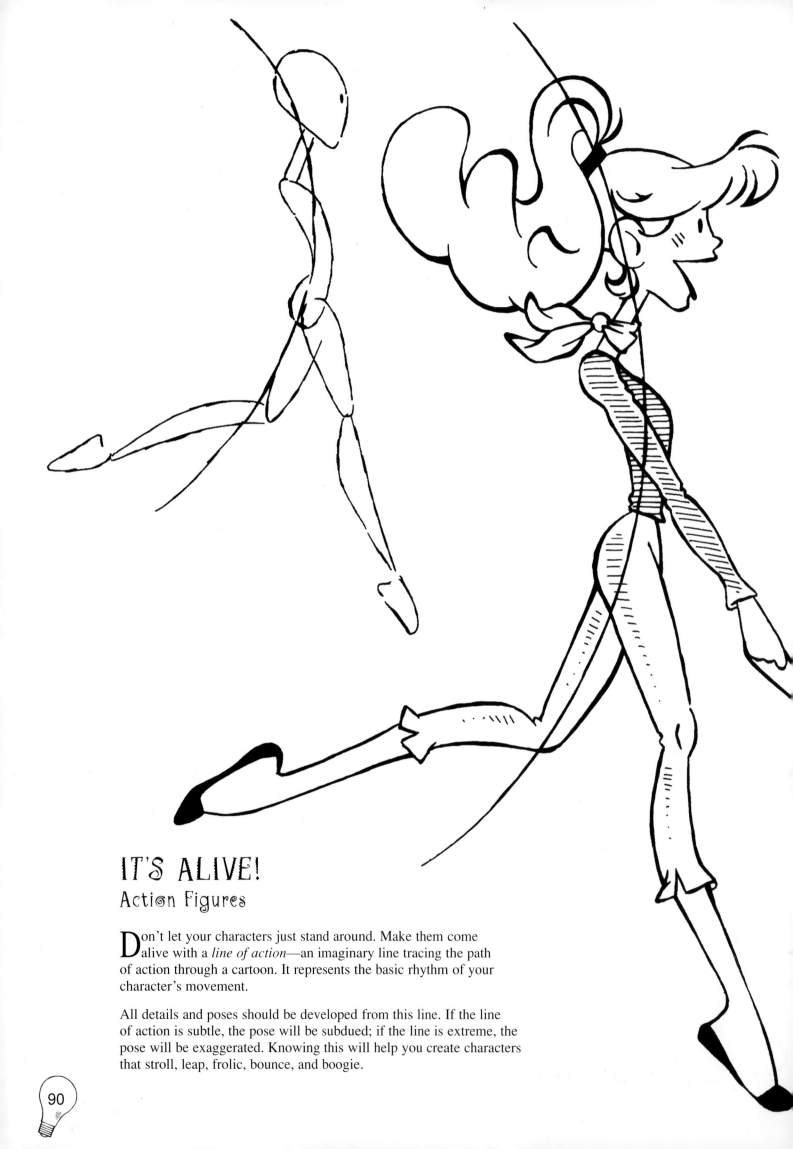

IT'S ALIVE!
Action Figures

Don't let your characters just stand around. Make them come alive with a *line of action*—an imaginary line tracing the path of action through a cartoon. It represents the basic rhythm of your character's movement.

All details and poses should be developed from this line. If the line of action is subtle, the pose will be subdued; if the line is extreme, the pose will be exaggerated. Knowing this will help you create characters that stroll, leap, frolic, bounce, and boogie.

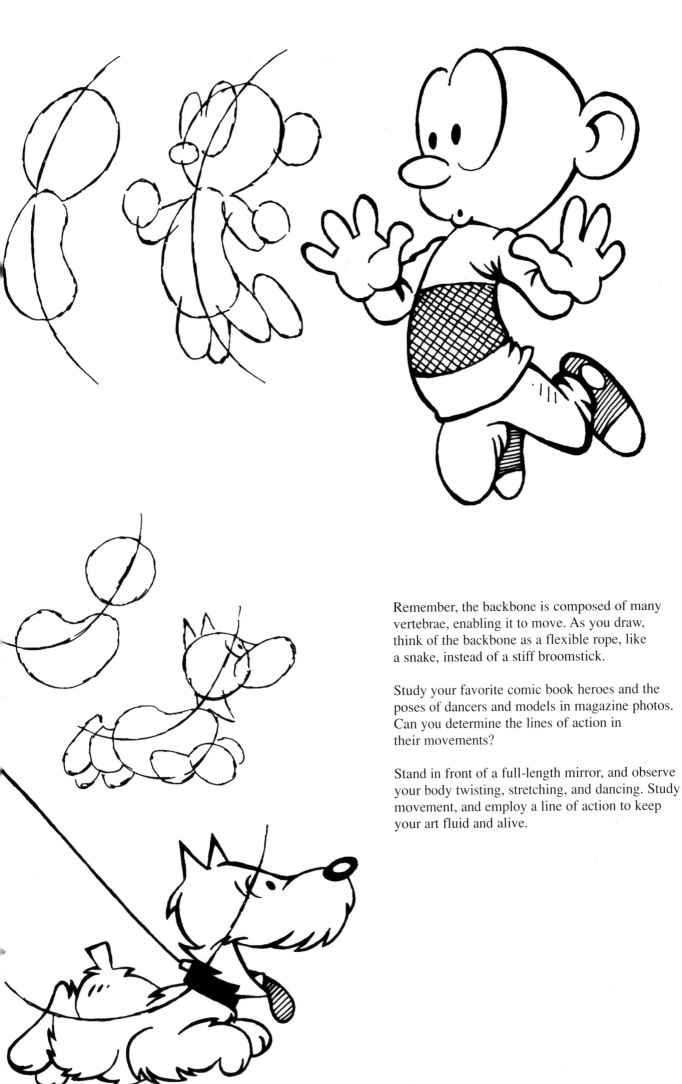

Remember, the backbone is composed of many vertebrae, enabling it to move. As you draw, think of the backbone as a flexible rope, like a snake, instead of a stiff broomstick.

Study your favorite comic book heroes and the poses of dancers and models in magazine photos. Can you determine the lines of action in their movements?

Stand in front of a full-length mirror, and observe your body twisting, stretching, and dancing. Study movement, and employ a line of action to keep your art fluid and alive.

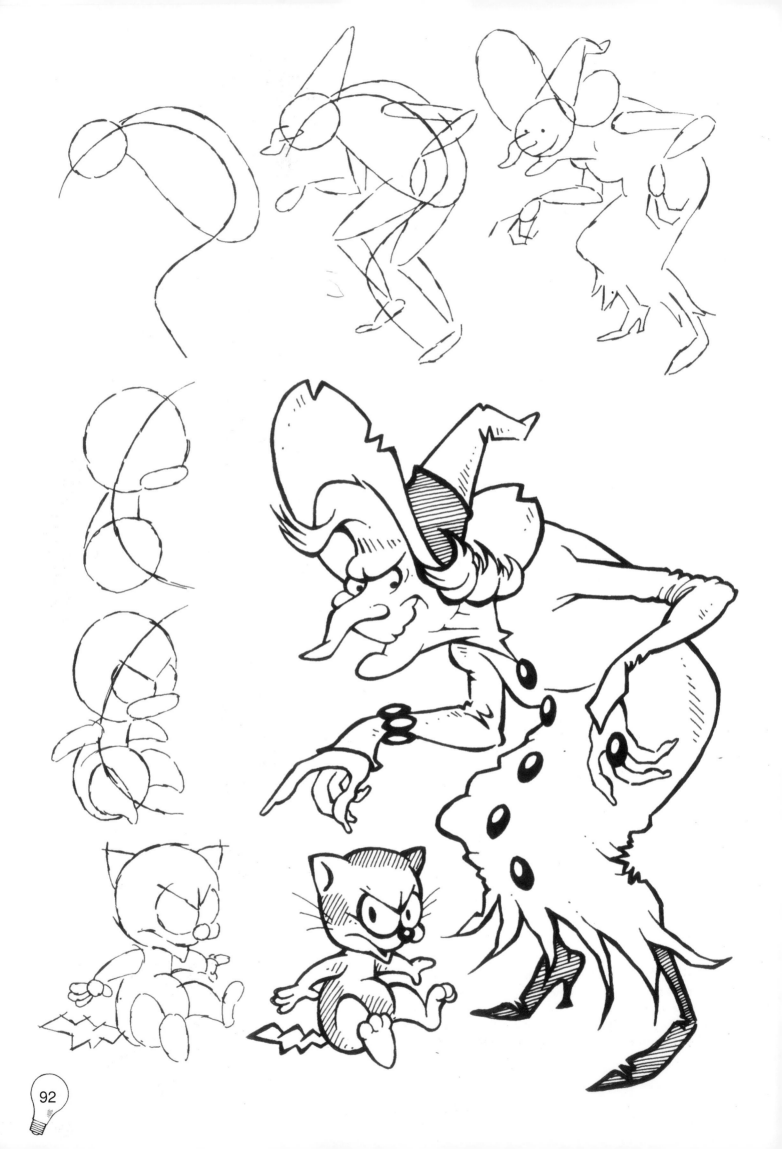

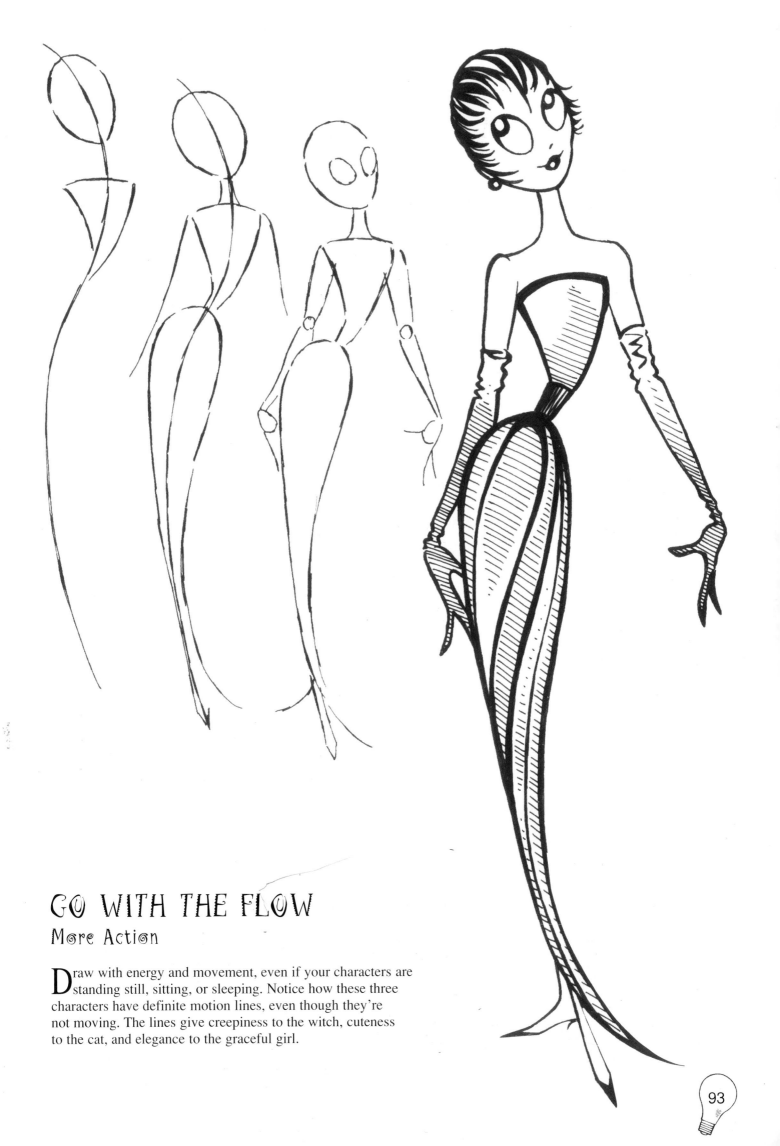

GO WITH THE FLOW
More Action

Draw with energy and movement, even if your characters are standing still, sitting, or sleeping. Notice how these three characters have definite motion lines, even though they're not moving. The lines give creepiness to the witch, cuteness to the cat, and elegance to the graceful girl.

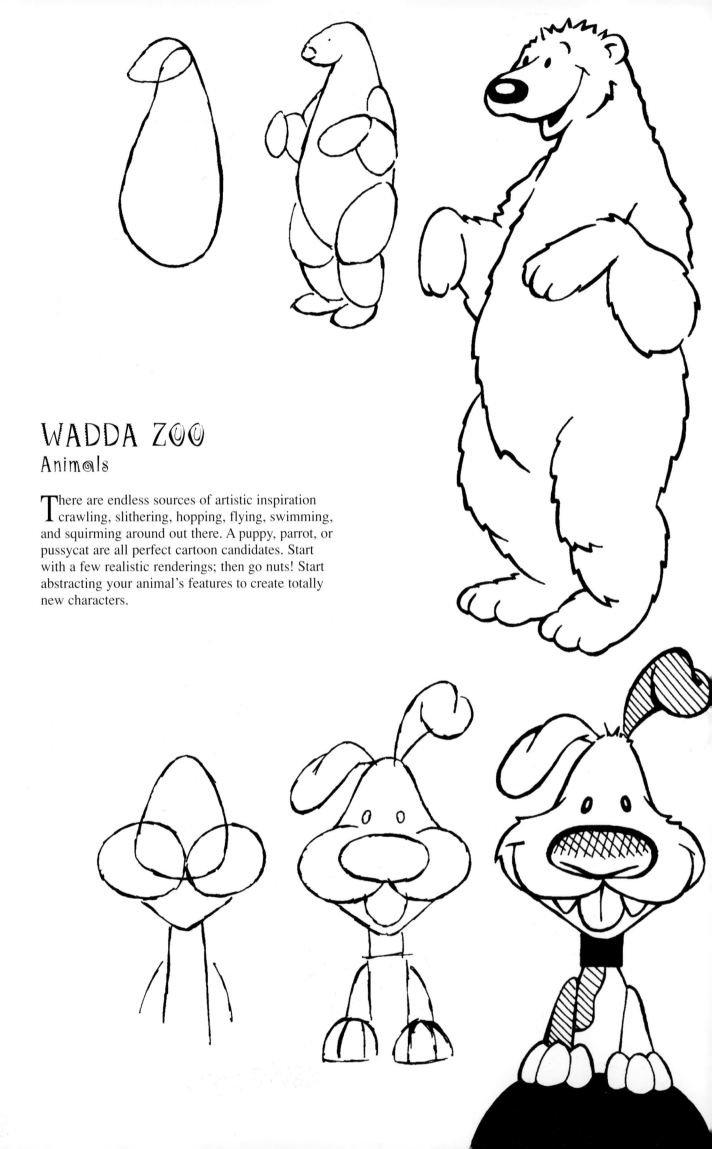

WADDA ZOO
Animals

There are endless sources of artistic inspiration crawling, slithering, hopping, flying, swimming, and squirming around out there. A puppy, parrot, or pussycat are all perfect cartoon candidates. Start with a few realistic renderings; then go nuts! Start abstracting your animal's features to create totally new characters.

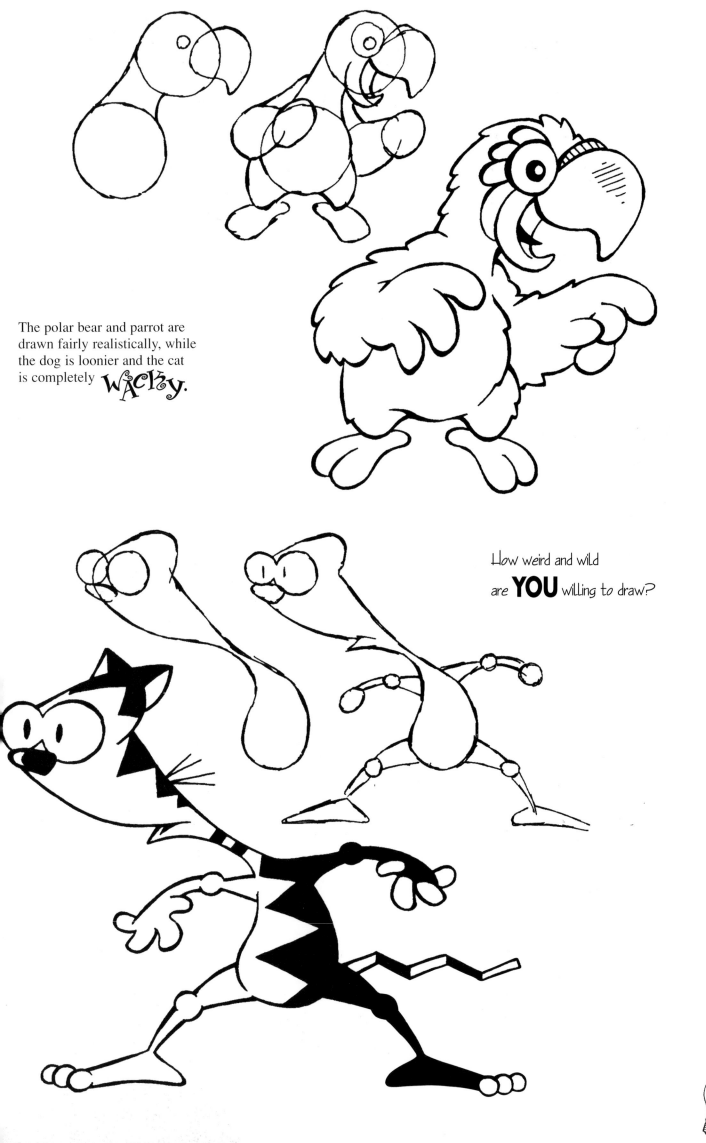

The polar bear and parrot are drawn fairly realistically, while the dog is loonier and the cat is completely WACKY.

How weird and wild are YOU willing to draw?

ANIMAL WISECRACKERS
Anthropomorphism

Applying human attributes to something like an animal, plant, or inanimate object is called **anthropomorphism.**

A wisecracking rabbit, sarcastic cat, stuttering pig, and flying squirrel in a pilot's helmet are among the humanized critters that have become cartoon stars.

Practice by drawing each of these cartoons, and then create some of your own examples. This will help you **stretch** your imagination.

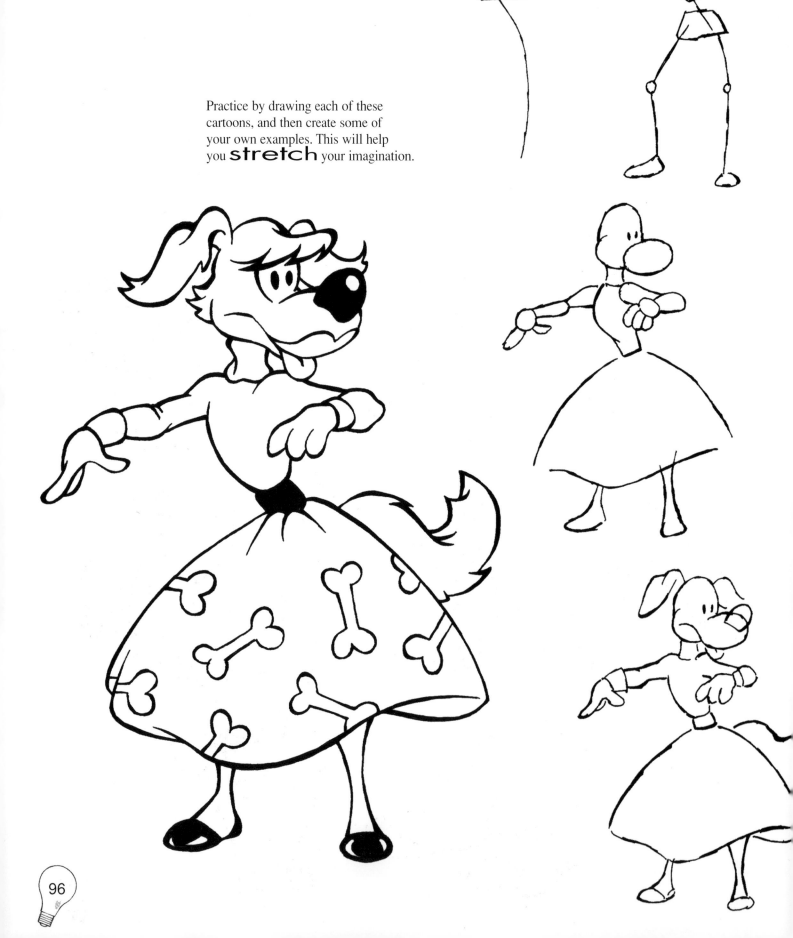

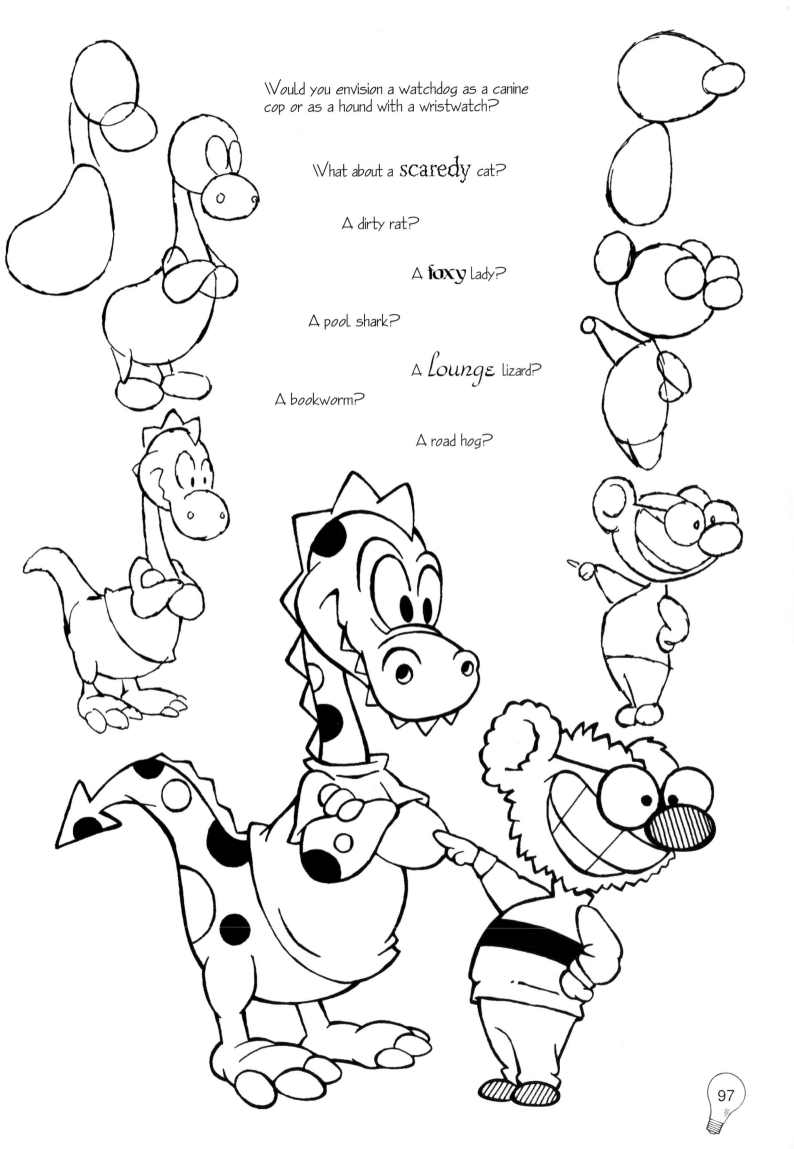

Would you envision a watchdog as a canine cop or as a hound with a wristwatch?

What about a **scaredy** cat?

A dirty rat?

A **foxy** lady?

A pool shark?

A *lounge* lizard?

A bookworm?

A road hog?

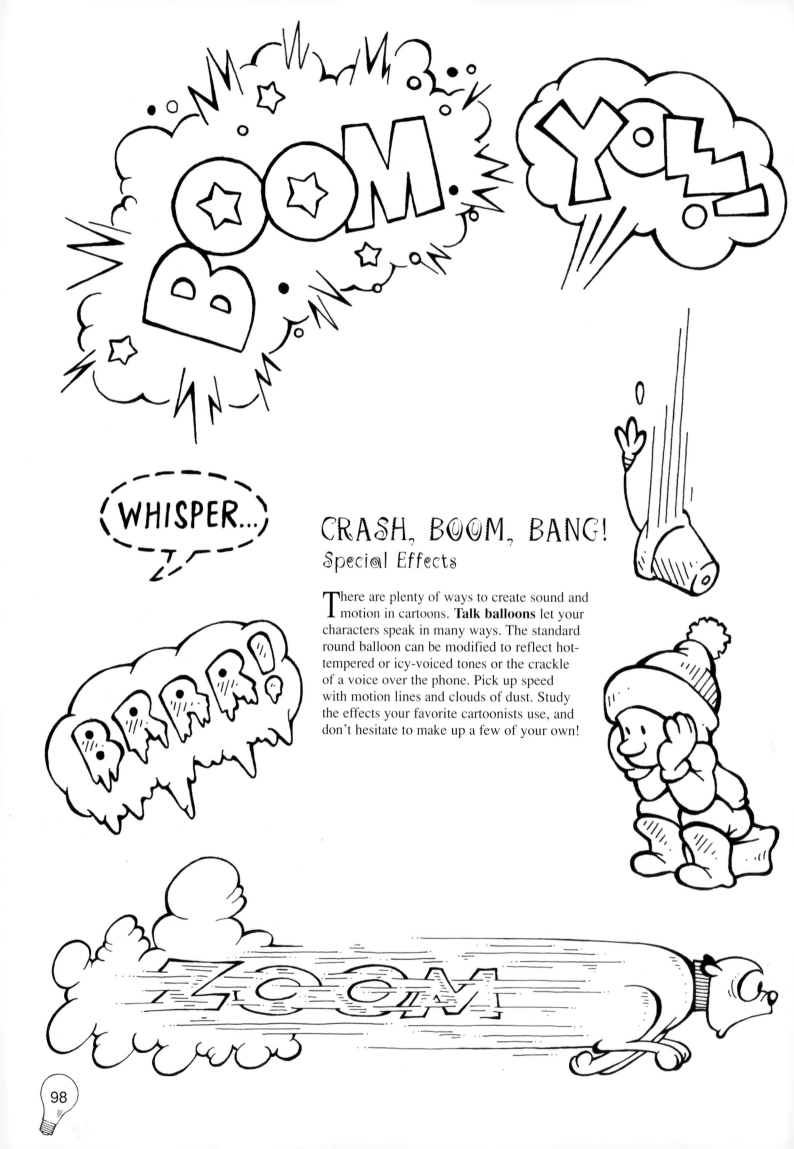

CRASH, BOOM, BANG!
Special Effects

There are plenty of ways to create sound and motion in cartoons. **Talk balloons** let your characters speak in many ways. The standard round balloon can be modified to reflect hot-tempered or icy-voiced tones or the crackle of a voice over the phone. Pick up speed with motion lines and clouds of dust. Study the effects your favorite cartoonists use, and don't hesitate to make up a few of your own!

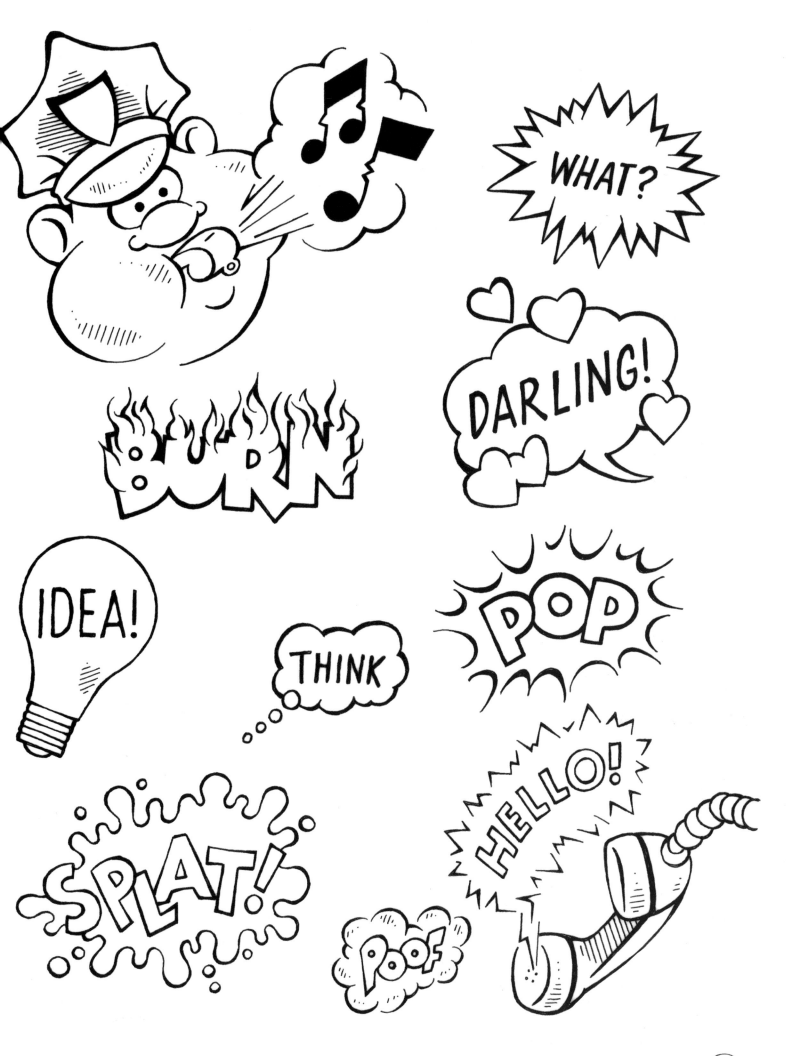

Comic Strips by Roger Armstrong

Roger Armstrong has been a cartoonist, a book illustrator, a freelance artist, and a story director for many well-known studios, newspaper syndicates, and publishing companies. During his 40-year profession, he has worked on many famous comic strips, including *Little Lulu, The Flintstones, Napoleon & Uncle Elby, Ella Cinders, Scamp,* and *Bugs Bunny.*

In addition to comics, Armstrong's artistic talents include watercolor, figure drawing, and painting. He has taught art classes at six colleges and art schools. He attended Pasadena City College and Chouinard Art Institute (now California Institute of the Arts). He is a member and past president of the National Watercolor Society, and he belongs to the National Cartoonist Society and the Comic Artists Professional Society. His work is included in the public collections of the Museum of Cartoon Art, the Smithsonian Institute, and Ohio State University, and it hangs in more than 200 private collections.

Section 5

ROGER ARMSTRONG
STRAIGHT FROM THE HORSE'S MOUTH

Roger Armstrong was only 10 when he decided that he wanted to become a cartoonist. "My grandmother was fascinated with comic strips when they were first introduced, and she pasted the very earliest ones in ledgers," Armstrong remembers. "So I learned from the first of the comic strip artists, including the artists of *Bringing Up Father* and *Mutt and Jeff*."

"I heard that cartoonists made a lot of money and didn't have to work very hard, so I decided that was the job for me," Armstrong jokes. "As it turned out, neither was true, but I enjoyed the work!"

Armstrong has plenty of valuable tips for aspiring cartoonists. "Be dependable," he begins. "In 50 years of drawing comic strips, I never missed a deadline. My clients knew they could count on me; it was one of my stocks in trade."

His second bit of advice is to learn to find ideas in ordinary events. "Part of the cartoonist's talent is the ability to watch and see," he says. "Take everyday ideas and adapt them. You need to develop that sort of mind to succeed in gag work. Some people are born able to see humor in anything; others have to work at it."

"Never be without a sketchbook," the artist adds. "Draw whatever is put in front of you. If you're at a restaurant, draw the table setting in front of you or the lady at the next table. You never know when you might use the drawing later as inspiration for a cartoon. It is important to have reference material. Since almost no one has a photographic memory, begin to collect a morgue of drawings and clippings of things you want to use someday."

Finally, Armstrong says to remember that you never know who might be able to help you one day. When he was 15, he borrowed a friend's truck and drove to the home of *Napoleon* originator Clifford McBride.

"*Napoleon* was my favorite comic strip ever," he says. "Luckily, McBride humored me. I haunted him until he finally let me do simple lettering and backgrounds for him. But while I worked for him, I learned how to use a pen and how to ink a drawing."

Years later, when McBride died, his widow asked Armstrong to draw the strip. That assignment continued for more than a decade. "This life consists of people you meet along the way who open doors for you in later occasions in life," Armstrong notes. "It is wise to treat others with the respect you hope to earn."

CREATING COMIC STRIP THEMES AND CHARACTERS

When creating a comic strip, you are inventing an entire world! It isn't much different from a motion picture production except that you are the whole production—you are the producer, director, actors, costume designer, set decorator, and the total production supervisor. You also write the script and control the dialogue.

Choosing a Theme

Don't make a slavish copy of an existing feature; come up with something new. Of course, it is difficult to think of something completely new or different, but there are many themes that have not been tried in comic pages. Editors say that talking animals are hard to sell, but look at Snoopy, Krazy Kat, Pogo, Garfield, Heathcliff, and Bugs Bunny, not to mention the champion of them all—Mickey Mouse! So don't be discouraged in your search for a theme.

Creating the Characters

When creating the principal characters, look for something that you are familiar with. Remember not to copy an existing comic; look for a fresh idea. Decide what you draw best, and then let that be your character. Do you prefer animals or humans, children or adults, or something completely different? Think in terms of basic, recognizable shapes. The opposite page contains basic shapes that are instantly identifiable—even in silhouette.

Developing a Format

There are two basic formats in comic strips; one is the **continuity strip** (adventures or "soap opera" concepts), the other is the **gag-a-day strip**. The deadlines for both are relentless, constant, and demanding. From my experience, the continuity strip is by far the easier of the two. After the strip is launched, the days, weeks, months, and years stretch out before you in an unbroken line. If you have skill writing dialogue and have a sharp narrative sense, you will find it much easier to meet deadlines with the continuing story strip. On the other hand, if you have a good gag mind and funny ideas come to you easily, you should probably develop a gag strip. The advantage of the gag-a-day strip is the freedom to have countless different characters and situations.

Creating a Concept and Character Research

Cartoonists think that drawing is the most important part of the comic strip. This is an erroneous idea; *cartoonists* might condemn or approve of another cartoonist's feature based on the quality (or lack thereof) of the drawings, but the *readers* are more interested in the words and the message of the strip. This is not to say that good drawing isn't essential; but good ideas and writing still account for at least 50 percent of the strip's success.

If you are planning a gag-a-day strip, you must think about gags constantly. Every situation, every idle remark, every conversation has the capacity to become the source of a funny gag. You must train yourself to become an objective observer who recognizes potential gags at all times.

It is also of paramount importance to learn to write. If you decide to write a **narrative** (continuity) strip, it is important to learn the mechanics and construction of storytelling: how to create suspense, when to withhold the plot line and expose it by degrees, and how to keep your reader coming back day after day to find out what will happen next. You must fulfill the reader's expectations. Your plotting and sequences must be logical, but the more story twists and unexpected directions of sequence and dialogue you can come up with, the happier the reader will be. Read and study comic strips in both genres—the narrative continuity strip and the gag-a-day strip—to decide which is best suited to you.

You might find that the narrative is easier to write because you can plot out an ongoing theme that takes your character into a certain situation, and then in the last week of the sequence you can introduce a "hook" for the next episode. An example might be a new character who appears during the last week and sets the stage for the next sequence. When plotting the sequence, it is helpful to first plot the entire sequence, being certain to bring the whole series of actions to a satisfying conclusion that leads logically to the next series of episodes. Then break it down into the number of weeks you'll need to tell the complete story. Finally, break it down into daily segments.

There are two ways to plan the story. One method is to type your story as if you were writing a movie script—one page for each day. The other method is to make a **storyboard** using thumbnail sketches. The storyboard can be done on plain paper, one for each day of the week. Draw the number of panels you will need (you can have a variety of panels, depending on the needs of your story). Then write in the dialogue; this can be just roughed in, since only you will see it. Finally, draw in the characters (this can also be done roughly). Staple each week together for the entire script, and you're ready to begin drawing the finished work.

MECHANICS

In both comic strips and comic books, the outer shape of the cartoon is a constant and must be maintained for the mechanics of the book or newspaper. But any breakdown within the basic format is permissible. As a general rule, it is better to have a center cut in the strip, as this increases the strip's salability. The newspaper is more motivated to buy a strip that can be used in either strip or block form.

Each syndicate has its own mechanics for the breakdown of its Sunday comics page. This is to make your feature available to the subscriber newspapers in (1) one-half page, (2) one-third page, and (3) tabloid format.

1/2 Page—Three banks of panels.

However, if the center-cut format inhibits your creativity, you can be more flexible with the random panel ideas, breaking the strip into any sizes or shapes you wish. Just remember: you will lose the potential of selling to an editor who wants to run your feature as a box.

1/3 Page—Drop the top bank of the panels; the story or gag must begin in the first panel of the second bank.

Tabloid—The story starts at the X. The panel break is at the heavy line. The last panel of the second bank and the first panel of the bottom bank combine.

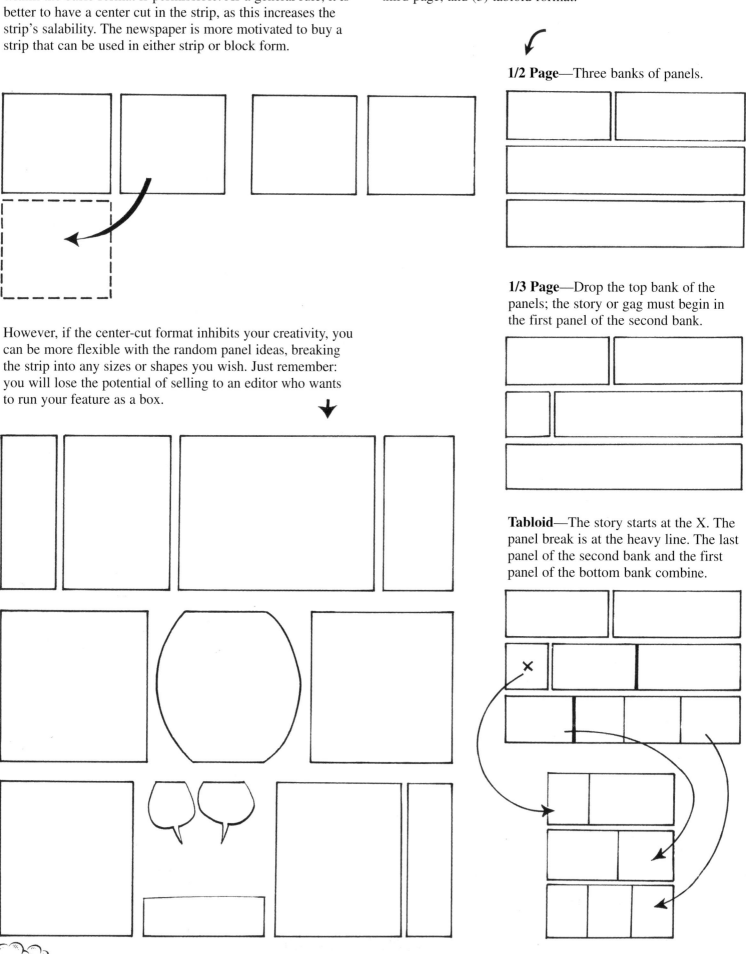

LETTERING

Lettering and the balloon are extremely important parts of successful comic strips. A good, legible lettering style that communicates well is essential to the success of your strip. The balloon also contributes to the strip's personality. Some cartoonists use offbeat lettering, allowing the style itself to enhance the content of the balloons: a notable example was the late Walt Kelly's *Pogo* strip. In the *Barnaby* strip by Crockett Johnson, the lettering was typeset and stripped in by the artist. In *Gasoline Alley*, a lowercase style is used, which is entirely different from the usual blurb style.

In the interest of simplicity and direct communication, you will be safest using the standard balloon letters.

STANDARD BALLOON LETTERING

ABCDEFGHIJKLMN
OPQRSTUVWXYYZ ?!!

ITALIC

ABCDEFGHIJKLMN
OPQRSTUVWXYZ ?!!

BOLD

ABCDEFGHIJKLMN
OPQRSTUVWXYZ ?!!

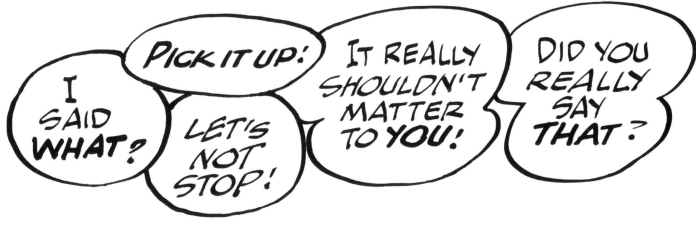

The shapes of the letters in the alphabet are built on three basic design elements.

Be sure to allow plenty of "air" in letter forms that tend to close up.

TRIANGLE CIRCLE SQUARE

HENCE: A RATHER THAN: A

LETTERING GUIDES

Your lettering should be easy to read. That's where lettering guides come in. Lettering guides are faint lines, drawn either directly on the page or placed under your art to allow you to create letters in the size and location you desire. There are lettering triangles that feature small holes into which you place the point of your pencil and run it back and forth along a T square. The holes are calibrated to let you choose whatever size and space you want your letters to have.

The wheel rotates to the desired position.

This is a lettering triangle with pencil holes.

Some syndicates provide ready-made strips that have dots up and down the left sides of the panels. Again, place the T square on the dots and run the pencil horizontally along the T square.

The simplest method I have found is to draw your lettering guides on clear acetate sheets, like the cels used in animation studios, and do your lettering over a light board. You can also use tracing paper in place of a cel, but the virtue of a cel is its permanence.

Another method is to make a ruling guide by penciling in correctly spaced guidelines along the edge of a piece of Bristol board.

LETTERING BALLOONS

A very important part of lettering is drawing the balloon. There is as much personality to the balloon as to the letter forms themselves. Each cartoonist develops the balloon to fit the personality of the characters and the feature.

One of the important aspects of the balloon is the need for plenty of space around the lettering. There is nothing that inhibits reading the dialogue more than a "tight" balloon.

Establish the lettering first! Remember, this part of the strip is what the readers see before they look at the drawings.

Visualize how your characters are going to interact with their lettered dialogue.

Place the lettering in such a way that the characters fit in comfortably. (You may have to juggle the balloons.)

Adapt the size of the characters to the length of the dialogue in closeups, single shots, two shots (two characters in one panel), and long shots (see page 118).

STANDARD BALLOONS

Remember to keep the balloon simple. Don't get fancy. The dialogue is important—the balloon just delivers the message.

Long balloons may require long shots. Shorter balloons will permit closeups, two shots, etc.

Balloons can take on many shapes.

Make the balloon conform to the shape of the lettering.

Sometimes, a character has two thoughts that become awkward in a single balloon. When this happens, it is more effective to make two balloons.

Some cartoonists favor no balloons.

Round off at the corners of the panels.

Characters may say the same thing simultaneously.

ECCENTRIC OR SPECIALIZED BALLOONS

The shape and style of the balloon can help emphasize the tone and indicate the source of the message.

ZZIPPP!!

?

WHISPER

RADIO OR TELEVISION.

USE ITALICS FOR *LIGHTER* BUT **IMPORTANT** EMPHASIS!

COMBINATION OF LIGHT AND **BOLD** LETTERING FOR ***EMPHASIS!***

MEANWHILE, THE TWO CHARACTERS DISCUSS THEIR PLAN...

CONTINUING BALLOONS FOR UNRELATED THOUGHTS...

BUT, ON THE OTHER HAND...

Omit balloons for narration between panels.

THOUGHT.

OOH! WHAT HE SAID!

!!

IDEA

FROSTY.

GRIEF...

DARK THOUGHT

DRAWING HEADS

The three important views of the head are frontal, three-quarter, and profile (side view). In the drawings below, the center line marks the central division point for the features.

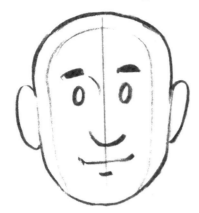 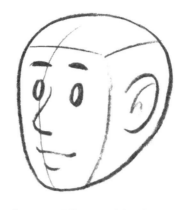 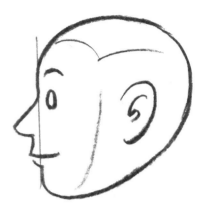

1. Frontal View—This is the most difficult view to draw because the face needs to be **symmetrical**—that is, evenly shaped on both sides.

2. Three-Quarter View—This view is easier to draw because the nose protrudes from the face instead of being flat to the head. The center line has shifted to accommodate the eyes, nose, and mouth on the front plane. The ear is on the side plane.

3. Profile View—Here the center line has shifted and is now the frontal dividing line. This is difficult to draw because you have only half of the features and a great expanse of the uninteresting side of the head.

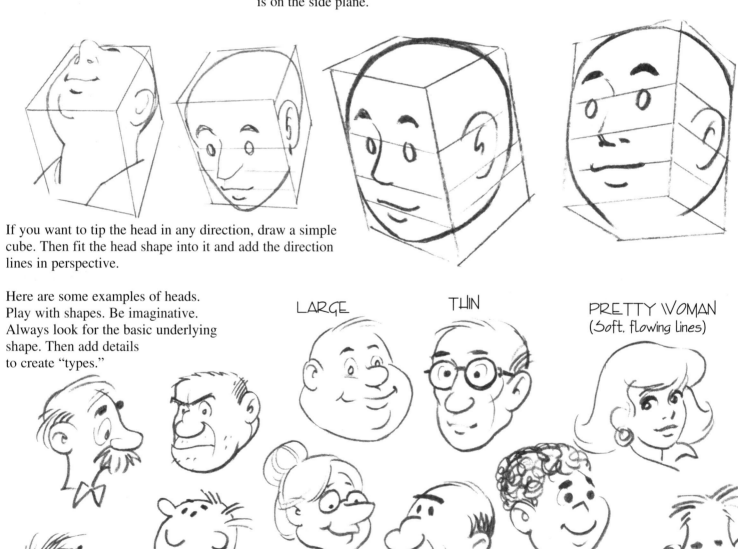

If you want to tip the head in any direction, draw a simple cube. Then fit the head shape into it and add the direction lines in perspective.

Here are some examples of heads. Play with shapes. Be imaginative. Always look for the basic underlying shape. Then add details to create "types."

LARGE

THIN

PRETTY WOMAN
(Soft, flowing lines)

GESTURES AND EXPRESSIONS

An understanding of human expressions is very important to the success of your drawing. The body language of a character establishes an expressive cartoon emotion. Here are a few examples.

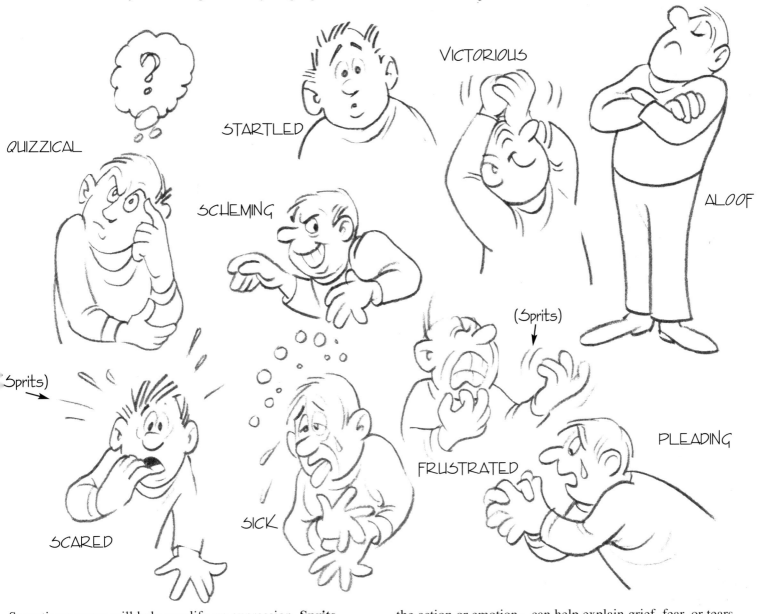

QUIZZICAL

STARTLED

VICTORIOUS

ALOOF

SCHEMING

(Sprits)

Sprits)

PLEADING

FRUSTRATED

SCARED

SICK

Sometimes props will help amplify an expression. **Sprits**— the marks drawn outside the character's outline to emphasize the action or emotion—can help explain grief, fear, or tears of laughter.

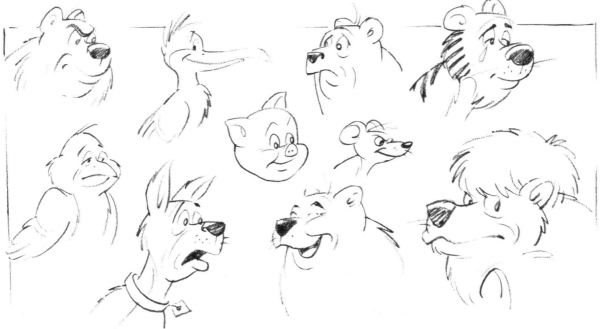

The same expressions can translate to animals and birds.

CREATING SIMPLE COMIC FIGURES

Here is a very simple lesson in anatomy: The figure can be broken down into three basic shapes that are self-contained (where there are no moving parts). These shapes are the head (skull), the rib cage, and the pelvic area.

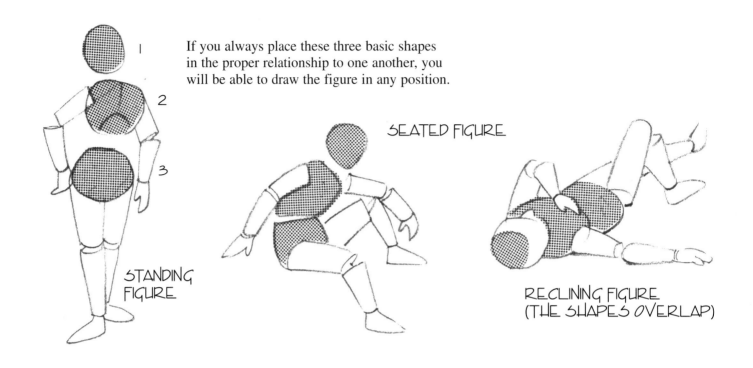

If you always place these three basic shapes in the proper relationship to one another, you will be able to draw the figure in any position.

STANDING FIGURE

SEATED FIGURE

RECLINING FIGURE (THE SHAPES OVERLAP)

The arms and legs become appendages. Think in terms of a tapering pipe attached to the rib cage and the pelvic area.

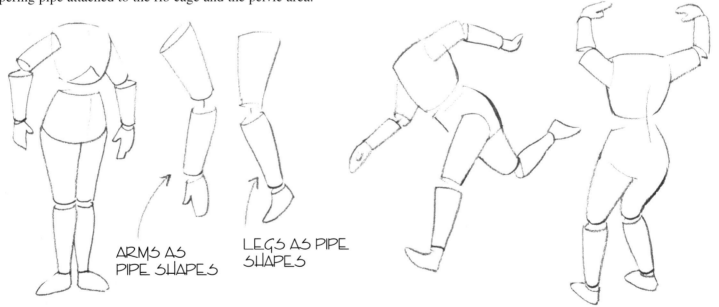

ARMS AS PIPE SHAPES

LEGS AS PIPE SHAPES

If you follow this simple formula, the human figure is easy to draw—in any position. Hands and feet can be simple shapes.

Look for the planes.

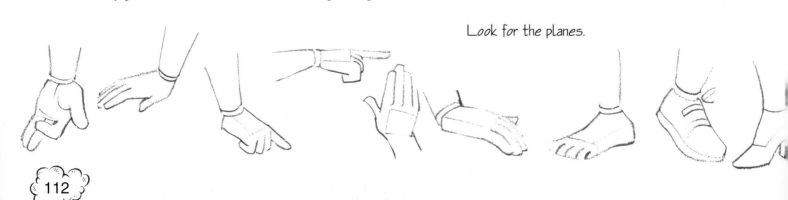

Now translate this into comic characters:
the rib cage and pelvis become one shape.

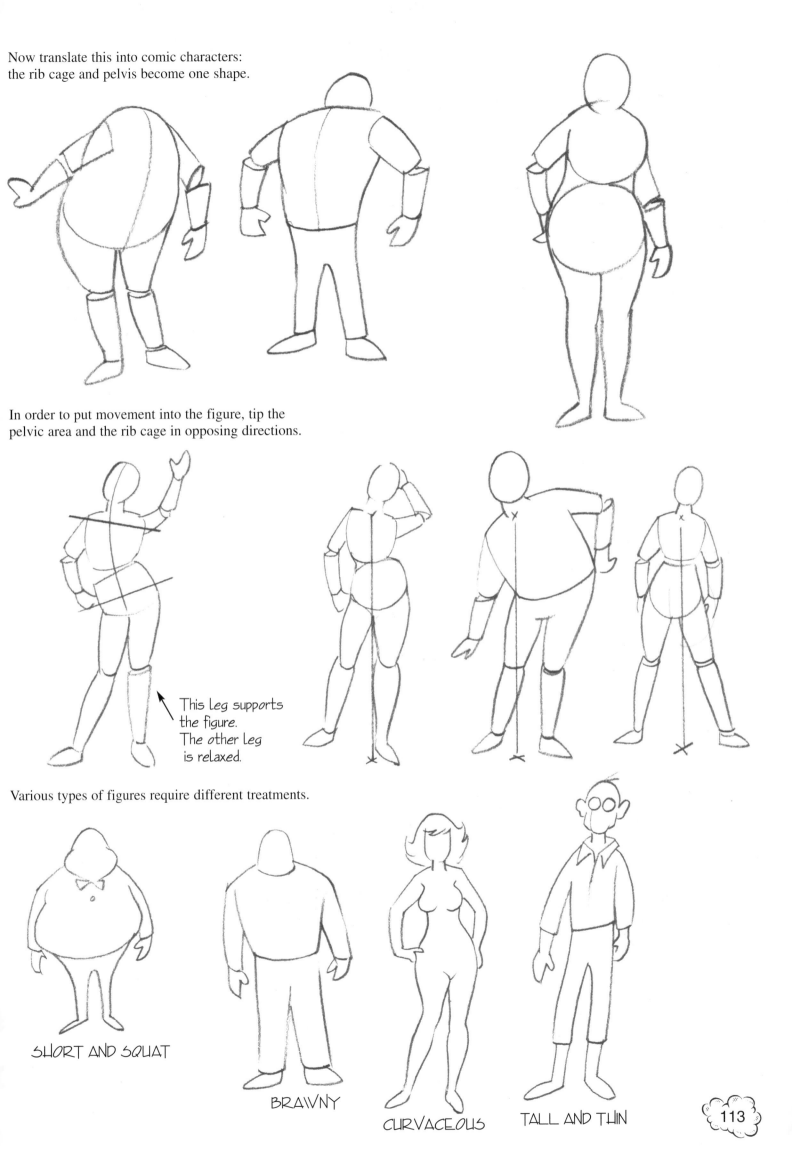

In order to put movement into the figure, tip the
pelvic area and the rib cage in opposing directions.

This leg supports
the figure.
The other leg
is relaxed.

Various types of figures require different treatments.

SHORT AND SQUAT

BRAWNY

CURVACEOUS

TALL AND THIN

ACTION LINES

To create action, use directional lines for the major thrust of the body, and then build the character's form around the lines.

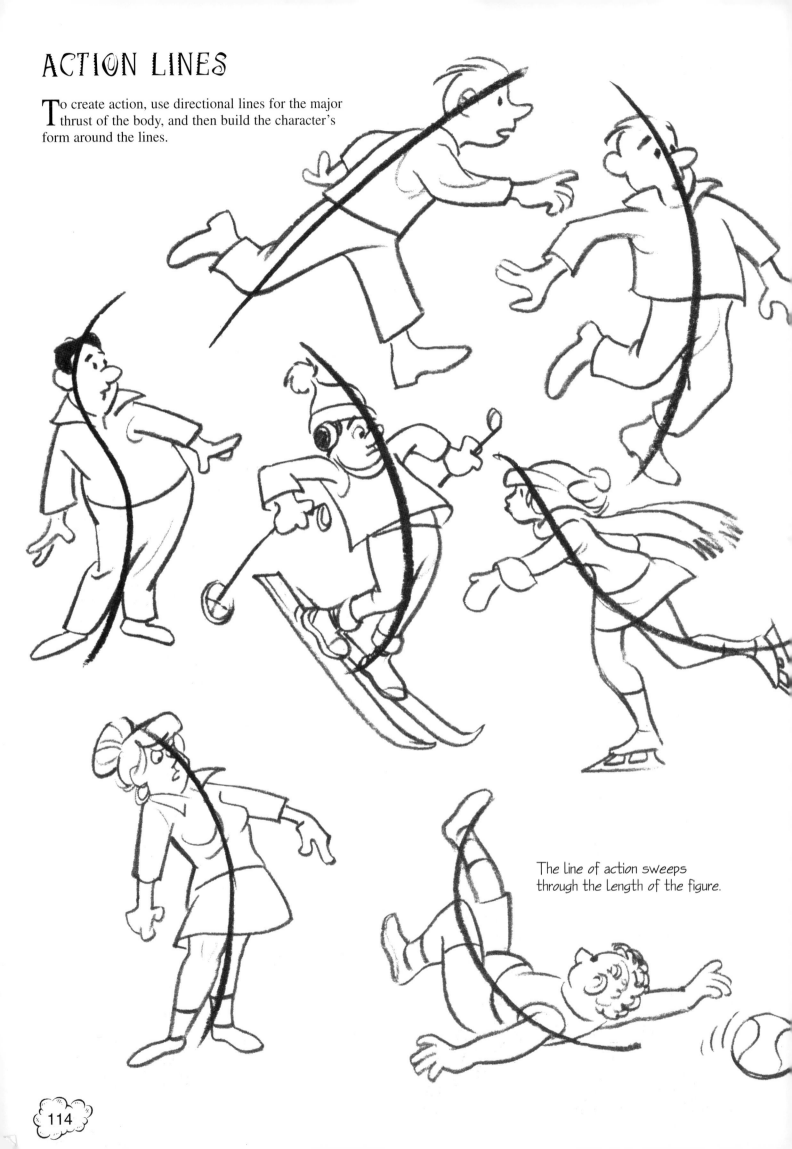

The line of action sweeps through the length of the figure.

IMAGINATIVE ACTION

Drawing a static pose is easy, so exercise your imagination to create dynamic action! Any pose you draw can stand exaggeration. Remember, cartooning requires drawing that goes beyond the norm. Push your action poses to the extreme! Below are a few examples for you to study.

Characters in groups look more interesting when the characters' corresponding body parts differ.

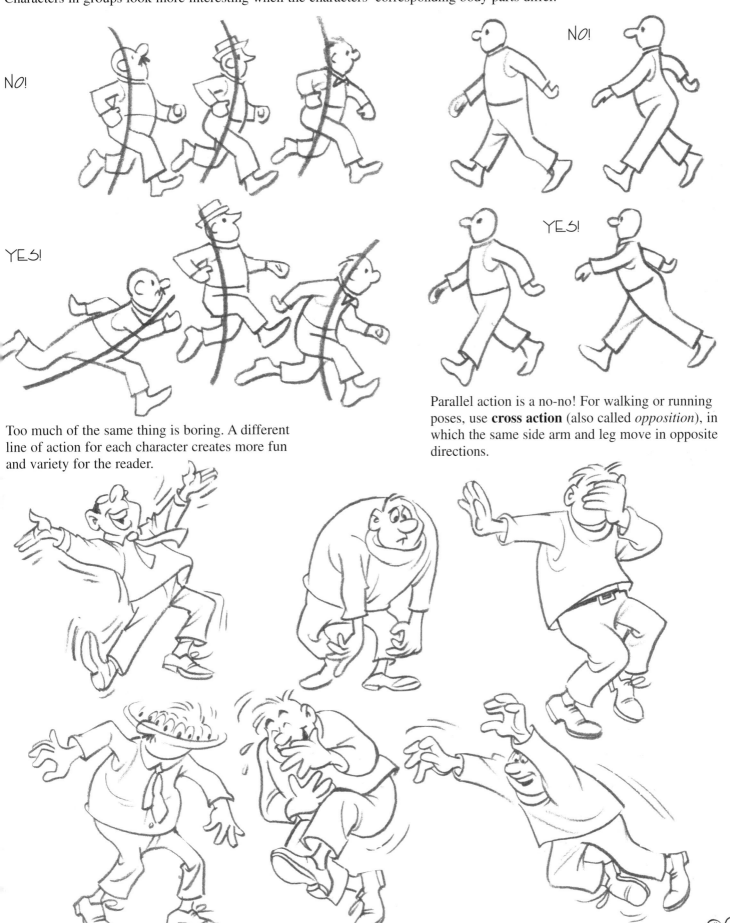

NO!

YES!

Too much of the same thing is boring. A different line of action for each character creates more fun and variety for the reader.

NO!

YES!

Parallel action is a no-no! For walking or running poses, use **cross action** (also called *opposition*), in which the same side arm and leg move in opposite directions.

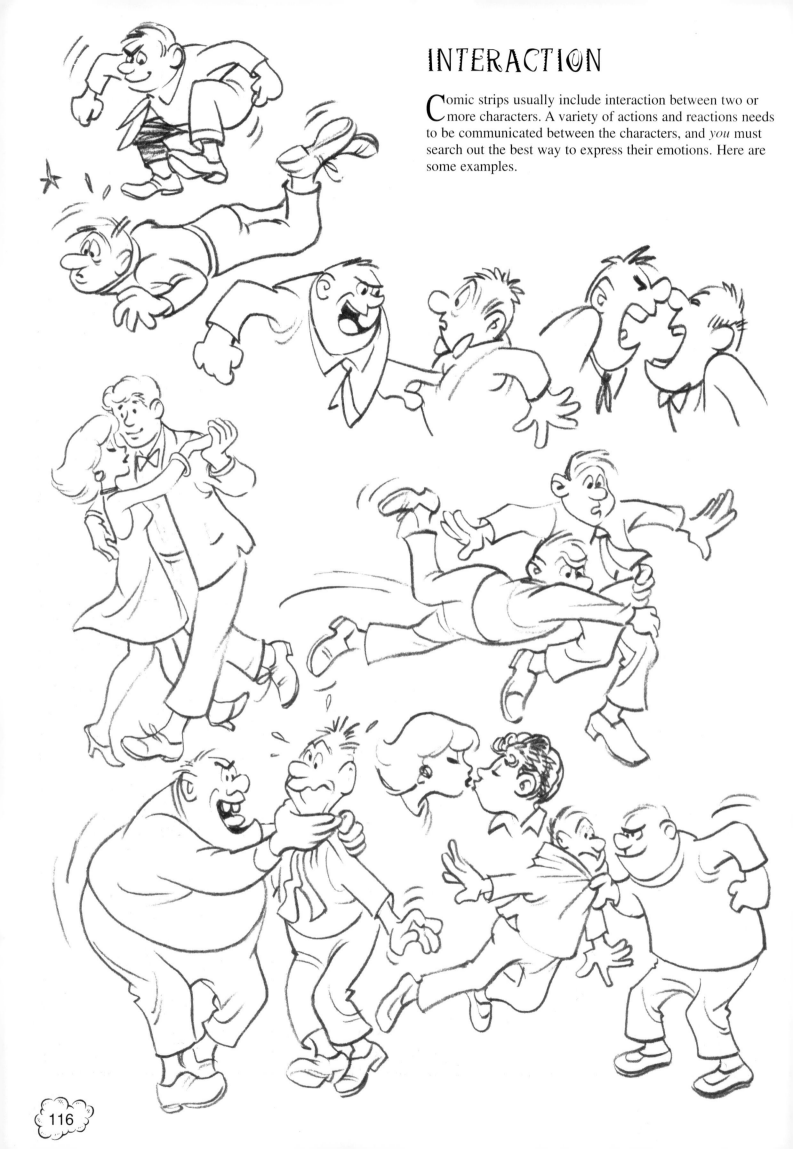

INTERACTION

Comic strips usually include interaction between two or more characters. A variety of actions and reactions needs to be communicated between the characters, and *you* must search out the best way to express their emotions. Here are some examples.

TYPES

Here is a page of clichés and tired stereotypes used by all cartoonists at one time or another. Can you come up with something more original? Doodle your way to originality! Remember, it's your own unique world that you're creating!

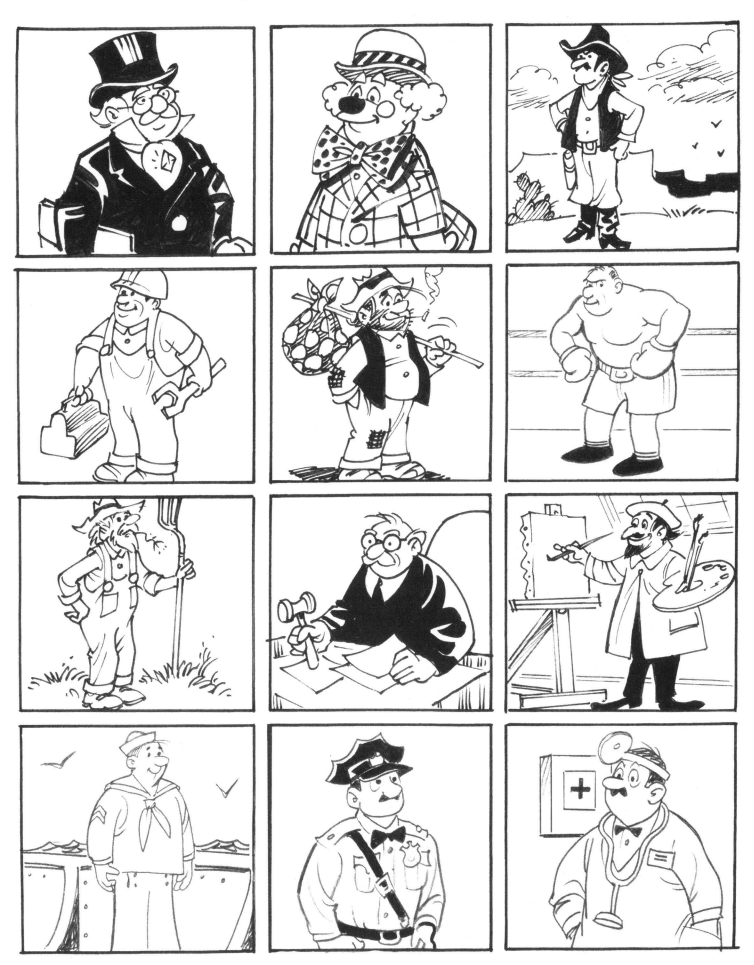

STAGING

Staging may be the most important aspect of drawing a comic strip. Try to avoid "talking heads." Look for interesting angles and vary the point of view. Pretend that you are drawing a movie. If you must use talking heads, avoid straight profile shots. Look over the shoulder to a frontal view of the second character. Here is a suggestion for good staging: (1) Establish the locale. (2) Have an exchange of dialogue in a **two shot.** (3) Portray emotion in a **closeup.** (4) Return to a **long shot** to wrap up the action.

 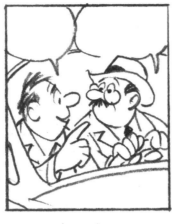

LOCALE SHOT TWO SHOT CLOSEUP LONG SHOT

Pencil balloons first, and then fit the characters around them to avoid the following problems:

Not this way because . . .

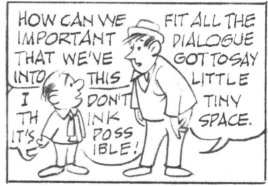

this can happen.

Chopping off hats or heads . . .

or feet.

Not enough space . . .

or too much!

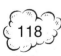

It is important to place the figures in position for correct reading of the balloons.

WRONG! Avoid this confusion.

BETTER, but it's not a good idea. Try to avoid this too.

CORRECT! The balloons and figures are both in the proper order to be read.

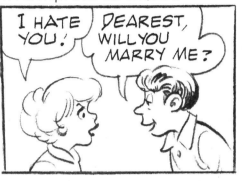

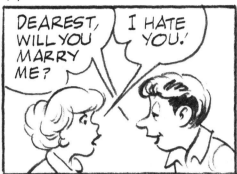

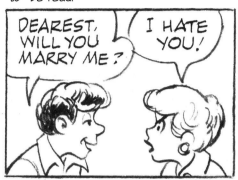

Sometimes it is impossible to shift the figures so that their balloons can be read in the right order. Below are a few ways to overcome this problem.

By lifting the first balloon over the second, you force it to be read first.

Word the balloon so the figure on the left speaks first.

Don't let the lettering go all over the panel.

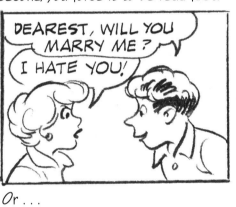

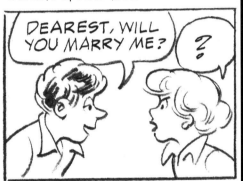

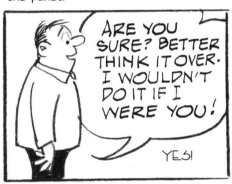

Or . . .

Better yet . . .

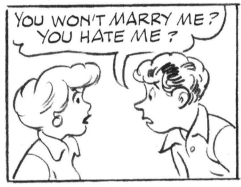

TWO SEQUENTIAL THOUGHTS OR A CHANGE OF MIND

CONFUSION

INDECISION

Draw thumbnail sketches to work out an introductory shot or action.

Use long shots to tell the entire story.

Most important, analyze the best angle to get your storytelling idea or gag across.

It is important to keep actions clear. When staging complicated action, be imaginative.

When you have two characters that vary greatly in size, you need to "fake" the relationship size in order to fit them into the same panel. Put the smaller character on steps or on a slight hill (if locale permits) to create two planes and to push the larger character farther back.

You can show a wide variety of perspectives in your drawings. Always select the best one to communicate and clarify the story (or gag) you are telling. For example, don't go to a long shot for an emotional scene. Match the mood, and don't avoid what seems to be difficult. Sometimes a **down shot** can be very effective. Make the drawing and dialogue unify to tell your story.

A down shot can heighten dramatic effect.

Exaggeration of perspective conveys strong interaction and drama.

Sometimes it creates greater interest to pull away to an extreme long shot to vary the focus.

Sometimes using a down shot can cause problems—such as uninteresting or empty spaces.

A down shot *should* be used when there are interesting or important things to look at.

By using a low horizon and flat, one-point perspective, the staging remains simple and easy. The example below is serviceable but static.

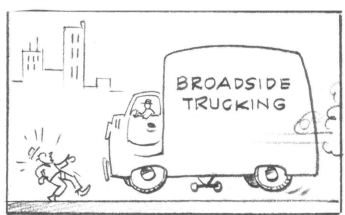

A low horizon can be effective in certain situations. It can give a greater feeling of depth. It can also create great drama when needed, such as having a character look up at an enormous truck barreling down on him!

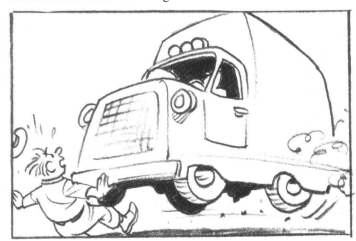

SILHOUETTES

One of the most effective ways to dramatically vary your staging is to use **silhouettes**. Silhouettes are a great way to draw attention to your strip because they present such a strong black-and-white contrast.

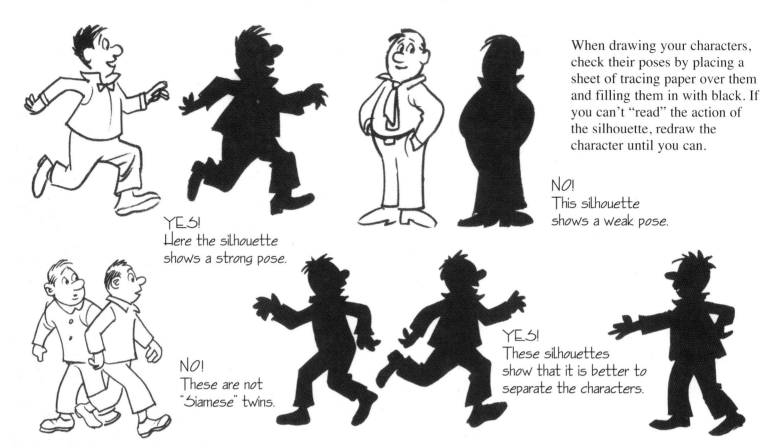

YES!
Here the silhouette shows a strong pose.

When drawing your characters, check their poses by placing a sheet of tracing paper over them and filling them in with black. If you can't "read" the action of the silhouette, redraw the character until you can.

NO!
This silhouette shows a weak pose.

NO!
These are not "Siamese" twins.

YES!
These silhouettes show that it is better to separate the characters.

Silhouettes help establish mood.

Silhouettes are excellent for long shots.

BACKGROUNDS

Get into the habit of always carrying a sketchbook with you. Then, whenever you have time, sketch your surroundings. Strive for authenticity; don't fake it. These sketches can be very helpful references when drawing **backgrounds** for comic strips. (The examples below might be useful to you too!) Good luck—and keep those gags coming!

Basic Animation by Walter Foster

Walter Foster was born in Woodland Park, Colorado, in 1891. In his younger years, he worked as a sign painter and a hog medicine salesman. He also performed in a singing and drawing vaudeville act. Foster invented the first postage stamp vending machine and drew political caricatures for several large newspapers. He's well known as an accomplished artist, art instructor, and art collector.

In the 1920s, while running his own advertising agency, Foster began writing self-help art instruction books. The books were first produced in his home in Laguna Beach, California. He wrote, illustrated, printed, bound, packaged, shipped, and distributed them himself. In the 1960s, as the product line grew, he moved the operation to a commercial facility, which allowed him to expand the company and achieve worldwide distribution.

Foster was a truly dominant force in the development of art instruction books that make it possible for many people to improve their art skills easily and economically. Foster passed away in 1981. He's fondly remembered for his warmth, dedication, and his unique instruction books.

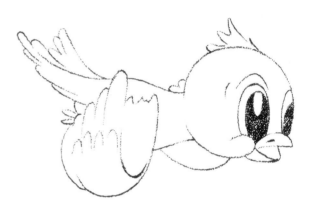

Section 6

WHAT IS ANIMATION?

To *animate* is to bring something to life—in this case, a drawing of a cartoon character. The character can be a person, an animal, or an inanimate object. The process of **animation** involves drawing the character in successive positions to create lifelike movements, such as a walk, a jump, or a dive. When all the drawings are shown rapidly in sequence, the character appears to be moving. A further illusion of life is given to the drawings by including the character's gestures and expressions.

To bring the character to life, the animator first analyzes the action and then works out a sequence of moves—called a **cycle**—by drawing a number of planned poses, or key drawings. The key poses that create the turning points of a movement are called the **extremes**. When the extremes are combined with the other key poses and their **in-between** poses, they make up a complete action cycle. The cycle can be repeated as many times as desired to keep the action going.

To animate your own characters, create and test a series of rough drawings. When you are satisfied with the action and movements in the cycle, add the details. Once the cycle or action is roughed in, run through the drawings in *flip-book* form to study your work.

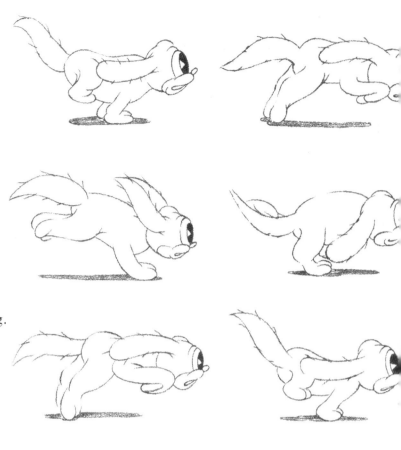

The Flip Book

A **flip book** is a series of pages in which successive drawings are laid on top of one another in close register. Each drawing is a pose from a sequence of positions that a character assumes to create a certain movement (such as a walk or a run) from beginning to end—the cycle. The number of poses in a cycle will vary depending on the action, but the cycle should contain enough poses to keep the movement smooth throughout.

The sequence of drawings of the little bear on the right side of the odd-numbered pages in this section is an example of a flip book of action cycles. To observe the action, hold the binding of the book in your left hand, as shown in the figure to the right. Then, with the outside edge between your right thumb and forefinger, flip through the pages quickly but separately as shown.

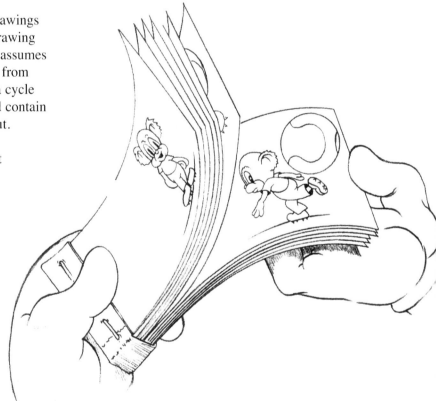

This section will acquaint you with some of the basic skills and techniques in animation. Try animating the characters you have created in previous sections. Who knows what stories they will tell once you bring them to life?

HEAD CONSTRUCTION

To draw cartoon heads, first draw the balance line and the line of action. The **balance line** establishes the center of the head, and the **action line** establishes the direction of the movement. Here the action is in the placement of the hat and the expression on the face. Once you've fixed these lines, you have a plan to go by for the rest of the drawing.

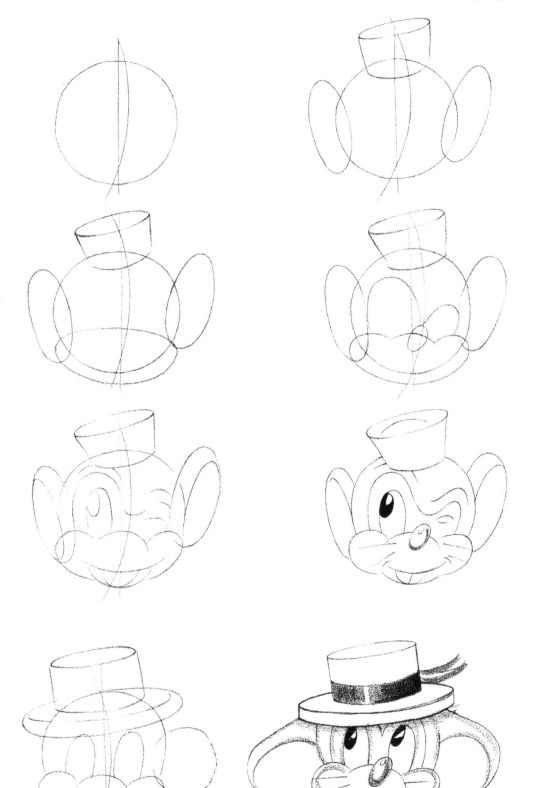

The basic head shape is a circle, and the hat is bucket shaped with an ellipse.

Once the basic head and hat shapes are established, set the placement of the ears, mouth, and eyes.

Place the pupil of the eye in the upper left of the eye area; then draw a small curved line for the right eye to create the winking, quizzical look.

Change the hat and ears, and open the mouse's left eye to create a completely different expression.

FLIP BOOK
*"Flip the pages to watch me wink—
then follow me through this section
as you learn how to animate."*

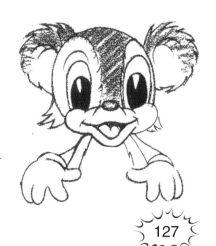

127

EXPRESSIONS

Your job as an animator is the same as an actor's job— you must be able to portray or draw various emotions: happiness, despair, anger, joy, fear, anxiety, disappointment, and so on. Practice by making faces in a mirror. Then choose a character and draw it with the same expressions, as shown below. Notice how the expressions are exaggerated to emphasize the emotions involved.

The heads can be tilted, squashed, or stretched to convey the emotion.

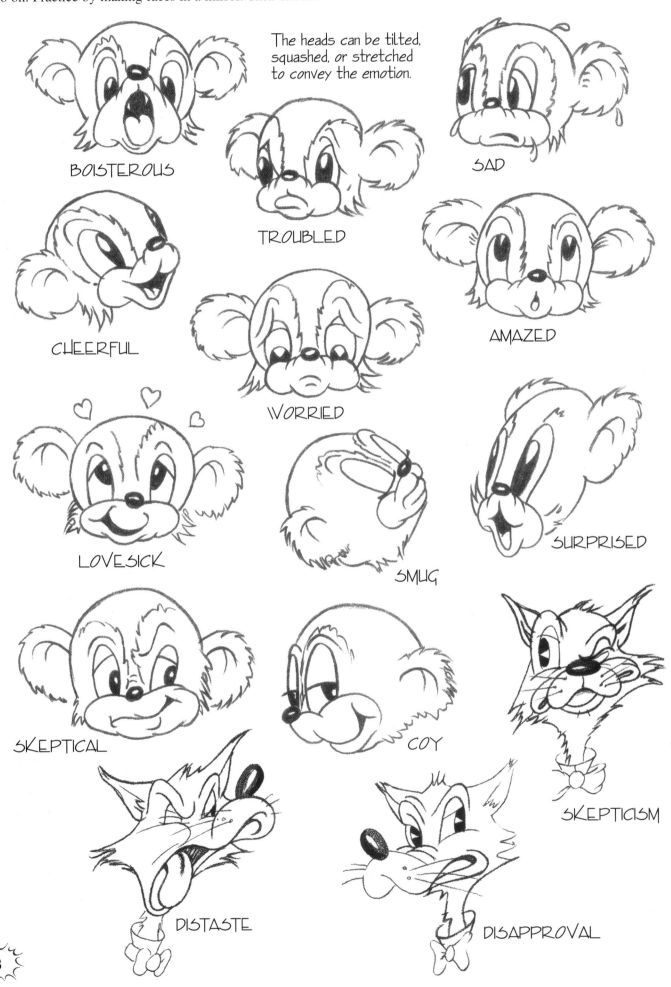

BOISTEROUS

TROUBLED

SAD

CHEERFUL

WORRIED

AMAZED

LOVESICK

SMUG

SURPRISED

SKEPTICAL

COY

SKEPTICISM

DISTASTE

DISAPPROVAL

HAND AND FOOT CONSTRUCTION

Cartoon hands are usually built on a circle. Although they are based on realistic hands, they are greatly simplified, often having only three fingers and a thumb.

Cartoon feet start with ovals. Webbed, clawed, or shoed, cartoon feet are just extreme simplifications of real feet.

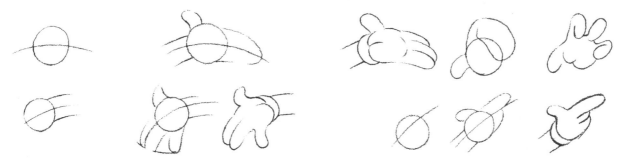

Cartoon hands are usually built on a circle. Follow the steps to construct them.

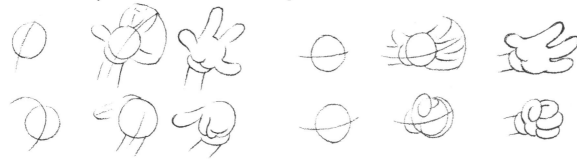

Most cartoon hands have only three fingers. This makes it easier to create different gestures.

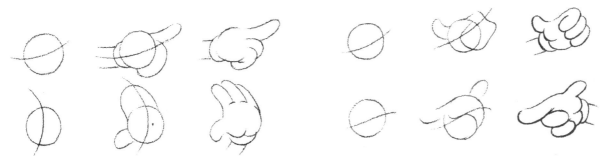

The center line establishes the curve and the action of the hand.

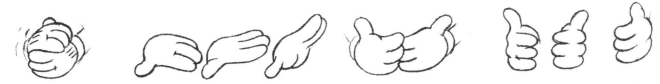

Study the construction of these feet. Notice how the cast shadows anchor the characters to the ground.

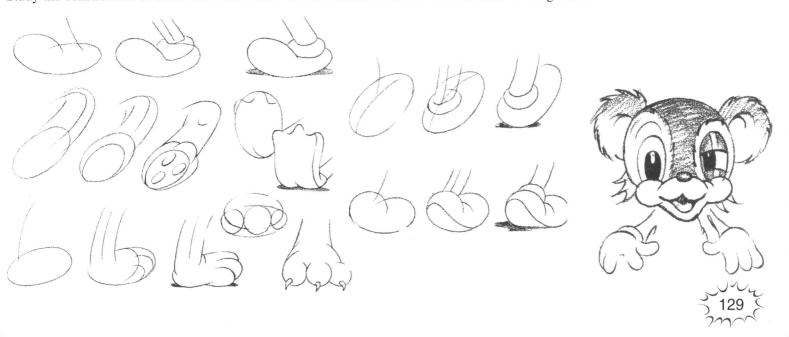

CHARACTER CONSTRUCTION

The first step in character construction is to draw a line of action. Remember, the action line is an imaginary line that determines the main action or the primary attitude of the character. You may also want to add a balance line. The weight of the character should be equal on each side of the balance line unless the position is intentionally distorted.

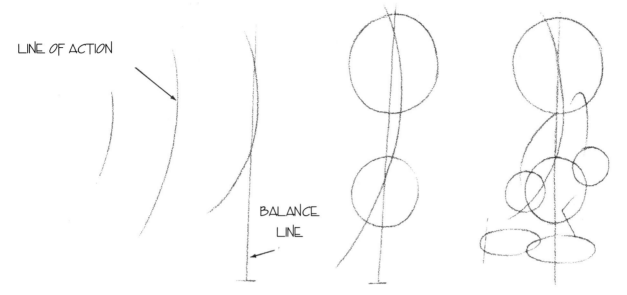

LINE OF ACTION

BALANCE LINE

After setting your action and balance lines, begin roughing in the body masses. The basic construction of this figure consists of circles. The upper body is attached to the lower body, creating a pear shape. Notice how the pose follows the line of action. The straight left arm emphasizes the weight of the bucket, and the character leans to the right to maintain his balance.

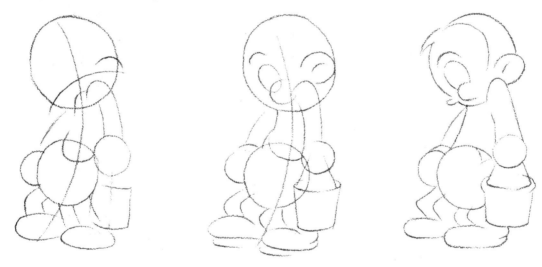

Once the rough is complete, clean up the details with one definite line. To make the action smooth and consistent, keep the lines on each consecutive drawing as uniform as possible (this prevents unwanted movement).

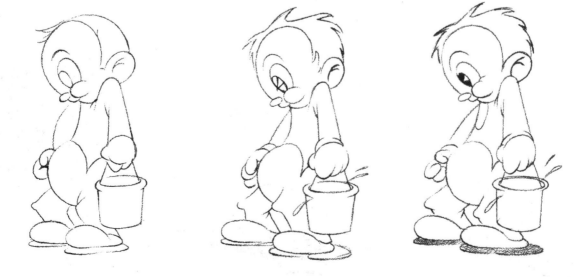

First draw the action lines, and then rough in the characters with an HB pencil. Keep in mind that the action line doesn't always show a lot of movement; it sets a character's attitude, or manner, as well.

 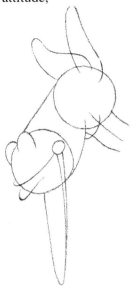 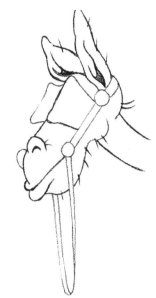

This S-curved action line establishes the figure's slouch, enhancing the character's glum emotion.

 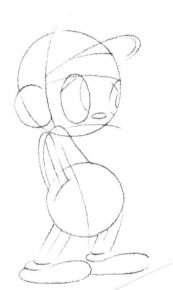

Here the line of action extends through the beach ball, ensuring that the ball appears balanced on the seal's nose. The expression of the mouth conveys the seal's happy attitude.

 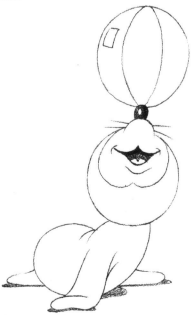

CHARACTERS IN ACTION

When the action line is extreme, the pose is extreme. Really exaggerate the line of action when you want to portray a lot of movement.

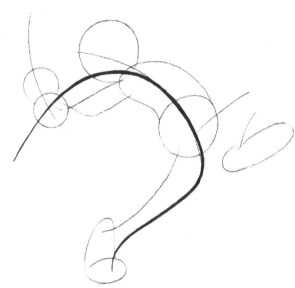

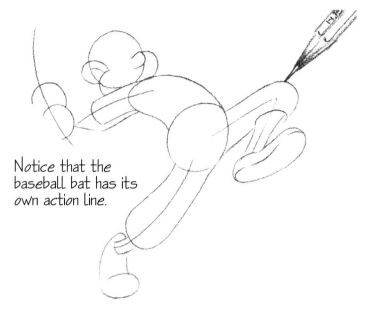

Notice that the baseball bat has its own action line.

Now rough in the masses, and place the features. Keep the first drawings simple; leave out the details until the action is correct.

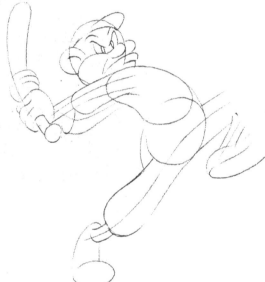

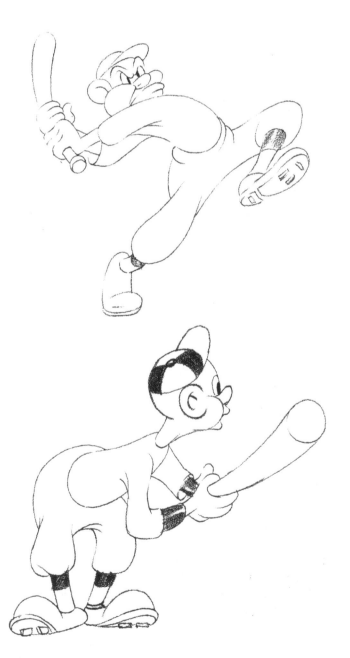

Don't be afraid to experiment with the first steps until you have perfected the action. (Test it with rough flip drawings.) Once the action is worked out, add the details.

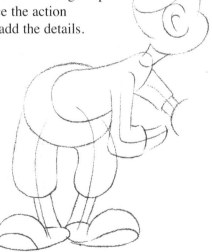

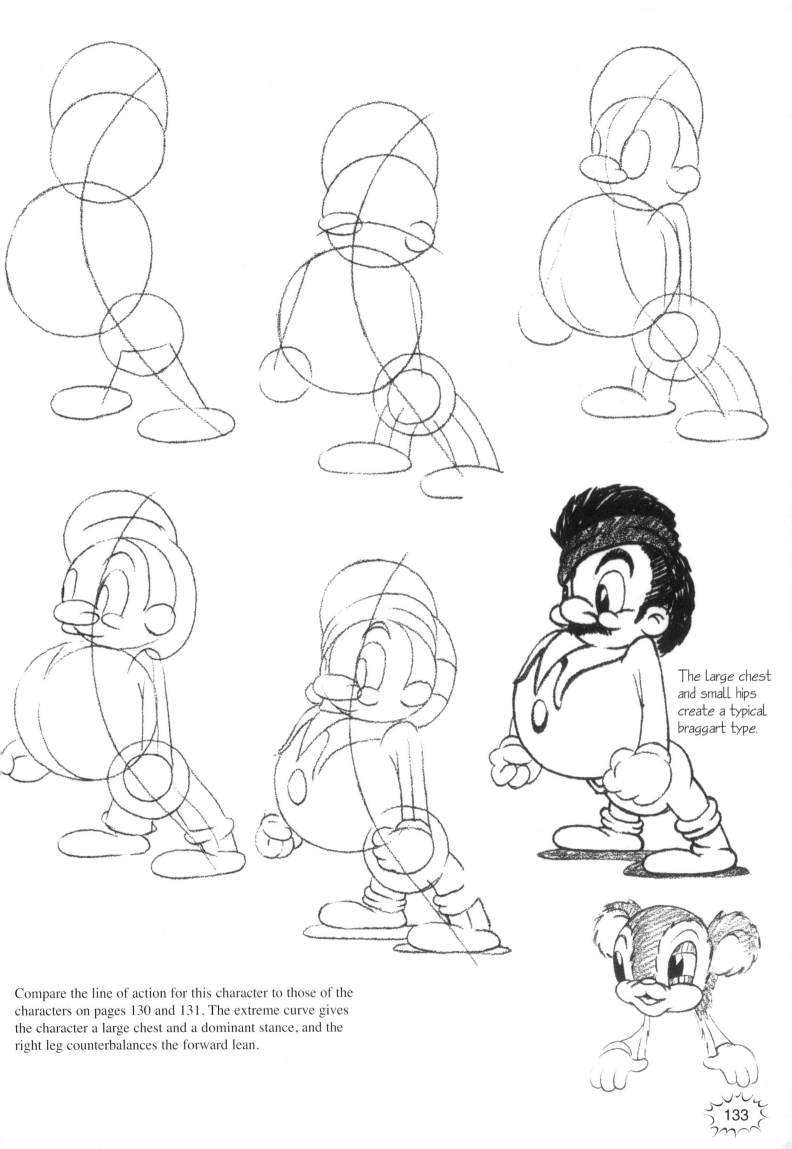

The large chest and small hips create a typical braggart type.

Compare the line of action for this character to those of the characters on pages 130 and 131. The extreme curve gives the character a large chest and a dominant stance, and the right leg counterbalances the forward lean.

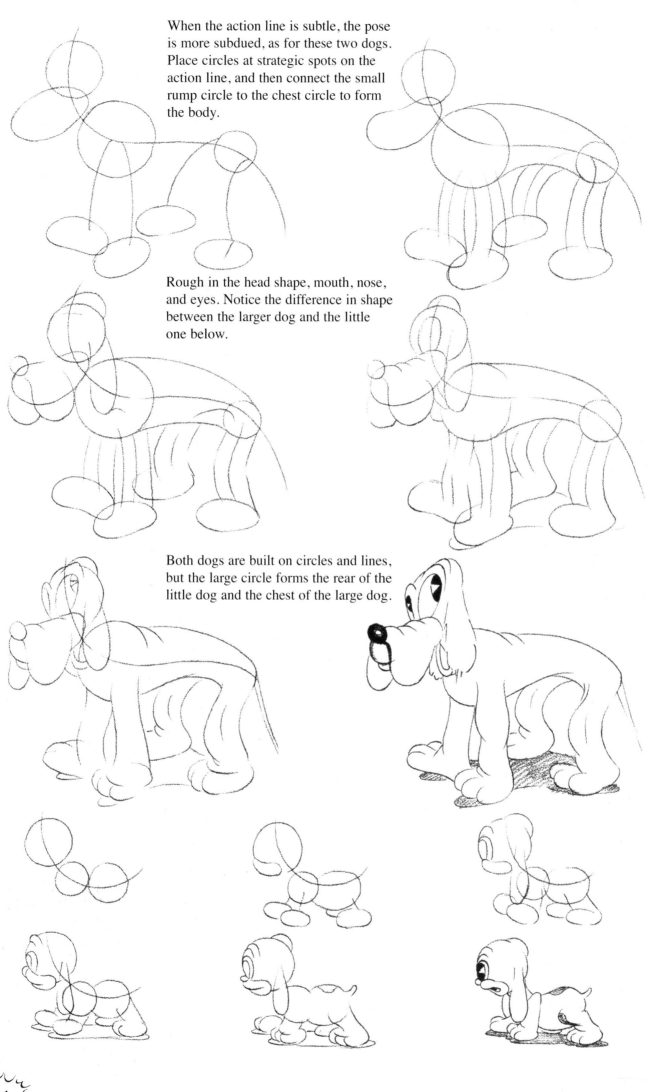

When the action line is subtle, the pose is more subdued, as for these two dogs. Place circles at strategic spots on the action line, and then connect the small rump circle to the chest circle to form the body.

Rough in the head shape, mouth, nose, and eyes. Notice the difference in shape between the larger dog and the little one below.

Both dogs are built on circles and lines, but the large circle forms the rear of the little dog and the chest of the large dog.

HOW TO ANIMATE

There are two basic ways to animate: (1) **straight ahead**, in which the animator simply draws one pose after another, creating a sequence of growth or movement; and (2) **pose planning,** in which the animator draws the extremes of an action and then adds in-betweens, as needed.

Straight-ahead animation is best for creating simple movements, such as a hand waving, a ball rolling, or a flower growing. Pose planning is best for more dramatic actions or gestures, such as a bird flying, an elf walking, or a pup chasing a butterfly.

Straight-Ahead Animation

To practice straight-ahead animation, start with a simple character, such as the flower below. Then place a piece of tracing paper over the initial drawing, and redraw the flower

in the same position, only slightly taller and fuller. Continue this process, making the flower taller and fuller as you progress. This cycle can take as few as five or six drawings — or as many as you wish, depending on the size of the flower.

Flip the stack of drawings from front to back to see the flower grow and bloom; flip them from back to front to watch the flower shrink and wilt.

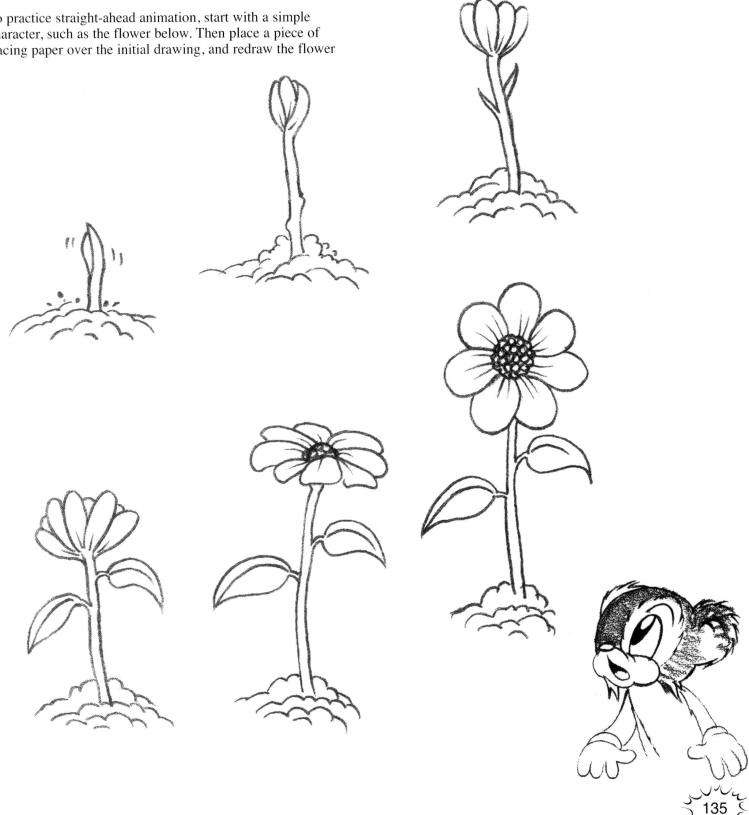

Pose-Planning Animation

Pose planning involves using extremes and in-betweens (see page 137) to take a character from one gesture to another. Usually the extreme poses are planned first, and then the in-betweens are roughed in to connect the extremes. As you draw the in-betweens, you may discover that you need to change one or both extremes. Because of this, work in pencil and keep your drawings simple until you have the action worked out. Once the action is correct, add the details, backgrounds, and props.

In the example below, a butterfly catches the pup's attention (extreme 1), and then he leaps up to chase it (extreme 2). The major in-betweens have been sketched in to show how the gesture and movement are created.

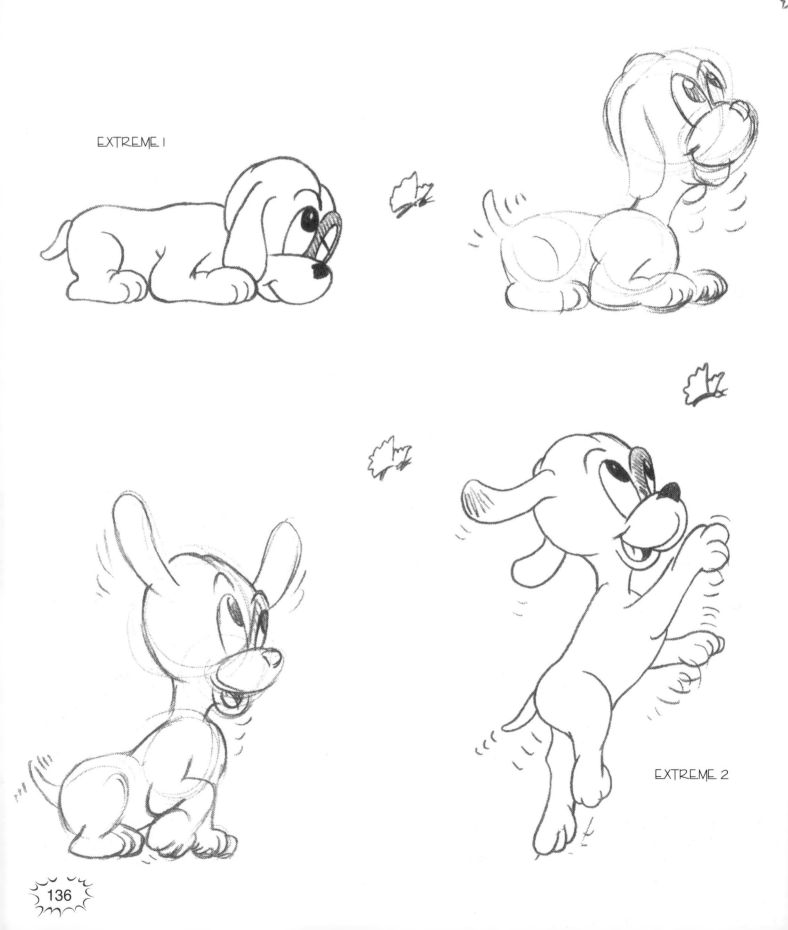

EXTREME 1

EXTREME 2

EXTREMES

Remember, to animate a character using pose-planning, you must first work out a sequence of moves by drawing a number of planned poses: the extremes and the in-betweens. The *extremes* of an action are the key poses that create the turning points of a movement. For instance, in a walk cycle, the body moves up and down, making the character appear taller and shorter. The poses at which the character is (1) shortest and (2) tallest are the extremes. This is because after

the tallest point, it starts moving down, and after the shortest point, it starts moving up.

The drawings between extremes are called *in-betweens*. In-betweens are used to smooth the action. The more in-betweens, the smoother the action. Thus, a slow movement, such as a walk, requires more in-betweens than a fast motion, such as a run, does.

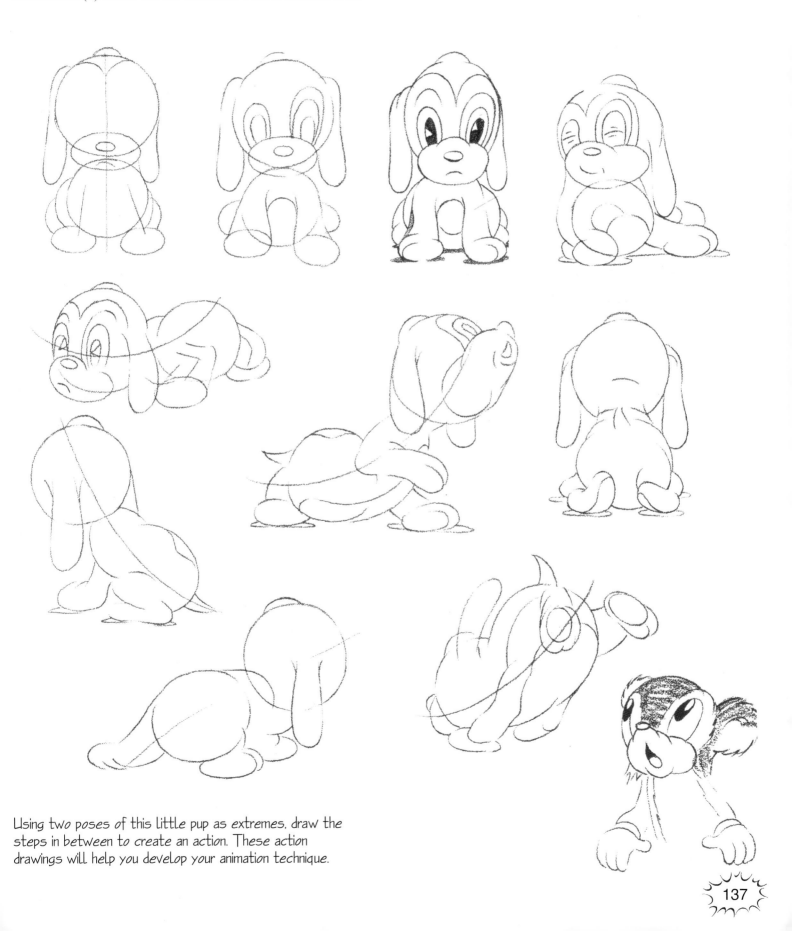

Using two poses of this little pup as extremes, draw the steps in between to create an action. These action drawings will help you develop your animation technique.

ACTION CYCLES

When the drawings of the extremes and the in-betweens are combined, they make up a complete action cycle. Slower action cycles generally require 12 drawings to complete the action, whereas faster cycles need only 8. To test the movement you've depicted, make a flip book, and then change the poses as needed.

1.

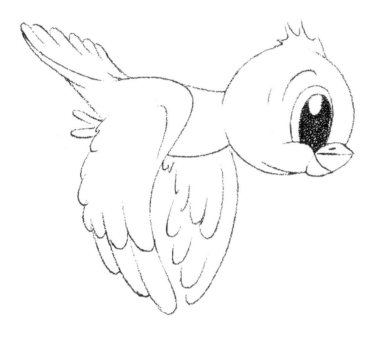

2.

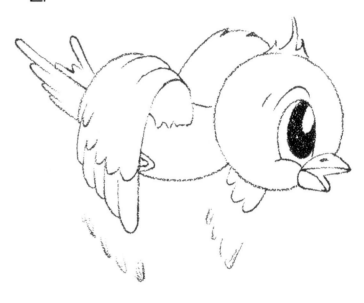

5.

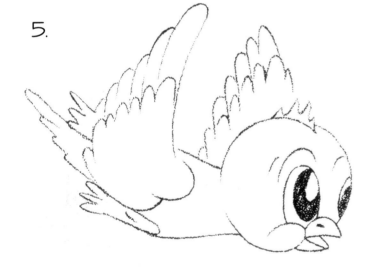

6.

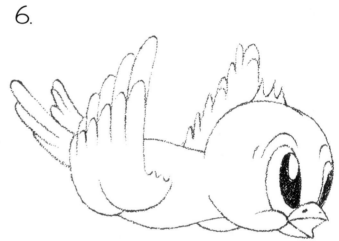

3.

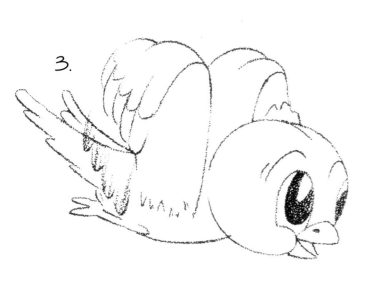

4.

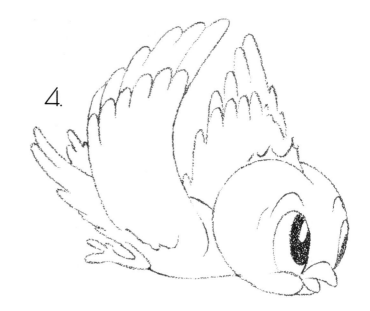

7.

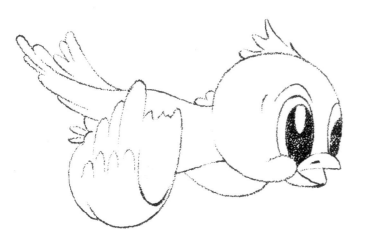

8.

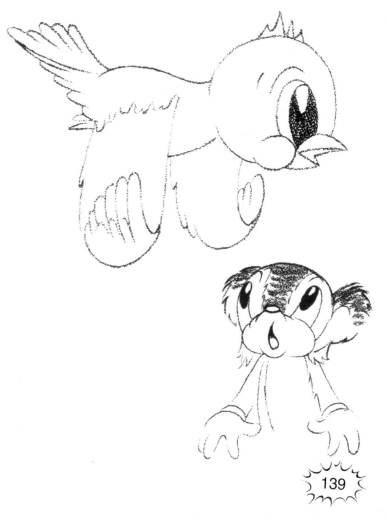

Flight Cycle

The cycle for a bird's flapping wings usually takes from 8 to 12 drawings. In this example, drawing 1 follows drawing 8 to continue the action. The two extremes in this movement are drawing 1, low-wing position, and drawing 4, high-wing position. To create a smoother action, simply add another step between each of the drawings shown here.

Walk Cycle

Here is a 12-drawing cycle of a walk. Recall that slower
actions require more drawings to make them flow smoothly.

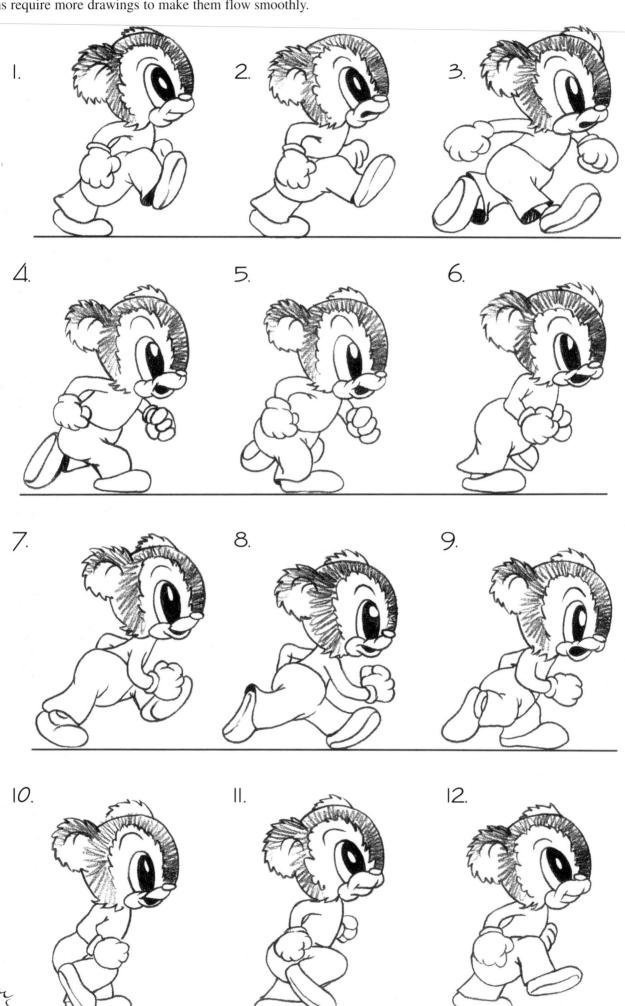

1.

2.

3.

4.

5.

6.

7.

8.

9.

10.

11.

12.

Run Cycle

This is a 12-drawing cycle of a slow run. In a faster run cycle of 8 drawings, the character would lean forward more and perhaps hold its arms out in front to create the illusion of speed. These details will make the animation believable.

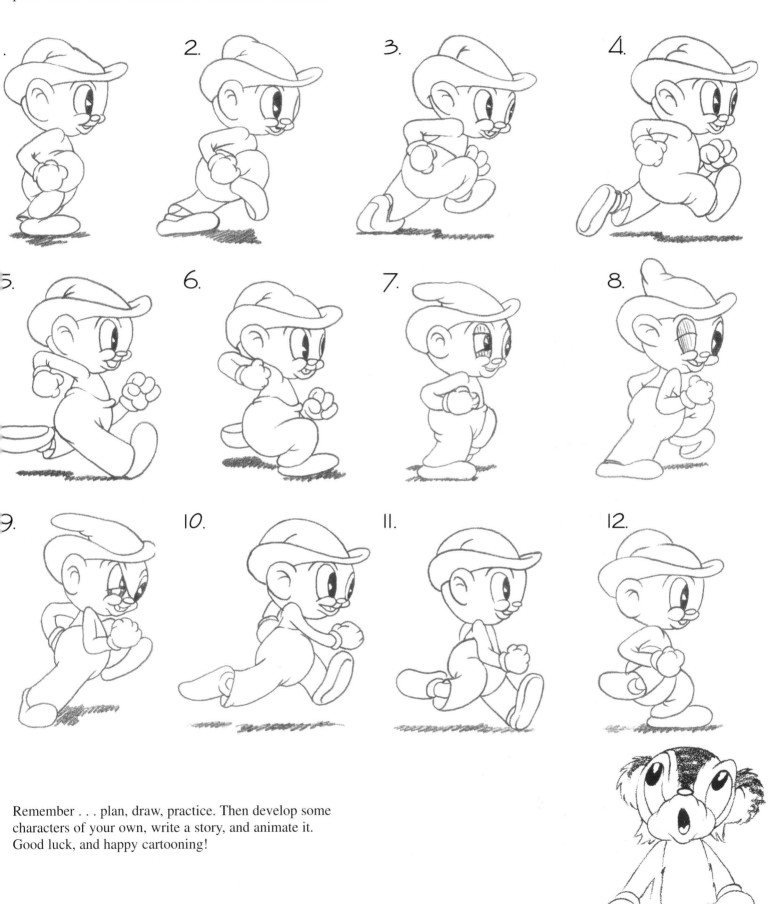

1. 2. 3. 4.

5. 6. 7. 8.

9. 10. 11. 12.

Remember . . . plan, draw, practice. Then develop some characters of your own, write a story, and animate it. Good luck, and happy cartooning!

GLOSSARY

action cycle: a series of drawings of successive poses of an action that make a complete movement, such as a run or walk; also called **cycle**

action line: see **line of action**

animation: a technique of creating lifelike movement, achieved by drawing a character in each of the successive positions of an action

anthropomorphism: the application of human attributes to an animal, plant, or inanimate object

background: the scenery in a cartoon or comic strip representing the setting in which the action takes place

balance line: a guideline for establishing the center of a character; the weight of the character should be equal on each side of the balance line unless the position is intentionally distorted

balloons: shapes that contain the dialogue or symbols for sound effects in a cartoon drawing

basic-shapes figure: a preliminary drawing created

by breaking down the body into simple shapes, such as circles, ovals, triangles, and rectangles

Bristol board: stiff paper or heavy illustration cardboard finished with either a smooth or a rough finish

caricature: (v) to exaggerate the physical features or characteristics of an animal or a human; (n) a drawing that shows such exaggeration

closeup: a cartoon panel in which the action is viewed from a close vantage point

continuity strip: a comic strip with an ongoing story line, such as an adventure or "soap opera"; also called a **narrative strip**

costume: the character's wardrobe; the costume often helps communicate the character's personality

cross action: a method of depicting action in which the arm and leg on the same side of the body move in opposite directions; also called **opposition**

cycle: see **action cycle**

down shot: a cartoon panel in which the action is viewed from above

drawing through: drawing an object in its complete form, showing the lines that will eventually be hidden from the viewer

exaggeration: the distortion of particular characteristics of a subject, often through magnification or minimization

extremes: the key poses in an animation cycle that create the turning points of a movement; see also **in-betweens**

flip book: a device for depicting the illusion of movement, in which a series of successive drawings representing an action are assembled

foreshortening: to reduce or distort parts of a drawing in order to convey the illusion of depth as perceived by the human eye

form: an object's or character's three-dimensional appearance; its mass and volume

gag: the humorous idea or story conveyed in a cartoon or comic strip; the joke

gag-a-day strip: a stand-alone comic strip that does not have an ongoing story line

in-betweens: the poses in an animation cycle that make up the intermediary positions between two extremes, or key poses

inking: applying ink with pen or brush to define the lines and shadows of a final cartoon drawing

line of action: an imaginary directional line tracing the path of action through a cartoon figure to establish its movement

long shot: a cartoon panel in which the action is viewed from a distant vantage point

mannequin: a wooden figurine composed of jointed basic shapes of body parts that artists use as a model for drawing figures

morgue: a collection of images to be used as references, or models, for drawing

movement lines: special-effect lines that accentuate a movement involved; also called **sprits**

narrative strip: see **continuity strip**

perspective: a technique for depicting volume and spatial relationships on a flat surface to give the illusion of three-dimensional form and depth

pose-planning animation: a form of animation in which the extremes of an action are drawn first, and then the in-betweens are added as needed, in contrast to **straight-ahead animation**

proportion: the proper relation of one part to another or to the whole, particularly in terms of size or shape

props: objects that accompany characters in a cartoon and that help advance the story line and define the characters' personalities

shading sheets: commercially produced screens, available in various patterns, used to create texture in cartoon drawings

silhouette: an outline of an object, such as a cartoon character, uniformly filled in with black

sprits: see **movement lines**

staging: planning and developing the story, scenes, shots, and order of events in a cartoon or comic strip

storyboard: a sequence of rough sketches that outlines the action and dialogue in a cartoon or comic strip

straight-ahead animation: a form of animation in which one simply draws one pose after another, creating a sequence of growth or movement, in contrast to **pose-planning animation**

symmetrical: evenly balanced on both sides of a line or a point

talk balloons: see **balloons**

two shot: a cartoon panel in which two characters appear, usually engaging in a dialogue

vellum: a smooth-finish, high-quality, translucent drawing surface